# difference/
# indifference

## musings on postmodernism,
## marcel duchamp and john cage

# Critical Voices in Art, Theory and Culture
A series edited by Saul Ostrow

This book is part of a series. The publisher will accept continuation orders which may be cancelled at any time and which provide for automatic billing and shipping of each title in the series upon publication. Please write for details.

# moira
# r o t h

introduction
and text

# difference/
# indifference

musings on postmodernism,
marcel duchamp and john cage

commentary
# jonathan d.
# katz

Australia · Canada · China · France · Germany · India · Japan · Luxembourg
Malaysia · The Netherlands · Russia · Singapore · Switzerland

G+B
ARTS
INTERNATIONAL

Copyright © 1998 OPA
(Overseas Publishers Association) N.V.
Published by license under the G+B Arts International imprint,
part of The Gordon and Breach Publishing Group.

Amsteldijk 166
1st Floor
1079 LH Amsterdam
The Netherlands

British Library Cataloguing in Publication Data
Roth, Moira
Difference/indifference : musings on postmodernism, Marcel
Duchamp and John Cage. — (Critical voices in art, theory
and culture — ISSN 1025-9325)
1. Duchamp, Marcel, 1887-1968 — Influence 2. Cage, John,
1912-1992 — Influence 3. Arts, Modern — 20th century
4. Postmodernism 5. Avant-garde (Aesthetics)
I. Title II. Katz, Jonathan D.
709' .04

ISBN 90-5701-331-2

# contents

part three
ESSAYS AND PERFORMANCE TEXTS BY ROTH, 1991—1995,
COMMENTARY BY KATZ, 1998

appendix
EXCERPTS FROM
"DUCHAMP FESTIVAL, IRVINE, CALIFORNIA, NOVEMBER, 1971"

# introduction
# to the series

CRITICAL VOICES IN ART, THEORY AND
Culture is a response to the changing
perspectives that have resulted from the
continuing application of structural
and poststructural methodologies and
interpretations to the cultural sphere. From the ongoing processes of decon-
struction and reorganization of the traditional canon, new forms of speculative,
intellectual inquiry and academic practices have emerged that are premised on
the realization that insights into differing aspects of the disciplines that make up
this realm are best provided by an interdisciplinary approach that follows a dis-
cursive, rather than a dialectic, model.

In recognition of these changes, and of the view that the histories and
practices that form our present circumstances are in turn transformed by the
social, economic, and political requirements of our lives, this series will pub-
lish not only those authors who already are prominent in their field—or those
who are now emerging—but also those writers who had previously been
acknowledged, then passed over, only now to become relevant once more.
This multigenerational approach will give many writers an opportunity to
analyze and reevaluate the position of those thinkers who have influenced

their own practices, or to present responses to the themes and writings that are significant to their own research.

In emphasizing dialogue, self-reflective critiques, and exegesis, the Critical Voices series not only acknowledges the deterritorialized nature of our present intellectual environment, but also extends the challenge to the traditional supremacy of the authorial voice by literally relocating it within a discursive network. This approach to text breaks with the current practice of speaking of multiplicity, while continuing to construct a singularly linear vision of discourse that retains the characteristics of dialectics. In an age when subjects are conceived of as acting upon one another, each within the context of its own history and without contradiction, the ideal of a totalizing system does not seem to suffice. I have come to realize that the near collapse of the endeavor to produce homogeneous terms, practices, and histories—once thought to be an essential aspect of defining the practices of art, theory, and culture—reopened each of these subjects to new interpretations and methods.

My intent as editor of Critical Voices in Art, Theory and Culture is to make available to our readers heterogeneous texts that provide a view that looks ahead to new and differing approaches, and back toward those views that make the dialogues and debates developing within the areas of cultural studies, art history, and critical theory possible and necessary. In this manner we hope to contribute to the expanding map not only of the borderlands of modernism, but also of those newly opened territories now identified with postmodernism.

Saul Ostrow

# foreword
## duchamp, cage, roth, and katz: accumulative effect

# saul ostrow

THIS VOLUME, *DIFFERENCE/INDIFFERENCE:*
*Musings on Postmodernism, Marcel*
*Duchamp and John Cage*, brings togeth-
er for the first time Moira Roth's influ-
ential articles, lectures, and interviews on
the two men who embodied the very spirit of the avant-garde: Duchamp, who
died in 1968 at age eighty-two, and Cage, who died in 1992 at almost eighty.
Cage and Duchamp both lived on what Roth describes as "the permissive bor-
ders of modernism," and their confluence forged what has become one of the
most influential models of postmodern cultural production. Though they came
from two different generations and emerged from differing milieus, both are the
products of the war that modernism declared on entropy in the name of
progress and change. Their respective aesthetics found movement, ideas, and
varied experience more appealing than practices based on self-expression or
categorical imperatives. To this end they both sought to develop practices that
were not purely nihilistic, but could self-critically avoid issues of taste and tran-
scendental subjectivity.

Duchamp, with the creation of his first readymade, *Bicycle Wheel*, in 1913,
had realized a new type of artist, one who could forgo art's traditional forms

altogether. By focusing on concept rather than form, he generated a practice premised on the inherent qualities of the emerging technologies of reproduction and their cultural affects. Perhaps this position was premature—so far ahead of its time—it could only become an oddity that would remain marginal to the development of art for the next forty years. It can be speculated that in part this was because the experience, conditions, and information necessary to understand Duchamp's practices in any terms other than "art versus the anti-, or non-art" dichotomy had not yet come into being.

The conditions for the acceptance of Duchamp's particular brand of anti-aesthetic practices were deferred until modernism's goals and practices were further elaborated and the nature of cultural development under capitalism was made explicit. This was not achieved until the early days of the Cold War period, in the wake of Auschwitz and Hiroshima, when *Kultur* had revealed itself to be a thin veneer that allowed us to project a humane façade for our increasingly technologically mediated sense of self. By the end of the 1950s, modernism ostensibly had played its last trump card in the guise of abstract expressionism, and it was apparent that its second generation was incapable of sustaining or further embellishing modernism's discourse. Vanguardism appeared to be doomed. The time seemed opportune for Marcel Duchamp to return, and with that return the historicized practices of the avant-garde that were once meant to *challenge* art became a way to *make* art.

John Cage was instrumental in Duchamp's return. This avant-garde composer is perhaps best known for *4'33''*, which he composed in 1952. This piece was performed that same year in Woodstock, New York, by David Tudor, who lowered the keyboard's lid and then sat for four minutes and thirty-three seconds without playing a single note of music. Cage, as early as 1949—as a means of solving the problems arising out of the theoretical foundations of serial music—had begun to apply Duchamp's practice of presenting readymades (here in the form of noises) as art, and to use chance as a decision-making process to produce "musical" compositions. Cage's idea was to use indeterminacy and nonmusical sound to distance the creator from his creation so that questions of subjectivity and taste would be minimized. This attitude was mirrored by Merce Cunningham, who began to use everyday movement as dance. (Cunningham's long-term love affair with Cage has been analyzed by Jonathan D. Katz.[1])

Cage's representation and application of Duchamp's attitude and practices had great appeal to certain younger artists who were seeking a way to continue

in the face of the sense of closure induced by abstract expressionism. Artists such as Robert Rauschenberg, who was a friend of Cage's, began to use common materials in their work to emphasize the expressiveness of everyday life. Duchamp's influence was further expanded in 1958, when Cage taught a composition class at the New School for Social Research in New York. The students included Allan Kaprow, Dick Higgins, Al Hansen, George Brecht, and Toshi Ichiyanagi, all of whom would come to be identified with Fluxus. With this the stage was set for Duchamp's return; in 1962, the Pasadena Art Museum organized Duchamp's first retrospective.

By the end of the 1960s, the notion of producing works that were anti- or nonaesthetic had come to dominate vanguard art outside of those various formalist circles committed to sustaining traditions in abstract painting and sculpture. The irony, of course, is that Duchamp, already having been a historical figure, receives the credit for this turn of events, though it is Cage—not Duchamp—who was present at Black Mountain College and at The New School delivering the message of chance and indifference. It was Cage who put forth the corrective to the commonly held understanding of Duchamp's readymades by proposing that everything can be *used* to make art rather than everything *is* art if so contextualized. It was Cage who freely circulated among the young neo-Dadaist and proto-pop artists, and it is his influence that can be found in Allan Kaprow's concept of "happenings," and Fluxus's performances. Paradoxically, it is also Cage's ideas concerning the systemic, and his desire for an impersonal art premised on everyday life, that resonates in the work of such minimalists as Robert Morris and Dan Flavin, and in the conceptualism of Dan Graham and Lawrence Weiner.

By the late 1970s, the events, gestures, anecdotes, and even the personalities of Duchamp had become exemplary acts. Ironically, these acts originally intended in part to expose the fact that art's institutional and conceptual core had come to be set aside—circumscribed—and decoded in a manner once preserved for "masterworks." Critics and historians sought to substantiate Duchamp's "works" by deciphering their esoteric meanings. Within the context of the age of communication and mass media, with their production and consumption of information, every inference became the premise for a new reading. In this manner Duchamp came to be reassigned a place in the history of modern art and his stance came to be characterized as fundamental to the continuation of the practice of the avant-garde. By the 1980s, Duchamp's practices

of using extra-art means and critical narratives came to be the foundation for
the practices of still another generation of artists seeking their way out of the
bind created by what had become an institutional acceptance of avant-garde art.

Due to the advent of structuralism, with its emphasis on semiotics, subjec-
tivity, and hermeneutics, the interpretation and understanding of representa-
tion has been subjected to shifting paradigms that have resulted in a
proliferation of information, theories, and frames of reference. These have in
turn defined trajectories that form networks of corollaries and alternatives.
Through trial and error, these systems increasingly make explicit the applica-
bility of their terms, methods, and conditions. Moira Roth used these then-
emerging discourses in the later 1970s when she reframed Duchamp and Cage's
"silence" within the context of Cold War politics and McCarthyism, as well as
when she explored Duchamp's "role-playing" in the context of the issues of
identity politics that had built up around performance art and feminism. The
recontextualization of what seemingly had been explained either in formal or
historical terms produced new ways to understand the contemporary cultural
implications of their respective stances. By doing this—unlike Jack Burnham,
for example, who sought the esoteric and hidden meaning of Duchamp's
work—Roth indicated the way these two "seers" could be rescued from the
early-twentieth-century discourse on art versus anti- or non-art as well as
exhibiting the continued relevance of the content of their work to a contempo-
rary situation.

Over the last twenty years, Roth has reflected upon what she has done, tak-
ing into account new interpretations and practices as well as her own changing
perspectives. She does not reorder the whole, but instead records the terms and
conditions that release and realize both her subjectivity and her subjects. This
process does not take place in isolation; others are required to supply key pieces
to the puzzle. These are delivered as unsuspected gifts in the form of works of
art, questions, comments, and even reprimands. The resulting dialogues are a
reminder that no body of knowledge or expertise is self-enclosed, that there is
always some opening to explore. Staying sensitive to such moments keeps such
projects honest—for it necessitates an awareness of the influence that one has
had on one's subject.

*Difference/Indifference* records just such a dialogue. Jonathan D. Katz—
who chairs the Department of Gay, Lesbian and Bisexual Studies at the City
College of San Francisco—in his commentaries in this book reopens the con-

tent of Roth's work on Duchamp and Cage, transforming them into the subject of a compelling and unique critical dialogue with Moira Roth. What Katz brings to this project is a range of experiences and perspectives that in the 1970s were not available to Roth, for he has benefited not only from her pioneering work on Duchamp and Cage, but is also equipped with a fuller picture of identity and gender politics, and their cultural effects— a picture that has developed in the last fifteen years. He also brings to bear his own work, which focuses on the emergence in the "mainstream" culture of a significant number of gay men (such as Johns, Warhol, Twombly, and Rauschenberg) during the 1950s and 1960s. His perspective, informed by queer studies, supplies an important corollary to Roth's initial thesis concerning the "politics" of Cage's and Duchamp's practices.

Without hesitancy, Katz and Roth have together critically delved into the hagiography surrounding these now sanctified figures. They have turned the monologue of the art historian into a dialogue in order to engage the heterogeneity of their subjects. This in turn gives insight into both the ongoing process of describing and mapping the complexity of Duchamp and Cage, as well as the effect of putting them into the world.

# preface

# moira roth
# and
# jonathan d. katz

WE HAVE WORKED VERY CLOSELY TOGETHER on this book. It has become more than a collaboration; it has become an exercise in building alliances. First meeting in person in 1991, it was our dialogues during the last year over *Difference/Indifference* that brought us deeply together. We have taught each other and learned from each other and have begun to see the world—albeit only occasionally and surely partially—through each other's eyes. However distinct our methods, preoccupations, and writerly voices (and they are definitely distinct), we have now identified in ourselves something of the other, something we can use to reexamine what has grown comfortable in us.

Such alliances aren't only about trying one another's methods, or developing an interest in each other's subjects. It is much more personal than that: it includes eating dinner together, debating political strategies, and weighing ethical responsibilities. As the distinction between collaborator and friend began to blur, we found a depth of commonality—and community—that surprised us both.

So much has changed since the 1970s (the decade of the first group of writings in this book) to make this alliance possible. It is no exaggeration to state that

it would have been nearly unthinkable twenty years ago. Then there was no such thing as queer studies, and in feminist circles it would have been highly unlikely to have a heterosexual woman collaborating with a gay man, especially about male subjects.

We are of different generations and different cultures. Moira, English-born (and, despite her last name, not Jewish) has been involved (writing and organizing) in feminist circles since 1970, and now teaches in a women's college. Jonathan, Jewish and twenty-five years younger, is a queer political organizer and activist, who was trained as an art historian, and now chairs a Gay/Lesbian/Bisexual Studies department.

We share an interest in Duchamp and Cage, social justice and community organizing. Moira lives in Berkeley, Jonathan in San Francisco—a bay and a bridge between us. Crossing that bridge in order to meet has become a routine, and at times a bother for us both; but it is an exercise we have grown to cherish and the distance continues to shrink.

For years we have both written on, over, and through Duchamp/Cage—according to our singular preoccupations. When invited by Saul Ostrow in the summer of 1996 to participate in the Critical Voices in Art, Theory and Culture series, Moira asked Jonathan if he would be interested in a dialogue. He was.

Berkeley, January, 1998

# acknowledgments

I WANT FIRST TO THANK Saul Ostrow, the editor of the Critical Voices in Art, Theory and Culture Series, both for including me in the series and for providing a wonderfully supportive ambience during the process of putting this book together—as did Fred van der Marck, the publisher. My deepest thanks go also to Whitney Chadwick for her insights during the initial planning stages; to Cheryl Leonard for all her meticulous hours of organizing the texts; to Heather Heise for her critical acumen; to Maria denBoer for her superb editing skills; to Liza Rudneva for handling the last-minute details; and to Brian Bendlin for such fine copy editing.

Many people have supported my scholarship over the years. I would like in particular to express my gratitude to Peter Selz for his help during my dissertation days, and to two editors who early on gave me publishing opportunities: Richard Martin, then editor of *Arts,* for inviting me to contribute "Marcel Duchamp in America: A Self Ready-Made" to his New York Dada issue, and to Joseph Masheck, then editor of *Artforum,* for his quick acceptance of "The Aesthetic of Indifference." I am most indebted also to Mary Jane Jacob, Naomi Sawelson-Gorse, and David Bernstein for later opportunities to reassess Marcel Duchamp and John Cage.

Working closely in the past year with Jonathan D. Katz, a most generous and gifted scholar, has been a remarkable experience. I have learned much from him as well as greatly enjoyed the collaborative aspects of our project. My contributions in this book are dedicated to him with deepest thanks and affection.

Moira Roth
January 26, 1998

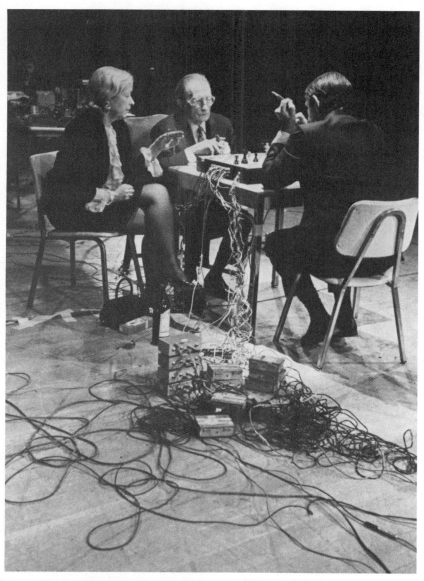

Teeny Duchamp, Marcel Duchamp, and John Cage, *Reunion*, 1968.
Photo: Shigeko Kubota

Teeny and Marcel Duchamp and Cage at a performance of Cage's *Reunion* in Toronto. This photograph is part of a series by Kubota, who came to Toronto from New York in order to record this game of chess between Cage and Marcel Duchamp; played on a prepared chessboard fitted with contact mikes, the game was watched by Teeny, Duchamp's wife.

# introduction
## now and then

## moira roth

> He [Duchamp] and Teeny
> performed with me in the
> chess piece in Toronto. I
> turned to him during the
> performance. I said, "Aren't
> these strange sounds?" He
> smiled and said, "To say
> the least."
>
> —John Cage, in Moira Roth
> and William Roth, "John
> Cage on Marcel Duchamp"

Marcel Duchamp died in 1968 at age eighty-two, and John Cage died in 1992, a few weeks short of his eightieth birthday. Cage and Duchamp are two grand old men, now dead and enshrined, who have fascinated, irritated, inspired, and daunted me for almost thirty years. At one time the two men represented for me a fresh edge of the American avant-garde; they seemed to live on a permissive border of modernism, and later, of postmodernism—which helped me gain access to those territories. For a considerable time, they deeply inspired me in both writing and teaching. These days, however, I have increasingly

encountered them as "classical" figures in the avant-garde canon—in part, because of the way they have become so entrenched in current academic and scholarly publications (obliquely aided, I would argue, by the artists themselves) and conferences.[1] This canon can, on occasion, create an obstacle course. Sometimes I manage to ignore it and march on; at other times, I feel compelled to pause in order to give it a piece of my mind.

Yet that is not to say that I have lost interest in Duchamp and Cage. No. It's not that simple.

In 1977, at the conclusion of "The Aesthetic of Indifference," I had briefly explained to *Artforum* readers that this was, in many ways, a "partial autobiography," a discussion of my "long, intense and ambivalent history of attitudes" and interest in Duchamp and Cage, which has extended to the present. It is an interest lasting several decades, one I can trace back to a chance encounter with John Cage in 1951.

## john cage's white loft,
## spring 1951—spring 1997

"You have to remember how straight-laced everything had always been in music. . . . Just to change one little thing in music was a life's work. But John changed everything. . . . John was freer than the rest of us."

—Morton Feldman, quoted in Calvin Tomkins,
*The Bride and the Bachelors*

Ironically, when I first encountered Cage, his music seemed too much a part of the vanguard for me to appreciate.[2] What is more, I have only the dimmest memories of this first meeting.

Cage's loft, situated on the corner of Monroe and Grand Streets in New York City, has become legendary in the history of avant-garde camaraderie. It was the setting for a series of pivotal encounters between Cage and Morton Feldman, along with David Tudor and, often, Christian Wolff. In this sparse space that pioneered a minimalist aesthetic, Cage discovered and studied the *I*

*Ching* (the Book of Changes) in the winter of 1950–1951, and in the following spring he was at work on the first part of his *Music of Changes*.

Calvin Tomkins describes Cage's loft as "a whitewashed aerie; its sole furniture was a long marble table and a grand piano...."[3] Cage reported that Isamu Noguchi had once said "an old shoe would look beautiful in this room."[4] Models were photographed in the space for *Harper's Bazaar* and *Vogue*, and many young members of the avant-garde came to the private concerts held there.[5]

I met Cage for the first time in this space in the spring of 1951 when, eighteen years old and fresh from an English childhood, I was staying for a month in New York. A former student of Black Mountain College brought me to several casual evening concerts in the Monroe Street loft. I remember being charmed by the loft's elegant bohemian ambience, the conversational exchanges, and the sense of being part of a privileged community. Yet during the concerts I would think to myself, "This isn't music" (I had been brought up on a strict diet of classical music in England). I recognized and appreciated Cage's free spirit and sense of play, and his haunting power, but I could not see this as an artistic framework—that was only to become apparent to me in the late 1960s.

Recently, while editing a book on Rachel Rosenthal, the performance artist and an early friend of Cage,[6] I came across a description that explains for me, more than any other accounts, the strength of this magical white space. In an interview, Rosenthal tells Alexandra Grilikhes:

> "In 1980, I did a piece about power called *Bonsoir Dr. Schön!* in which I said that an image of power for me was John Cage's apartment in the early 1950s in New York. He had a corner walkup next to the Brooklyn Bridge. We used to go there often to hear David Tudor's concerts. It was an old building with floor-to-ceiling windows that looked out onto the river. The floor was covered with jute matting and there were no curtains or blinds. The only thing in that apartment was a big piano with green plants on it. At night it felt free, available, and open to all currents. Sounds and lights would come from the river and because there were no impediments, the air circulated freely around the apartment. The music's sound waves, people's thoughts and speech all seemed to flow. What was circulating was so powerful, it became my model for an image of power."[7]

Such sites of friendship, creativity, and intimate audiences have always intrigued me; indeed, I suspect I romanticize them. I experienced them as a child—for ten years my mother and I shared a house outside London with Hans

Redlich, a musicologist and German Jewish World War II refugee, and we would have weekly informal concerts and gatherings of composers and scholars. As an adult, I have always invested much time and energy in private conversations and ceremonious exchanges between friends. A few years ago, in connection with feminist friendships, I wrote, "I wonder if future art historians will be able to conjure up vividly enough the central place such friendships have in our lives as well as in our art and writing—and the conversations in which we generate ideas collectively."[8]

But there is often a threatening world outside these sites of personal friendships and private creativity.

The late 1940s and early 1950s, usually read as a powerfully freeing moment in the formation of American avant-garde music and art, was also a period of increasing threats to political and intellectual freedom, and—among other targets—modern art.[9] I encountered this coercive political climate directly during my first stay in this country, from the summer of 1950 to that of 1951. I lived in Washington, D.C., where my father worked at the International Monetary Fund. It was at the start of the McCarthy era (1950–1954), and he was increasingly distressed by Washington's right-wing politics.

In the early 1970s, while doing research for my dissertation, I was surprised to find this McCarthy context had been relatively little investigated as the ambience in which an "aesthetic of indifference"—my term—developed. I argued that this "indifference" was central to a loosely coalesced group of artists, composers, writers, and dancers—among them Cage, Merce Cunningham, Jasper Johns, and Robert Rauschenberg, with Duchamp as a European father figure. In "The Aesthetic of Indifference" I wrote, "Because of this seemingly indifferent attitude to politics, such artists themselves—and most of their critics—have never acknowledged the influence of the historical context in which this aesthetic was formed. . . . Such aloofness from political events of the time was part of these artists' general indifference, but now, today, a quarter of a century later, it is part of their self-image which should be questioned."[10]

On the other hand, there were questions that I, too, did not really address at this time. With the exception of Marcel Duchamp,[11] the leading figures in this "Aesthetic of Indifference" group were gay. The Monroe Street loft of 1951, among its other readings, must be seen as the home and workplace of a gay white

man. What did that signify in 1951 for Cage as a man and as a composer? And what does it signify, in retrospect, to us in the 1990s?

Attacks on contemporary art were rampant during this highly homophobic time of the Cold War and McCarthyism, both from the outside (witness the attacks by Congressman George Dondero in 1949 in the House of Representatives) and from within art world circles. One gets a vivid picture of this in an exchange between Frank Lloyd Wright and Duchamp during The Western Round Table on Modern Art in San Francisco in 1949. Wright attacked modern art as degenerate, singling out the prevalence of homosexual artists as a major cause.

> Wright: Would you say that [homosexuality] was degenerate?
> Duchamp: No, it is not degenerate.
> Wright: You would say that this movement which we call modern art and painting has been greatly . . . in debt to homosexualism?
> Duchamp: I admit it, but—not in your terms.
> Wright: To me it is significant.
> Duchamp: I believe that the homosexual public has shown more interest or curiosity for modern art [than] the heterosexual: so it happened but it does not involve modern art itself.[12]

In my 1977 *Artforum* article I only obliquely explored the role and influence of homosexuality. Now, returning with hindsight, I am struck by the fact that even in recent publications on Cage this subject has rarely been addressed in any depth.[13] In the past year, Jonathan D. Katz has completed two essays: "John Cage's Queer Silence or How to Avoid Making Matters Worse" and "Passive Resistance: On the Success of Queer Artists in Cold War American Art." These texts, together with his 1993 published article, "The Art of Code: Jasper Johns and Robert Rauschenberg,"[14] have been enormously illuminating for me, as have our frequent conversations on the phone, by fax, and in person.

Guided by Katz's speculations, I am tempted to return to musing more about the gay nature of this white space of Cage that I had glimpsed so briefly in 1951 and had incompletely understood when I wrote "The Aesthetic of Indifference." But these are Katz's ideas, not mine, and so I will leave it to him in his commentary, "Identification," to look critically through the lens of his current research and speculations not only at my early writings but more generally at the 1950s.

## bloomington, indiana,
## 1968—1969

Marcel Duchamp, whom I was to meet in my imagination but never in person, died shortly after I arrived in the fall of 1968 to teach for the year at Indiana University. Except for passing references to the readymades in Herschel Chipp's single crammed lecture on Dada and surrealism, I had been introduced to neither Cage nor Duchamp at the University of California. In Bloomington, however, I became deeply drawn to both of them and quickly evolved a dramatic teaching style for presenting their ideas.

By 1968, the theatrical modes of the decade's demonstrations had greatly affected me. In my everyday life in Berkeley I had encountered street theater and political demonstrations. I had attended such events as the first "Be-In" at San Francisco's Golden Gate Park (1967), and participated in early northern California performance art. Later, in 1978, I wrote one of its first histories.[15] My essay of the previous year, "Marcel Duchamp in America: A Self Ready-Made,"[16] was clearly influenced by my interest in contemporary performance.

In 1968—the year of the assassinations of Martin Luther King, Jr. and Robert Kennedy, the arrest of the Chicago Seven, Richard Nixon's election, and the anti-war student shutdowns of Columbia and San Francisco State Universities—I was desperate to find ways of reconciling the impact of all these events with my doctoral studies in art history. It was hard, and I had almost dropped out of graduate school when an opportunity to teach at Bloomington suddenly appeared.

The Midwest was extremely foreign to me, and living there for a year from 1968 to 1969 profoundly jolted my Berkeley view of the world. Now, of course, it seems ironic that I turned in this place and this time to Cage and Duchamp as radicals. But I did. Studying their work allowed me to continue in art history, while keeping my distance from both traditional art history and classroom practices. As Cage, a close friend of Duchamp in his later years, once explained to Bill Roth, then my husband, and myself: "I'm out to blur the distinctions between art and life, as I think Duchamp was. And between teacher and student. And between performer and audience, et cetera."[17]

Increasingly I saw Duchamp—in terms of his multiple personae, the theatrical aspects of the readymades, and the dramatic narrative of *The Large Glass*—as an actor and scriptwriter, who performed at his best in the limelight of New York and on the stage of American modernism.[18] In Bloomington, I fell

headlong under the spell of Duchamp's seemingly chameleon-like character in life and art. I taught a class on European Dada and surrealism, and the works of Cage and Duchamp kept appearing in class discussions and inspiring event after event.

Two were particularly memorable.

One of the seemingly more stolid students arrived one day in a rare state of excitement for his presentation. A few days before, to his surprise, he told us, his mother had sent him a blueprint, one that Duchamp had been circulating shortly before he died, of the design for an object to be made of ready-made materials. He then showed us both the sketch—its French instructions written convincingly in Duchamp's elegant, spidery-thin handwriting—and the ready-made he had made from it.

In another class meeting, we did readings from Cage's *Silence;* each student chose a passage at random by opening the book. One student searched through the texts purposefully, however, and began to read "Lecture on Boredom" in a droning voice. Silently and ceremoniously students one by one began to leave the room to stand just outside. Finally, I was the only person left. After the reading had finished, the students sauntered back in the room slowly. No one said anything, and the class resumed in a normal manner.

On May 16, 1969, I re-met John Cage (I had not encountered him since 1951) when I took a large group of students by bus from Bloomington to Urbana to see the five-hour performance of *HPSCHD*, a collaboration between Cage and Lejaren Hiller staged at the University of Illinois.[19] On huge translucent screens, over fifty projectors created a constant barrage of slides and films. The event's sounds, recorded on fifty-two tapes, were based on the results of a random number generator, responding to some eighteen thousand I Ching coin tossings. Richard Kostelanetz remembers 'spinning mirrored balls reflecting dots of light in all directions—a device reminiscent of a discotheque or a planetarium.... There was such an incredible abundance of things to see that the eye could scarcely focus on anything in particular."[20] This extravaganza was witnessed by an audience of some six thousand, who as the hours progressed not only moved in and out among the live performers—a group of harpsichord players—but often became performers themselves.

At one point I was wandering around at the top of the auditorium and encountered Cage, who was in an almost manic state of delight and surprise. Together we briefly looked down on the wild scene and he just kept laughing. It

was a dramatic ending to my first year of teaching, and my first immersion, so imprinted with theater and excitement, in the work of Cage and Duchamp.[21]

What did Cage and Duchamp offer me in Indiana at this time? They provided a seemingly different relationship to avant-garde authority; integral to their work was its deliberately unfinished nature. It seemed at the time that my students and I—together with all other readers of the work—could freely perform *our* readings and *our* endings. It was the audience, after all, who had not only heard but literally made the sounds (combined with ambient ones) in Cage's famous "silent" piece, *4'33"*, when it was first performed in 1952. A few years later, in 1957 in Texas, Duchamp began his terse text of "The Creative Act" with "Let us consider two important factors, the two poles of the creative act: the artist on one hand, and on the other, the spectator who later becomes posterity." He concluded with, "All in all, the creative act is not performed by the artist alone; the spectator brings the work in contact with the external world by deciphering and interpreting its inner qualifications and thus adds his contribution to the creative act."[22]

Only later did I discover that, unbeknownst to me in Indiana, French structuralist debates (together with their American counterparts) were heating up at this time about the existence of "the author," the multiple meanings of "the text," and the role of "the reader." In 1968, Roland Barthes published his famous essay, "The Death of the Author," in which he tells us that "everything is to be disentangled, but nothing deciphered, structure can be followed [in] all of its stages, but there is no end to it, no bottom.... The birth of the reader must be requited by the Death of the Author." A year later, Foucault answered with "What Is an Author?"[23]

## california, cuba, and italy, 1970—1990

In the early 1970s, now back in California,[24] I worked on my dissertation, "Marcel Duchamp and America, 1913–1973," which started with *The Nude Descending a Staircase* and Duchamp's first New York Dada visit in which his personae plays begin to emerge. Later in the thesis I turned to his role in 1950s America, and ended with multiple readings of him in the 1960s, grouping together American artists and historian-critics who saw him variously as the Liberator and Iconoclast, the Enemy, and the Cryptic Scholar. For this section,

I conducted some forty interviews and exchanges on the East and West Coasts with contemporary artists and critics concerning their reactions to Duchamp.[25] (See the republication in this book of the interviews with Cage and Robert Smithson, and the publication for the first time of interviews with Vito Acconci and George Segal, together with the two 1977 essays, "Marcel Duchamp in America: A Self Ready-Made" and "The Aesthetic of Indifference," all of which are drawn from material explored originally in my dissertation.)

As the 1970s progressed, I begin to wrestle—not always successfully—with Duchamp's spell and seductive appeal. (See my 1995 performance/lecture, reprinted in this book, entitled "Talking Back: An Exchange with Marcel Duchamp.") Slowly I developed more of a critical edge to my reading of Duchamp—not only through the influence of early feminism, but also through the insights of Smithson and his circle of friends. And, of course, this all occurred in the context of the increasing beatification of Duchamp as the years progressed. (In 1980, I remember being greatly amused by two lines in a punk manifesto by Peter Urban: "When Marcel Duchamp offered a urinal to the bourgeois art patrons, it was a negation of art. Now that it's a museum piece, we must piss in that urinal to give it back its meaning."[26])

Robert Smithson definitely saw Duchamp as the enemy. Witness his comment in my 1973 interview: "in America we have a certain view of art history that comes down to us from the Armory Show, and Duchamp had a lot to do with that history. . . . the notion of art history itself is so animated by Duchamp. . . . Duchamp is really more in line with postmodernism insofar as he is very knowledgeable about the modernist traditions but disdains them. So, I think there is a kind of false view of art history, an attempt to set up a lineage. And I would like to step outside [this] situation."[27] For me, such a "stepping outside" has taken many years.

In the 1980s, I did not write on either Cage or Duchamp, although I included Duchamp in public lectures.[28] My time and energy were focused in a different direction; by 1980, this country was headed for conservative times (beginning with the election of Ronald Reagan that year) and feminism was clearly threatened. There was urgent work to do on behalf of feminist art history and criticism. I tried to articulate some of these tasks in a 1980 *Artforum* article and, in the same year, became involved with a big exhibition of feminist performance art in Louisiana as part of a protest against the state's nonratification of the Equal Rights Amendment.[29]

In 1985, I moved back to northern California and began to teach at Mills College, a women's college in Oakland. By the late 1980s, I was deeply involved in multicultural exchanges in the Bay Area and in 1989, I became a consultant for Carlos Villa's seven-part symposia, "Art of a Distinct Majority," at the San Francisco Art Institute (1989–1994).[30] At the same time, I began to see contemporary art more globally. In November 1989, I attended the Havana Biennale, and in January 1990 was in the Soviet Union visiting artists' studios in Moscow and Leningrad.

Finally, in the summer of 1990, while in Venice to participate in the conference "Expanding Internationalism," I reencountered Marcel Duchamp (and also John Cage) in the context of the work of Shigeko Kubota.[31] Unexpectedly, earlier in the year Mary Jane Jacob had invited me to contribute to a catalog to accompany an exhibition at The Museum of the Moving Image in New York City—the largest exhibition of Kubota's work to date. For years much of Kubota's art had been a dialogue with that of Duchamp, and Jacob had chosen me because of my Duchampian expertise.

## a meeting in venice, 1990

As I sat amidst the Fluxus world, I speculated about the splendid bravado of a young Japanese artist taking on the European sophisticate, Duchamp—and managing to make the works her own.

—Moira Roth, "The Voice of Shigeko Kubota"

In June 1990, Shigeko Kubota and I had arranged to meet for the first time at the large Fluxus show in Venice, but something went amiss.[32] As a result, I sat alone for a long time in the exhibition—first waiting for her, but then absorbed in the meditative and cyclical nature of her video installations. I was mesmerized. For over an hour, I studied three pieces: *Nude Descending a Staircase*, with its four-step wooden staircase containing color monitors and a female nude in the footage; *Bicycle Wheel*, with its mobile wheel and miniature monitor displaying a spinning landscape; and *Window*, with its constant flickering video "snow." I scribbled my first impressions in a notebook: "I'm struck by the distinctiveness

of Kubota's sensibilities. The longer I spend with these three pieces, the less I think about Duchamp."

I spent months researching the Japanese avant-garde, reading about the Gutai as well as the Fluxus performance scenes, and, most of all, looking at Kubota's work. From the start, I was deeply drawn to its innate inventiveness and to her involvement in video (a new fascination of mine by 1990). It also intrigued me, as an immigrant, to study an immigrant artist's responses to America and its diverse worlds (she was, for example, fascinated with Navajo culture). I was beginning to work on Asian American art history.[33] What was Kubota's role in this history? How was she affected by her unusual interest in and access to mainstream American avant-garde circles? How had she learned to assert her voice in these circles, primarily dominated by men? And, finally, how had she figured out a way to dialogue with Duchamp and make her voice heard distinctly?

During these months of research and writing, I enjoyed the pleasure of discovering Kubota in depth. Over the next few years, I wrote on such figures as Judy Baca, Sutapa Biswas, Pauline Cummins and Louise Walsh, Hung Liu, Rachel Rosenthal, May Stevens and Pat Ward Williams. In 1994, Yolanda M. Lopez and I collaborated on an article, "Social Protest; Racism and Sexism," for the anthology *The Power of Feminist Art*.[34]

As I grow older, time and energy are increasingly precious to me. I like to spend them on what I care about most. I would sometimes, however, reflect not only on the durability of Duchamp's appeal, but on its seductive nature—for Kubota and, concomitantly, for me, as well as for American modernism, postmodernism, and contemporary critical theory. How could I occasionally speak my mind in these rarefied theoretical debates around postmodernism, yet avoid their seductive demands?

## edgewise interventions

> *Get a word in edgewise,* to manage to break into a lengthy monologue.
>
> —"Edgewise," *Oxford American Dictionary*

How does one "get a word in edgewise"? What works and what doesn't when one is trying "to break into a lengthy monologue" of theoretical discourse and

scholarly investment? I often mull over the efficacy (mine as well as that of others) of "interventions" in sturdily fortified institutions—be they conferences, educational spaces, or art history itself. Unlike that period of my life in Indiana in the late 1960s—when I was literally on the edge of beginning a career in art history—now, in 1998, I have not only considerably more access to academic institutions and power, but, like it or not, I am actually part of these systems.

What I am absolutely clear about, however, in terms of my own current interventions is that I frequently—and now quite consciously—seek out different modes and different voices according to the varied and shifting circumstances of my scholarship and activism. I work both individually and in groups. Sometimes I feel the need to organize and protest rather than write. At other times, I do extensive interviews with and about artists, and assemble archives.[35] When I sense the need to explore and analyze valuable but little-known material, I spend months on meticulous research and present it in a traditional manner in mainstream publications. Occasionally, I turn to a more performance-style approach.

I continue to enjoy a performative mode as I did in my Bloomington days, and this was to prove helpful in 1995 for two "edgewise interventions" concerning Duchamp and Cage.

## talking back and "storying"

History is, after all, a storying. The French language has it very conveniently in the word *histoire,* which means both "history" and "story."

—Gayatri Chakravorty Spivak, "Bonding in Difference"

In the fall of 1995, I was in the midst of writing a long essay (which included diary entries) on Rachel Rosenthal, the Los Angeles performance artist, had just finished editing Faith Ringgold's autobiography, and was about to edit another (the autobiography of my English ninety-year-old mother surrogate).[37] Earlier in the year, I had devised a successful assignment, "Fictions in History/Histories in Fiction," in which I had asked students to assume fictional voices and to invent situations, diaries, and letters in order to "intervene" in art history. For this I had reread a book I greatly admire: Eunice Lipton's *Alias Olympia: A Woman's Search*

*for Manet's Notorious Model and Her Own Desire,* in which Lipton blends scholarship, autobiography, and invented diaries of Victorine Meurent. I was also drawn to Gayatri Chakravorty Spivak's discussions of history and fiction and her "Subaltern Studies: Deconstructing a Historiography."[38] In an interview with Alfred Arteaga, a Chicano poet-scholar, she states: "Fiction-making can become an ally of history, when it is understood that history is a very strong fictioning where, to quote Derrida, the possibility of fiction is not derived from anterior truths. *Counterfactual histories* that exercise *imaginative responsibility*—is that the limit?"[39] I like the way Spivak couples counterfactual histories and imaginative responsibility; I like her asking, "Is that the limit?"

This was the context in which I was offered an opportunity to return once more to musing in public not only about Duchamp but also about Cage. In Los Angeles, I took part in "generating lines and engendering figures: a symposium on and about Marcel Duchamp" (October 28, 1995) and in Oakland, "Here Comes Everybody: The Music, Poetry, and Art of John Cage" (November 19, 1995).[40] The modes I had been working with at this time in my scholarship, readings, and teaching all sprung into play—autobiography, fiction, and performance. I produced two pieces for these symposia quickly, in a state of mind that was simultaneously reckless and apprehensive. I remember savoring the quite giddy and creative intensity of the process, being slightly defiant about expectations in scholarly settings, and yet, at the same time, being genuinely concerned that my "interventions" might seem disrespectful to the other panelists and to the organizers.

In "Talking Back: An Exchange with Marcel Duchamp," completed the day before the Los Angeles event, I combined slides and videos with invented letters between Duchamp and myself, together with my musings to the audience and diary entries. In one of my letters to Duchamp, I cited bell hooks's definition of Talking Back: "speaking as an equal to an authority figure. It meant daring to disagree and sometimes it meant just having an opinion."[41]

My Oakland performance, "Five Stories about St. John, Seven Stories about St. Pauline, Surely There Is Trouble in the John Cage Studies Paradise, and Readings from Today's Headlines of the *New York Times*," began with short stories about my various encounters with John Cage and Pauline Oliveros. The last section (written on the morning of my panel) consisted of nine statements. In one I remarked, "This is, after all, a conference and not a memorial. Also, I've always thought a love affair with a saint would have rather a lot of drawbacks—

too many relics around, not to mention devotees—and that flawed human beings with an edge (and Cage certainly has an edge) are more interesting. This 'edginess' of Cage seems to be disappearing with his elevation to sainthood."

I only enjoy spending a certain amount of my time with (and investing energy in) avant-garde saints and authority figures, however, and so, after these two 1995 performances I drew back from them again. Duchamp and Cage and their circles are, however, the focus of this book and thus have necessitated in the last year engaging with them once more.[2] Incidentally, the title for the book came late in the game; earlier I had opted solely for *Musings on Postmodernism, Marcel Duchamp, and John Cage*. The truth is, though, that as much as I like to muse, I also like to try my hand at making a difference (and so does Jonathan D. Katz), hence the final choice for this volume's title, *Difference/Indifference*.

Berkeley, January 1998

# part one

ESSAYS BY ROTH, 1977, AND
COMMENTARY BY KATZ, 1998

**"Marcel Duchamp in America:
A Self Ready-Made," *Arts* 51,
no. 9 (May 1977): 92—96.**

An article in which I place Duchamp, a
French symbolist dandy and hermetic
scholar, and Rrose Sèlavy, a femme
fatale, in modernist America, and dis-
cuss the roles Duchamp's art and per-
sonae inventions played in American
art history. The May 1997 issue of *Arts*
was devoted to New York Dada.

# marcel duchamp
# in america
## a self ready-made

## moira roth

Cabanne: You were a man predestined for America.
Duchamp: So to speak, yes.

—Pierre Cabanne,
*Dialogues with Marcel Duchamp*

He was twenty-nine years old and wore a halo. . . . He was creating his own legend. . . . At that time, Marcel Duchamp's reputation in New York as a Frenchman was equalled only by Napoleon and Sarah Bernhardt.

—H. P. Roché,
"Souvenirs of Marcel Duchamp"

The New York that Duchamp first visited in 1915 was the New York of Diamond Jim Brady, a millionaire best known for his eating habits and his diamonds. He sported diamonds on his cuff links, shirt, and suspender buttons and, according to rumor, had diamond bridge work in his mouth. When questioned on this display he would answer, "Them as has 'em, wears 'em." His eating style was equally lavish: he would consume three dozen oysters, just as a starter. Upon settling down for a meal, he would carefully leave four inches between his stomach and the table so that "when I can feel 'em rubbing together, I know I've had enough."

Fritz Lang first saw the skyline of Diamond Jim Brady's city in the early 1920s. This vision inspired a story about a city of the future, with high-rise office buildings, aerial freeways, and suspended pleasure gardens. The city of *Metropolis* was a spectacular example of the futurist dreams that New York excited in its visitors. From the vantage point of Europe, this futuristic and vulgar image of New York overshadowed its other aspects of sophistication and elegance. Obviously, New York possessed an educated and well-mannered upper class and artists aware of emerging new directions in art. But this was not basically what its European visitors knew or wanted from New York.

On June 15, 1915 this futuristic and vulgar city received another visitor, the fastidious Marcel Duchamp, an artist profoundly rooted in nineteenth-century thoughts and types. Yet it was to be America, not France, which first created and then maintained Duchamp's fame, beginning with the notoriety of his *Nude Descending a Staircase* in the Armory Show. From 1913 onwards, the relationship between Duchamp and America became mutually supportive, positive, and intimate. It was America that finally gave Duchamp his first major retrospective exhibition (1963) and where virtually all his works are located, and it was America that provided a home for Duchamp off and on since 1915, and where his iconoclasm was immediately incorporated into the history of American modernism.

During the period of his early visits, New York supported in many ways the expansion and elaboration of earlier Duchamp ideas which had been formulated in prewar Europe. The *Bicycle Wheel* was made in 1913 Paris, but the Readymades were only named as such in 1915 New York and were exhibited there for the first time in 1916. *The Bride Stripped Bare by Her Bachelors, Even (The Large Glass)* was conceived a few years earlier, but only in New York was the work actually begun in 1915. Most significantly, it was the New York Dada group that watched and protected Duchamp's *personae* experiments and per-

formances, which amplified his life style, his art, and his definitions of himself as an artist.

New York in 1915 was a modern city in a way Paris would never be. Duchamp needed the freedom and approval of such modernity. This context and this city provided Duchamp the license to explore two psychological types, the dandy and femme fatale. To characterize Duchamp through these two nineteenth-century and essentially European types points to the amazing juxtaposition of two worlds, old and new, when Duchamp and modernist America took to each other so warmly.

Common to both the dandy and femme fatale are psychological traits of distancing, mystery, and moral indifference—all of which Duchamp possessed in abundance. It is hard to know whether these characteristics are innate or assumed, assumed as theatrical modes of self-presentation to the public or perhaps as self-preservation devices to mask private and less confident selves. What is clear is that both the dandy and femme fatale are dependent upon an audience and a particular form of adulation, or at least, public recognition. The archetypical forms have a long history but literary discussions of the types are generally confined to the nineteenth century. Duchamp grew up in the symbolist period, a time when the final extravagant, often bizarre flowering of these two types occurred.[1]

Duchamp is generally described as a modern day dandy in appearance and temperament. To see the dandy merely as a man meticulously elegant in dress and manners is to misunderstand that, at least in Charles Baudelaire's eyes, these were only the outward manifestations of a state of mind. For Baudelaire, the dandy was a psychological type, a type obsessed with a "cult of self" who used elegance and aloofness of appearance and mind as a way of separating himself from both an inferior external world, and from overt pessimistic self-knowledge.

The lifestyle of the dandy had been lived out and chronicled before Baudelaire but it was Baudelaire's classic 1863 essay, "The Painter of Modern Life," which crystallized the concept of the dandy. It is interesting that Baudelaire not only dealt with the dandy in the context of art and modernity, but also, more to our point, he stressed that the dandy's first concern was with his own character rather than with his art or the society in which he lived.

Also, in his essay, Baudelaire talked about the *flâneur*, the observer who strolls through the crowd but is not really part of it. The *flâneur* is a key aspect of the dandy's psychology, for the dandy's elegance demands an appreciative public. The

context of the crowd makes his own superiority all the more obvious, at least in his own eyes. Also, for the *flâneur* to live apart as a recluse might force him into an intolerable introspection and psychological confrontation with himself. He chooses rather to stroll casually through the world, the dandy *flâneur* constantly preserving his psychological distance and protecting his intellectual superiority.

Much of Duchamp's imagination during his first 1915–1918 New York visit (and his two later visits of 1920–1921 and 1922–1923) focused upon a conscious expansion and transmutation of his personality and intensification of the dandy's "cult of self," both in his real life behavior and in his various artistic *personae* culminating in Rrose Sélavy. For a European *flâneur* New York City was a perfect place to parade in and yet not be part of. The readymades, too, benefited from an American setting where their alien nature was more prominent than if they had publicly emerged alongside collage and assemblage productions of Cubist Paris.

Within Duchamp the dandy, in 1915, there is another element of his personality, namely that of the femme fatale. A dandy might have intimidated a New York audience, he would never have charmed it. Two qualities in Duchamp are mentioned repeatedly by contemporary observers: his seductive charm and physical beauty and his psychological distance and indifference, a combination which is key to the phenomenon of the femme fatale. She is involved in the seduction of others but never submits herself to seduction.

Greta Garbo, certainly one of the most famous femme fatales of all, has been described in a way that recalls the Duchamp of 1915:

> As attractive to women as to men, At the same time, she seemed emotionally and philosophically wary, detached, passive. [Garbo's] face ... had an extraordinary plasticity, a mirror-like quality; people could see in it their own conflicts and desires.[2]

There is an astonishing similarity between Garbo and Duchamp (posed as Rrose Sélavy) in their beauty and remoteness: staring out of their photographs, with their hands idly protecting them, they both project an image of utter aloofness. In both portraits there is an inpenetrable impassivity. It is impossible to tell their thoughts but perpetually intriguing to speculate.

The fact that Garbo is a movie star literally relates her on another level to Duchamp and to the long tradition of artist "stars" beginning with Leonardo, if not earlier. These artist-stars, and Duchamp stands prominently in this category, pro-

ject a glamour which seduces their audience into an almost obsessive attention to their presence as artists and sets up a condition of uncritical adulation of their art.

From the moment of Duchamp's arrival, this star charmed both the newspaper reporters who met him at the dock and a more elitist New York intellectual circle. Neither had met or really knew the prewar Parisian Duchamp. Whatever their expectations, the Duchamp they encountered in New York was a new creation of personality, a theatrical and seemingly far more outgoing character than Europe had known. In 1912, after the debacle with his brothers and their fellow cubists over the exclusion of the *Nude* from their 1912 avant-garde show, Duchamp had deliberately withdrawn himself from close commitments to artistic groups. He lived a life of seclusion. Yet in New York, he was to shine as a central presence in the Arensbergs' salon. Duchamp has described this Paris period of 1912–1915:

> I knew no one in Paris . . . I stayed very much apart, being a librarian. . . I had no intention of having shows or creating an *oeuvre,* or living a painter's life.[3]

Gabrielle Buffet-Picabia had met Duchamp in 1910, and confirms Duchamp's recollections of those years:

> In that period [Francis] Picabia led a rather sumptuous, extravagant life, while Duchamp enclosed himself in the solitude of his studio at Neuilly, keeping in touch with only a few friends and [living by] a discipline that was almost Jansenist and mystical.[4]

The astonishing and abrupt transformation of Duchamp's character in New York was witnessed by Picabia's wife, when they arrived in America, shortly after Duchamp's first appearance there:

> We had found Marcel Duchamp perfectly adapted to the violent rhythm of New York. He was the hero of the artists and intellectuals, and of the young ladies who frequented these circles. Leaving his almost monastic isolation [of Paris], he flung himself into orgies of drunkenness and every other excess. But in a life of license as of asceticism, he preserved his consciousness of purpose: extravagant as his gestures sometimes seemed, they were perfectly adequate to his experimental study of a personality disengaged from the normal contingencies of human life.[5]

His compatriot and friend H. P. Roché had similar memories of Duchamp's new manner. Upon their first meeting in New York, Duchamp immediately swept

Roché off to a costume ball where Roché watched admiringly as the women swarmed around Duchamp. Roché recalled another evening which ended up with Duchamp drunk, balanced on the edge of the elevated with a young woman.[6]

Duchamp was a highly controlled and contrived individual. If his personality and lifestyle seemed to change drastically upon arriving in New York, at least some of the changes were conscious. Later Duchamp himself was to admit to "this fabrication of his personality,"[7] and acknowledged the influence of a model, Jacques Vaché, the Dada dandy so admired by Breton.

Duchamp's appearance in 1915 New York was the appearance of a new type of artist in America, a type novel and alien in a country dominated by the protestant work ethic. Also, New York had been virtually untouched by the symbolist movement, Duchamp's breeding ground; such strange artist-priests as Mallarmé simply did not exist in late-nineteenth-century America. The sense of a new type of artist was picked up clearly, though simplistically, in the first published reaction to Duchamp's visit. Here, the surprised journalist noted:

> He neither talks nor looks, nor acts like an artist. It may be in the accepted sense of the word he is not an artist.[8]

This September 1915 article, a neat piece of American typecasting of Duchamp, bore the title, "A Complete Reversal of Art Opinions by Marcel Duchamp. Iconoclast."

Duchamp elegantly enacted for his New York audience the dandy's aversion toward excessive commitment or obvious effort. Later Georges Hugnet spoke of Duchamp's work in terms of "the relaxation of a brilliant dandy."[9] Duchamp, the artist-dandy, comes out most clearly in his verbal responses to art and in the readymades, which, at their best, are brilliant shifts and gestures of the mind rather than objects dependent upon physical labor. Duchamp *did* devote much labor and almost obsessive attention to his *Large Glass* during these early New York visits. Yet, *The Large Glass* lay for months literally gathering dust in Duchamp's studio, in preparation of *Dust Breeding*. And when *The Large Glass* was broken in 1926 and its cracked state only discovered years later, Duchamp could preserve a carefully indifferent public attitude toward this mishap, could be "amused" by the near destruction of such a major work.

Much that Duchamp said and presented himself as doing, or rather not doing, violently contradicted the prevailing American protestant attitude that

everything, including art, must be the result of hard work. For Duchamp, how-
ever, art must be a product of the mind:

> I wanted to get away from the physical aspect of painting . . . I was interested
> in ideas—not merely in visual products. I wanted to put painting once again
> at the service of the mind.[10]

Shortly after Duchamp's new theatrical *persona* was seen in life, he established
another *persona*, that of R. Mutt. Duchamp selected the urinal in 1917, called it
*Fountain,* and signed it R. Mutt. The exclusion of the *Fountain* from the 1917
Independent Artists' show provoked the famous *Blind Man* text:

> Whether Mr. Mutt with his own hands made the fountain or not has no
> importance. He CHOSE it. He took an ordinary article of life, placed it so
> that its useful significance disappeared under the new title and point of
> view—created a new thought for that object.

Whether Duchamp himself wrote the text, or merely inspired it, is beside the
point. The significant point is that here the views of the artist-dandy, through the
medium of R. Mutt, were articulated in America for the first time in this New
York Dada magazine.

R. Mutt was a one-shot deal; however, in 1920 there emerged an artistic
*persona* to accompany Duchamp for the rest of his life. Duchamp had left
New York in 1918 and returned in 1920. As before, his second encounter with
New York again triggered his imagination. In 1919 Europe, he created
*L.H.O.O.Q.,* the disturbingly androgynous Mona Lisa print; a year later in
New York, he transformed his own male presence into a female one, Rose
Sélavy (later spelled Rrose Sélavy). Fashionably dressed as a woman, Duchamp
appeared in Man Ray's studio to be photographed during the 1920–1921 New
York stay. Duchamp himself never appeared in drag on the New York streets.
The physical existence of Rrose Sélavy was a highly contrived and limited one,
but she was to have a lasting role in the idea of the artist-substitute for
Duchamp. It is she, beginning with *Fresh Widow,* who was to sign (or cosign)
much of his work from 1920 onward. Not only was the artist often separated
from art labor, but now the she-artist, Rrose Sélavy, began to separate from
Marcel Duchamp, the man.

One can speculate endlessly as to the meaning of Rrose Sélavy in
Duchamp's life and art.[11] Is Rrose Sélavy a Mona Lisa, taking the ready-made

existence of Duchamp and "giving new thcught for that object"? Is she a way for Duchamp to literally incorporate the femme fatale into himself? Is she a way in which Duchamp allowed himself a more playful attitude to his art? She can take care of business, and he can go off and play chess and make machines. Is she made explicable by the recurring use of androgynous symbolism in alchemical texts and illustrations?

Whatever, or whomever, Rrose Sélavy is, she is also involved in speculations as to what an artist is and how art is made and by whom. In 1922, Robert Desnos in a medium trance in Paris received "puns" from another "medium," Rrose Sélavy in New York. In 1957, Duchamp began a talk on "The Creative Act" by describing the artist who

> acts like a mediumistic being, who, from the labyrinth beyond time and space, seeks his way out to a clearing.

Already, by 1920, Duchamp had created his own mediumistic being for his art, Rrose Sélavy.

A series of readymades in 1920–1921 New York quickly confirmed Rrose Sélavy's femme fatale character. Her first act was to sign *Fresh Widow*, a curious and slightly ominous pun when seen in relation to Duchamp, the Bachelor. In her next appearance, she scented and purified the air in *Belle Haleine* (Beautiful Breath), the perfume bottle with the Rrose Sélavy image on its label. By now, she is a scented, seductive, and merry widow who deceives. Deception was indeed the guiding idea—as in many of Duchamp's works at this time—in *Why Not Sneeze Rose Sélavy?*, a construction of heavy, small marble blocks which looked like sugar cubes.

In the same year as the creation of Rrose Sélavy there appeared another artist's *persona*: the inventor-engineer. Just as there were visual images of Rrose Sélavy, there was one for this new *persona*—a photograph showing the artist, Duchamp, half hidden behind the blurred motions of his first constructed machine, the *Rotary Glass Plates*. Later, this inventor-engineer submitted another of his machines, the *Rotoreliefs*, to an annual inventors' salon rather than into an art one.

The *persona* games continued. There is a curious performance in 1921, upon Duchamp's return to Paris, where the back of his head was shaved into a star design. The event was documented, of course, by a photograph. Also the same year, while still in New York, Duchamp sent a cabled refusal to participate in the Paris Salon Dada, the famous PODE BAL cable ("balls to you") which

elaborated on Duchamp's lifelong play at the artist going underground, a femme fatale play of withdrawal.

In the 1920s, Duchamp developed *personae* and performances which revolved around questions of art and money and the question of how an artist makes his living. In his 1919 *Tzanck Check* made in France, he had already played with these ideas. Here he paid off his debt to the dentist with an American bank check of his own invention—The Teeth's Loan & Trust Consolidated, 2 Wall Street, New York. In 1922, Duchamp became the artist-businessman when he and a friend attempted to set up a fabric-dyeing business in New York. In 1924, he added the image of the artist-gambler playing at the tables in Monte Carlo (*Monte Carlo Bond*). In 1926–1927, the artist-businessman moved into the art business: as the artist-dealer, Duchamp began in earnest with speculative purchases and sales of works of art, mainly for American collectors. For most of these creations, he allowed one or more carefully chosen photographs or documents to appear.

These Duchamp *personae* occurred in the Dada and early surrealist periods, i.e., movements that delighted in transformed appearances and assumed roles for its artists. But such images and acts were for the most part sporadic, unlike Duchamp's relentless and lifelong invention of stand-ins. In Duchamp, these roles, including perhaps his most famous one, that of the chess-player,[12] are sustained expansions of his art and personality which by now have become inseparably fused. Rrose Sélavy, the inventor-engineer, the underground artist, and the artist-businessman are all inventions of his second and third New York trips, just as R. Mutt and the theatrical life style were the products of his first visit. As if to emphasize the relationship of these personae to America, Duchamp issued his own *Wanted/$2,OOO Reward* poster, in 1923 New York, just before leaving for a long stay in Europe. In this joke-poster adaptation, the criminal-artist had pasted on two photographs of himself, frontal and profile, and beneath them had added: "Known also under the name RROSE SÉLAVY." Duchamp was disappearing under a welter of *personae*. And so he intended an escape hatch, the idea of the artist who had given up art.

Years later, when talking to William Seitz in 1963, Duchamp told Seitz that he had never believed in art movements: "Art doesn't interest me. Only artists interest me."[13]

But, of course, Duchamp *did* make art and he was involved with art movements. In a trick photo of 1917, Duchamp appears surrounded only by himself

at a table, a tribute to his dandy's "cult of self." Two other photos of that time show his New York studio and his work in progress. In one, the *Bicycle Wheel* and *Trap* (coat rack) stand on the studio floor, still occupying that no man's land between studio object and art object. In another photo, equally famous, the two parts of *The Large Glass* lean on top of one another, strangely imprinting the Bachelors upon their Bride. There is another and more casual category of photographs from this period which shows Duchamp posing with various artists. One might, at random, choose one of these: Duchamp standing in a New Jersey orchard in 1916 with a group of artists and writers including Walter Arensberg and Man Ray.

These four photographs, all from Duchamp's first American visit, document his concerns at that time: his explorations of self, of objects, of a hermetic world (*The Large Glass*), and of the American avant-garde and literary world.

Duchamp had already worked out the ideas behind the readymades and *The Large Glass* in Europe, but these European explorations were virtually unknown in 1915 America, where he was simply known as the painter of the *Nude:*

> That painting was known but I was not. I was obliterated by the painting . . . I spent my life hidden behind it.[14]

The *Nude* was a theatrical work, and in 1915 New York the creator of the *Nude*, while assuming an increasingly theatrical lifestyle, expanded both his definition of personality and of art objects. In his new American life, Duchamp now disengaged his readymades from their normally accepted context and function in human life. Revolutionary as artistic Paris was in 1913, and iconoclastic as Duchamp was, he was nevertheless hesitant to define his *Bicycle Wheel* in art terms at that time. It stood obscurely in Duchamp's studio, a place rarely visited by other artists.

Only when Duchamp arrived in New York and bought a snow shovel, inscribing it *In Advance of The Broken Arm*, was he to appropriate the term readymade for such objects. Both the actual title of the work and the newly invented generic term readymade are experiments undertaken in a new language. Duchamp's obsession and delight with language have always been acknowledged, but there is little discussion of the impact of English on him.[15] It must have set up a new domain of play for him, and allowed a dialogue between his French and English, a dialogue not dissimilar to that between the readymades and their new found environment or, for that matter, the dialogue or interplay between Duchamp and his newly assumed *personae*.

In 1913, Duchamp wrote a note to himself: "Can one make works which are not works of 'art'?"[16] If one is Duchamp, the answer is probably no. But Duchamp did "make" works which were not immediately works of art. The readymades can be seen as brutal Dada attacks on art or as magical objects which briefly hover between art and life. Through Duchampian strategies including his exquisite sense of timing, they have become works of art. They are *flâneur* objects, which require, and indeed demand, a foreign and public setting—galleries, dealers, patrons, critics and viewers—in order to exist and flourish.

The readymades are acts of a dandy's arrogance. He, and he alone, can point to an object and make it art. He can do what he likes. He makes his own rules. Some critics, and even some artists, might like to imagine it, but the message from Duchamp's readymades is clear: anything and everything does not constitute art, not is anyone and everyone an artist. Duchamp makes readymades. Other people do not.

During this initial courtship with America, Duchamp was encouraged to expand and experiment before an admiring audience of both the American and expatriate European members of the New York Dada circle.[17] In a profound way, he was given permission to play. And so he found ready-made toys, adorned them with titles, and invented casual, but secretly elaborate, rules for the games he played with them. Already in 1913 he had invented a unique space-toy (i.e., the eccentric measuring devices of the *3 Standard Stoppages*), and now, in 1915, he invented eccentric art objects to occupy another Duchampian space. Duchamp had invented this new play of readymades and was the only critic allowed to call the rules. For the readymades had moved into the domain of criticism with a force that no painting could ever produce, not even *The Large Glass*.

America was a country whose art Duchamp could disparage, as in the *Blind Man* editorial (previously quoted in connection with the R. Mutt case): "The only works of art America has given [us] are her plumbing and her bridges." American art, by the time of Duchamp's arrival, obviously had a long and respectable tradition, but it also lacked self-confidence. From the beginning, Europe was the model and inspiration for much of American art, and in 1915 the readymades were odd guidance from Europe, at worst sarcastic and at best cryptic. America was a country peculiarly vulnerable to the onslaught of the readymades.

On occasions, the readymades did provide guidance for young American artists at the time. Stuart Davis has reminisced about the impact on him of the *Fountain*'s "unaesthetic material, absurd material, [and] non-arty material."[18]

Man Ray made a number of objects responding to the ideas of the readymades. But basically, the course of American art continued on its way, unguided by the sporadic arrival of these strange new objects.

At the same time as the readymades were christened, Duchamp began making his *Large Glass*. Its iconography, mathematics, and much of its techniques were worked out previously in Europe: but it was constructed in New York and left there (when Duchamp returned to Europe in 1923), finally ending up in the Philadelphia Museum of Art.

Duchamp had evolved the messages and images of *The Large Glass* through a series of notes and sketches, and had also done actual paintings of individual images before assembling the whole work in 1915–1923. The story told by its strange mechanical forms concerns the courtship of a Bride by her Bachelors. In the notations that he wrote himself between 1911–1920 (published in facsimile form in the *Green Box*), this courtship was to lead (where else?) to love-making. But *The Large Glass* was left unfinished in 1923 in precisely these areas (the Boxing Match and the Juggler of Gravity) which were to bring the two parts of *The Large Glass* together. Thus no love-making occurred. The innate pessimism and private fears of life behind the mask of Duchamp's dandyism can be seen in this final lack of commitment between the yearning characters of *The Large Glass*.

Baudelaire has discussed the *flâneur* as a psychological component in the dandy. If the *flâneur* mask slips, the dandy is confronted and haunted by his despairs; witness the suicides of Vaché and Jacques Rigaud, two contemporary dandies much admired by Duchamp. In 1917, Vaché had written to Breton:

> The air we breathe had to turn dry . . . Two eyes—dead— flame—and also the crystal round of a monocle.

A year later, the despairing Vaché had killed himself. Close friends of Duchamp have speculated on the extreme pessimism concealed within Duchamp.[19]

The pessimism enveloping the Bachelors in *The Large Glass* is felt in the *Green Box* "litanies" (Duchamp's term), which are sung just below the Malic Moulds, the point of departure of the Bachelors on their journey toward the Bride:

—Slow life—

—Vicious circle—

—Onanism —

—Horizontal —

—Buffer of life—

—Bach. Life regarded as an alternating rebounding on this buffer.

—Rebounding = junk of life . . .

—Monotonous fly wheel[20]

The *Green Box* notes abound in such ironies and pessimisms. Duchamp never published this collection of material until 1934 in France, and it was only fully translated into English in 1960. Meanwhile, the work itself was in Katherine S. Dreier's house in Connecticut. For most of its limited American public, the meaning of the work was inaccessible. And for its European public, the oblique explanations of the *Green Box* could be consulted but the work it referred to could not be seen, except through photographs.

For psychological and intellectual reasons *The Large Glass* was easier to make and exhibit in America than in Europe. In New York, its pessimistic and hermetic qualities could come to the surface more slowly; in Paris, it would have had less novelty, and its message might have been read too hastily. Duchamp often preferred not to be understood immediately and only according to his own timetable. The iconoclasm of the readymades and his general role in New York Dada seem increasingly, from the perspective of the 1970s, to be a cloak drawn over Duchamp's more private, pessimistic, and hermetic thoughts.

Where does the dandy go when he is not on display? *The Large Glass* provides an answer to this question in terms of Duchamp the dandy. He turned to hermetic studies. Ulf Linde, Jack Burnham, and Arturo Schwarz have shown that Duchamp's work is immersed in alchemical and occult references. This is true of the readymades as well as *The Large Glass*.

There are many reasons for being drawn to hermetic ideas. Although, if experienced profoundly, they can transform one's life, they can also be merely fashionable and intellectually amusing to dabble with. The symbolist period has seen many advocates of the hermetic tradition, especially among artists and writers. Some took the ideas seriously and made a profound study of the occult. Some found it glamorous and esoteric and not much more. It is hard to speculate on the depths of Duchamp's commitment.

The hermetic tradition embraces many occult pursuits—one thinks of the alchemist in his laboratory, the Cabala scholar, or the reader of the Tarot—but

the point is that they all have much in common with the dandy tradition. For the hermetic figure and the dandy, their lives can be seen as *the* focus of their work. Irony and iconoclasm are usually present in both traditions. Like the dandy, the hermetic figure often seeks to conceal his real essence through various public guises and deceptions, and Duchamp's personality places him psychologically at ease within this tradition.

Thus Duchamp's conscious and deliberately cultivated *personae* (in all their manifestations), his iconoclasm, irony, and aloofness, seem close to the personality characteristics and devices of both traditions. In America, more easily than France, Duchamp could conceal his dandy pessimism and his hermetic obsessions. On the other hand, conditions in America in 1915 could reveal Duchamp's life and art more dramatically than in France, and with less competition, indeed, with none whatsoever.

Duchamp's choice of America in 1915 was the right one for a man obsessed with the making of his own image, the perpetuation of that image, and the total control over its reading. Duchamp and America served one another well. Duchamp wanted fame and got it. America wanted to establish its place in the history of art more firmly and it used Duchamp for this purpose.[21] The New York Dada movement and Duchamp's art, together with the more genuinely American contributions of the Stieglitz group, built the edifice of American modernism. Duchamp was in on the ground floor.

**"The Aesthetic of Indifference,"**
*Artforum* 16, no. 3
(November 1997): 46—53

A study of Cage, Cunningham, Duchamp, Johns, and Rauschenberg in the context of the McCarthy period, setting up the notion of their advocacy of a certain sort of indifferent "cool" stance. Equally they contributed to the creation of a new cerebral breed of artist. In the essay I discuss Duchamp's role during this period as a European "father" figure, Cage's description of Rauschenberg's all-white paintings, together with an analysis of Johns's iconography in terms of Cold War metaphors.

# the aesthetic of indifference

## moira roth

TWO NOVELS SET THE PARAMETERS OF national feeling in the McCarthy period (1950–1954) and provide an index to an important new aesthetic impulse in American art during those years. In *One Lonely Night* (1951), Mickey Spillane's hero, Mike Hammer, tells a friend: "I killed more people tonight than I have fingers on my hands. I shot them in cold blood and enjoyed every minute of it. I pumped slugs into the nastiest bunch of bastards you ever saw and here I am calmer than I've ever been and happy too. They were Commies, Lee. They were red sons-of-bitches who should have died long ago."

Holden Caulfield, the dispirited hero of J. D. Salinger's *The Catcher in the Rye* (1951), sees his life as a pointless game against hopeless odds. One night, unable to sleep, he thinks of committing suicide: "I felt like jumping out the window. Probably would've done it, too, if I'd been sure somebody'd cover me up as soon as I landed. I didn't want a bunch of stupid rubbernecks looking at me when I was all gory."

These attitudes—bigoted conviction and embittered passivity—expressed by Spillane's Mike Hammer and Salinger's Holden Caulfield were in many ways

characteristic of America's state of mind during the McCarthy period, when those with right-wing commitments pursued their goals with a blind and ardent zeal that was often channeled into the cause of anti-Communism. Others of a more liberal and self-critical persuasion found themselves paralyzed when called upon to act on their convictions, and this paralysis frequently appeared as indifference. This essay will deal with a number of artists—Duchamp, Cage, Cunningham, Rauschenberg and Johns—who made a positive cult of indifference and whose ideology, as a group, coalesced during the McCarthy period. This group espoused a new aesthetic that I shall call here the Aesthetic of Indifference.[1]

The 1950s were assaulted with literature, popular culture and art describing feelings of indifference, neutrality and passivity in the world of the Cold War; and the Aesthetic of Indifference should be seen in this psychological ambience. A sociological study of this pervasive sense of "alienation" (which itself became a catch-all term of the period) was undertaken by David Riesman in *The Lonely Crowd* (1950). In film, one of the most famous contemporary portraits of alienation was the James Dean character in *Rebel Without a Cause* (1955), whose impotent defiance of an indifferent world led to his inevitable defeat. The early 1950s also witnessed Beat literature and lifestyle, the curious Beat blend of passion and indifference which was crystallized in Allen Ginsberg's *Howl* (1956) and Jack Kerouac's *On the Road* (1957). In *The Dharma Bums* (1959), Kerouac describes the choice for himself and his generation: "The only alternative to sleeping out, hopping freights, and doing what I wanted, I saw in a vision would be just to sit with a hundred other patients in front of a nice television set in a madhouse where we could be 'supervised.'" But in the early 1950s, a growing number of intellectuals consciously espoused indifference as a virtue, as the correct way to deal with an uncertain world.

A language of neutrality developed during the McCarthy period. Marshall McLuhan's *The Mechanical Bride*, published in 1951, the same year as the Spillane novel, was an early announcement of this new tone of indifference. *The Mechanical Bride*, a study in advertising manipulations, was written in a cool rather than indignant manner. McLuhan likened his nonjudgmental stance to that of the imperiled sailor in Poe's "The Maelstrom," a figure who saved himself by studying a whirlpool's movements with "amusement," estimating the velocity of objects as they were drawn downward. McLuhan specifies: "It is in the same spirit that this book is offered as amusement. Many who are accustomed to the note of moral indignation will mistake this amusement for mere

indifference." In this statement McLuhan defended himself against anticipated criticism that he lacked moral indignation, but more to the point here was his choice of the words "amusement" and "mere indifference." They signalled a new language of neutrality, one cultivated by artists as well as writers.

The key exponents of the Aesthetic of Indifference were Duchamp, Cage, Cunningham, Rauschenberg and Johns. That these artists loosely came together, intellectually and psychologically, in terms of a shared aesthetic during and just after the McCarthy period has received scant attention by art historians and critics. It is time to see their art and artistic stances in the Cold War context in order, first, to understand the art itself, and second, to explain, at least in part, the bizarre disjunction of art and politics that emerged in the 1960s. The radical political movements of the 1960s had virtually no expression in the art of that time, an art that was strangely appealing and acceptable to the very forces—governmental, corporate and middle-class powers—that these radical movements opposed. A major cause of this discrepancy between art and politics was no doubt the enormous impact of the Aesthetic of Indifference on art of the 1960s.

The Aesthetic of Indifference appeared in the early works of Jasper Johns and Robert Rauschenberg, and in the Cage/Cunningham music and theater experiments: all used neutrality as their springboard. These artists made and talked about an art characterized by tones of neutrality, passivity, irony and, often, negation. "Amusement" and "indifference" became positive values. Parallels and precedents for these ideas were found in Dada and Duchamp. Indeed, Marcel Duchamp was a pivotal figure in the aesthetic as well as being, of course, one of its main historical sources. The indifferent aesthetic emerged in the early 1950s, and had three fairly distinct phases: its cool and ironic beginnings in Cage, Rauschenberg and Cunningham (with Duchamp as a major role model); its more poignant expression in the muted anxiety of early Johns; and its weakened final phase in the bland indifference of pop and minimal art.

By the late 1940s, in the arena of Truman's presidency, one political and moral crisis had followed another: the Iron Curtain divided Europe, Mainland China was won by the Communists in 1949, and a few months later a nuclear device was detonated in the Soviet Union. In the summer of 1950 the Korean War started. These events, and others, caused America to devote more and more of her energy and power to countering this specter of a Communist world takeover. Abroad, the Truman Policy, the Marshall Plan and the Policy of Containment were attempts to prevent, or at least curtail, Communist power. At

home, anti-Communism dominated politics. In 1947, Truman established a new loyalty program to weed out "traitors" and security-risk employees from the federal government. The House Un-American Activities Committee (HUAC) became the stage for endless investigations of loyalty cases, and in 1950 Senator McCarthy, embarking on the first of his charges concerning Communist infiltration of the American government, himself became a terrifying force in political life. Spillane's *One Lonely Night* is a fictitious document of the virulent hatreds of the time. Mike Hammer killed more Communists in a single night than he could count on the fingers of his hands. In life, this did not happen in the United States, but what did happen was that friendships and reputations were killed off, and people were irreparably damaged by the psychological anguish and economic realities of the blacklist.

The Aesthetic of Indifference emerged at a time when, as a fallout of anti-Communist rage, American modernism was being attacked from all sides. The staccato and relentless rhythm of these attacks is felt in *Modern Artists in America* (1951), edited by Robert Motherwell and Ad Reinhardt. In the section on "Art in the World of Events . . . 1946–1950," the editors chronicle a flood of indictments against American modernism, including the tirades of Congressman George Dondero (in the 1949 *Congressional Record*) with such titles as "Communist Art in Government Hospitals," and "Communism in the Heart of American Art—What To Do About It?"[2] Some artists fought back against these assaults on modernism. For many, including most of the abstract expressionists (accustomed to WPA and political activity among artists in the 1930s), the current/political paralysis was painful, and they tried to mitigate it by passionate investments in art "politics." Merely to defend the right to make modern art—given that modernism was under attack from so many quarters—became one of the main "political" causes for artists and critics during this period.[3]

Characteristically, however, the artists of the Aesthetic of Indifference were neither involved in real politics nor concerned about a vigorous defense of modernism. As McCarthyism erupted in the world around them, the "Indifferent" group viewed politics (meaning political bureaucracy and governmental strategies) with distance and irony. If Duchamp himself was later to describe politics as "a stupid activity which leads to nothing,"[4] Cage once envisioned a future in which "economics and politics as we knew them would disappear and people would be in a position, so to speak, to live anarchistically."[5] Because of this seemingly indifferent attitude to politics, such artists themselves—and most of their

critics—have never acknowledged the influence of the historical context in which this aesthetic was formed, namely the Cold War and McCarthy periods. Such aloofness from political events of the time was part of these artists' general indifference, but now, today, a quarter of a century later, it is a part of their self-image which should be questioned. I do not see how one could paint the American flag in 1954 and claim, as Johns did, that it was merely inspired by a dream. Perhaps so, but dreams are ultimately connected with reality. Nineteen fifty-four was, in reality, a year of hysterical patriotism. Johns could not have been insensitive to this.

In its deliberately apolitical and generally neutral stance, the Aesthetic of Indifference represented a new breed of artist, an alternative to the politically concerned abstract expressionists.[6] George Segal, a young artist at this time, has described his memory of the typical abstract expressionist: heavy-set appearance with drooping moustache and corduroy jacket. As Segal reported, "If you had an education, you had to hide it and sound like a New York cab driver."[7] Segal recalled the contrast when he first encountered Duchamp and Cage, who struck him as models for a new "slender, cerebral, philosophical, iconoclastic type," physically and intellectually very different from the abstract expressionist one. For Segal and others, the new artist had a dandylike elegance of body build and a manner which delighted in cool and elegant plays of the mind: playfulness indeed was a key characteristic in most of this new breed of artist.

The changes in appearance and temperament were also expressed by differences in sexual mores. The machismo attitudes proudly displayed by the abstract expressionists were now countered by the homosexuality and bisexuality permissible and even common among the new aesthetic group. Soon after World War I, Duchamp had created a female alter ego, Rrose Sèlavy, who frequently signed his work and for whose photograph he posed in drag. For the abstract expressionists, such a creation must have been one more confirmation of Duchamp's disturbing artistic tastes. But for the Aesthetic of Indifference, Rrose Sélavy might well have served as a symbol of new sexual and artistic freedoms and flexibilities.

John Cage and Marcel Duchamp provided the keystones for ideas for the new aesthetic.[8] Meeting first in the early 1940s, the American inventor-composer and the European *fin-de-siécle* dandy formed a gradual friendship, close but characteristically casual and private in tone, unlike the stormy Cedar Tavern friendships of the abstract expressionists. If Duchamp was the ful-

crum of this new movement, Cage was the lever. The artists involved in the aesthetic gravitated toward one another during the 1950s, although they never existed as a group in the public sense of the abstract expressionist movement. The chronology is well known, but I will briefly recapitulate certain fundamental facts. Cage and Merce Cunningham had begun work together in the mid-1940s. Cunningham, together with a number of students in about 1949, formed his new dance company with Cage as the company's musical director. The company became clearly delineated in 1953 during a stay at Black Mountain College (the site of the Cage proto-"happening" in 1952 in which Cunningham and Rauschenberg had taken part), and in 1954 Rauschenberg was appointed the costume and set designer for the ensemble. Cage, already a close friend of Cunningham's, quickly formed friendships with Rauschenberg and Johns, who had met one another in 1955 when they had studios in the same building in New York, and were to see one another almost daily for several years. Duchamp, also in the city in the 1950s, was a familiar figure on the art scene, courted and admired. Not only was Duchamp accessible to American artists but his art was also, for the first time, publicly accessible in 1954 when the Philadelphia Museum of Art displayed its huge Arensberg Collection of his work.

The group began to define its own artistic history and precedents. The most supportive movement of the past was, of course, Dada, a movement which had been activated by feelings of moral anger, political impotency and nihilism engendered by the First World War. Originally Dada was a bitter art, but its abrupt and dramatic revival in the McCarthy 1950s saw it commercialized and tamed.[9] It was in Dada that the Aesthetic of Indifference found its precedents, and it was in Duchamp that its artists sensed their greatest resonance. Duchamp had always been "indifferent" and was thus a perfect older model for the new aesthetic: the "cool" artist who had made the readymades, those objects so frequently acclaimed as being "indifferent" to aesthetic values and to the artist's personal "touch" and taste.

How Duchamp publicly projected himself during this period comes through clearly in a description by Winthrop Sargeant. Collecting material for the 1952 *Life* magazine lead article, "Dada's Daddy," Sargeant visited Duchamp in his New York studio and met "a wiry, genial grey-eyed Frenchman . . . [who] can talk interestingly by the hour, allowing an amazing stream of aesthetic, philosophical and purely Dada ideas to filter through his detached, ironic mind."

Although secretly at work on the *Etant Donnés*, Duchamp presented himself as an elderly, brilliant, but detached artist who produced only occasional works.

Duchamp's detachment was reflected in both his personality and his art, and this detachment, which had irritated most of the abstract expressionists, now delighted the new Indifferent group. Duchamp's personal "cool" was noted with approval as the cool of a gracious but remote, affable but ironic, old European artist. All this made him a very different type from the anguished and romantic abstract expressionist. For the first time, with Duchamp and Cage as guides, American artists began to leave the romantic studio-attic. Many younger artists drew back from the Van Gogh stereotype of the romantic artist—a contemporary portrait of which was readily found in the 1957 film *Lust for Life*, where Van Gogh (played by Kirk Douglas) was seen furiously painting against a darkening crow-covered sky. However, in vanguard circles, the new model was Segal's "slender and cerebral" cool artist.

For Duchamp and the new aesthetic generally, intelligence was as highly esteemed as coolness. *Cool intelligence* was the ideal. Unlike most of the abstract expressionists, whom Segal has described as publicly denying their education and, by implication, their intelligence, most of the new group loved to air theirs. Coolness and intelligence were the hallmarks of the Aesthetic of Indifference and, as a concomitant, there was among the new group a widespread proclaimed disdain for traditional artistic manual skills and the artist's personal "touch." Again, Duchamp was a major model. The taste for ready-made materials and images, and often impersonal techniques, brilliantly maneuvered by Duchamp, Cage, Rauschenberg and Johns, spread generally among artists involved in "assemblage" and "junk" sculpture and "happenings." The vestiges of this indifference toward the artist's "personal" touch can be seen in the automated techniques which produced much of pop and minimalism.

Finally, Duchamp played a central role in this period in terms of the huge shift in the relationship and attitude of American artists toward their European artistic heritage. The Aesthetic of Indifference was formed during the period of profound realignments of world power. The global strength of American political and economic power supported the rising power and prestige of American art in the world.[10] In the 1940s and 1950s, American artists and critics increasingly acclaimed the superiority of American art in the contemporary art world: they particularly congratulated themselves on surpassing the French as modernists.[11] Living proof of this was the "capture" of a famous French artist,

Duchamp. Duchamp had been part of the early history of American modernism through his role in New York Dada and the fact that it was America and not Europe which had originally created his fame (the *Nude*'s success in the Armory Show of 1913) and had sustained it. Not only did America house Duchamp's art, but it now housed the artist himself, for since the outbreak of World War II, Duchamp had chosen New York rather than Europe as his home. Other Europeans left America immediately after the war. Not so Duchamp, and this must have had its appeal, consciously or not, in the 1950s. Still lingeringly caught up in the need for European approval, American artists also resented this need. With Duchamp, they could have their cake and eat it, too. Obdurately European in manner and taste, Duchamp was a perfect European cult hero for this period: part of America's artistic past, he was also part confirmation of its present.

Duchamp was the European role model for many of the new notions about the artist: the cool, intelligent artist who disdained manual skills in favor of skillful plays of the mind. But Duchamp was old in 1950—over sixty—and seemingly not producing much in the way of current art.[12] The actual artistic production of the Aesthetic of Indifference came rather from younger American artists.

In 1950, John Cage made a major leap of imagination by entering into his experiments with chance. It was a period of much excitement and exchange between Cage himself, David Tudor and Morton Feldman. But, although the Zen-like chance operations of Cage were exciting to invent, they also exhibited an extreme passivity: a decision not to assert but rather to let happen what may. One of the most famous of these early passive chance pieces by Cage was his *4'33"*. First performed in 1952, Cage's "empty" composition lasted four minutes and thirty-three seconds, its only sounds being incidental noises from a restless audience and the outside environment. A similar theme of emptiness and passivity resided in Rauschenberg's white paintings of a year or so earlier. The large all-white canvases contained no image except the fleeting shadows of passers-by. The paintings had perplexed the public who saw them for the first time in 1953, a year after Cage's *4'33"* perplexed *its* first audience. In 1953, Cage wrote a description of these all white paintings. His haiku-like response constitutes a poetic manifesto of the Aesthetic of Indifference:

To whom
No subject
No image

No taste
No object
No beauty
No message
No talent
No technique (no why)
No idea
No intention
No art
No feeling ... [13]

The American public at large had been presented in that year of the silent, empty white paintings with the violent sounds and gestures of Joe McCarthy's performance in his new role as chairman of the Government Operations Committee, following the victory of Eisenhower and the emergence of a Republican majority in the Senate. In the spring of 1953, McCarthy's henchmen Roy M. Cohn and G. David Schine made a lightning censorship tour of the American overseas information program in Europe. Their search for "subversive" Communist literature led to a monstrous "cleaning up" of libraries and, literally, to bookburning. In the political ambience of hysterical anti-Communism and right-wing action, the Cage poem reads like an unconscious tragic acknowledgment of total paralysis. The Aesthetic of Indifference had literally gone "blank." There are no messages, no feelings and no ideas. Only emptiness.

Cage would object to such an interpretation. He would, I believe, argue that the denial of conventional meaning was in order to allow a different sort of meaning to emerge: that he was interested in the 4'33" piece, for example, in getting the audience to make music/sound rather than merely listen passively. But the negativity and passivity of such works cannot be disassociated from the historical moment at which they were produced.

The chance experiments of Cage, the undramatic movements and narratives of the Cunningham company, the white paintings of Rauschenberg and the artistic stance of Duchamp had been neutral aesthetic moves in a singularly fervent period of American political history. In the work of Jasper Johns, however, the Aesthetic entered its second and more poignant phase.

Nineteen fifty-three was the year when Rauschenberg executed his symbolic negation of abstract expressionism, the *Erased de Kooning Drawing*. In the

following year, Johns performed an act of far more radical erasure and denial (of American patriotism rather than an American art movement) when he executed the first of his flat and neutral reproductions of the American flag. This was the year when McCarthy, pushing his luck too far, had taken on the Army as a new domain of investigations, and, goaded into a showdown, the Army confronted McCarthy head-on. The American public was bombarded with uninterrupted media coverage of these Army-McCarthy hearings, including the famous television presentation in which the Army's attorney, Joseph Welch, was seen by millions of viewers scoring victory after victory over the beleaguered and finally defeated McCarthy. Even if we assume that Johns had had no television set, had read no newspapers and had had no politically concerned friends, he would still surely have sniffed the hysteria of prevailing patriotic sentiments. Johns took the American flag and reduced it from a potentially emotional symbol to a passive, flat, neutral object: an amazing act by an amazing artist. No longer merely all-white paintings or an "empty" musical score, but now the main symbol of American beliefs during this Cold War period was itself presented through the Aesthetic of Indifference.

Between 1954 and 1956, Johns established most of his basic iconography: flags and targets; concealed or painted-over objects; manipulations of language; and the numbers and alphabet series. Critics (and Johns himself in his rare public utterances) talk about the work in abstract terms of sustained ambiguities, concealment and waiting, disintegration, and of the artist's play with the viewer's expectations and perceptions. Johns is almost always presented as a wonderful, wily and convoluted imagination which operates outside the confines and influences of history. Not so: Johns was brought up in the late 1940s and early 1950s and his work reflects these years.

Jasper Johns was born in 1930. He grew up, intellectually and emotionally, in the atmosphere of the Cold War. He was seventeen when the CIA was created, in 1947; eighteen when Hiss was accused of perjury; twenty when McCarthy rose to power; twenty-one when the Rosenbergs were put on trial (Spillane's *One Lonely Night* was a best-seller that year); and twenty-four when McCarthy's power collapsed. Johns was a product of just this epoch of paranoia and anger. His upbringing was thus very different from that of older artists in the Aesthetic of Indifference—Cage, who came from a background of the Depression, and Duchamp, whose early work was created in the ambience of late symbolism and the cubist revolution of the 1900s.

More than any other artist, Johns incorporated in his early art the Cold War and the McCarthy era preoccupations and moods. This is not to imply that Johns did this consciously and single-mindedly, or that there is one simplistic reading for any particular image, but what emerges out of a collective examination of his work is a dense concentration of metaphors dealing with spying, conspiracy, secrecy and concealment, misleading information, coded messages and clues. These were the very subjects of newspaper headlines of the period, reiterated on the radio and shown on television; and these were the meat and meaning of the early work of Johns. His early work is a warehouse of Cold War metaphors.

Certain images in the works were relentlessly examined, as if to force a disclosure of meaning: especially the way the newspaper collage surfaces and the numbers and alphabet series suggest secret ciphering. Indeed, Johns himself wrote in 1964, "The 'spy' is a different person.... The spy must be ready to 'move,' must be aware of his entrances and exits.... The spy designs himself to be overlooked."[14]

The year before Johns' earliest preserved work was the year of the execution of the Rosenbergs, a couple accused of transmitting information about the atomic bomb to the Russians. The mood of that 1953 summer has been described by Sylvia Plath in *The Bell Jar*. The novel begins abruptly: "It was a queer, sultry summer, the summer they electrocuted the Rosenbergs, and I didn't know what I was doing in New York. I'm stupid about executions. The idea of being electrocuted makes me sick, and that's all there was to read about in the papers ... I kept hearing about the Rosenbergs over the radio and at the office till I couldn't get them out of my mind ... I knew something was wrong with me that summer, because all I could think about was the Rosenbergs ... "

The Rosenberg execution occurred the year Johns was twenty-three, the year before he painted his first American flag. He and millions of other Americans in their early twenties had been brought up in the atmosphere of such espionage and loyalty trials: the "Hollywood Ten" trial in 1947, the trial of eleven top-ranking Communist Party officials of 1948, the Judith Coplan scandal in 1949 and the Alger Hiss versus Whittaker Chambers two-year trial of 1948–50. It was a period of endless Communist witchhunts.

In these trials, witnesses and evidence were relentlessly and monotonously questioned. There was always a sense of the trial proceedings being on the brink of revelation: the next examination of witness and/or object will break the code and expose the traitor. Certain objects became endowed with fascinating, even magical, meaning for the American public: the Jell-o box in the Rosenberg case

and the Pumpkin Papers and Woodstock typewriter in the Hiss trial. It is from this world of investigations of witness and object that Johns, almost certainly unconsciously, drew the substance of his early art. In the world of early Johns, his objects and ciphers invite investigation of their meaning. If the book (the painted-over *Book*, 1957) were legible, we might know what is going on. If the drawn-down *Shade*, 1959, could be raised, we might see what is going on. But, like the Pumpkin Papers and the Woodstock typewriter, Johns's objects tantalize but do not prove. These early works of Johns suggest a perpetual and obsessive interrogation of evidence. Unlike the verdicts of guilt in real-life Cold War trials, however, we are never sure of the conclusion, or of whether Johns himself knows the verdict, or, indeed, whether the trial is really over.

In his interrogation of language, numbers and objects, Johns' manner is neutral and indifferent. Yet there are undercurrents of poignancy. Max Kozloff relates that Johns had made a special visit while in England to see Leonardo's "Deluge" drawings. When asked by Kozloff why he had sought out these late Leonardo drawings, drawings of a catastrophe-ridden and eroded world, Johns replied: "Because here was a man depicting the end of the world and his hand was not trembling." It is impossible to think of any o her figure sharing in the Indifferent Aesthetic giving exactly such an answer, or, indeed, seeking out such images.

Again and again in the 1950s, Johns took emotion-laden material and ran it through a filter of indifference. Like Leonardo, his hand did not tremble as he depicted a world of distintegration and blankness. At the heart of these early works—and it is this that makes them singularly moving, for me, in spite of their neutral surface—is a pull between the search for meaning and a denial of meaning. Johns chose subjects to paint that revolved around the basic tools of meaning: tools of light, measurement and language by which the world is conventionally apprehended and described. We need light literally to see the world we live in, but the flashlights and lightbulbs (themselves artificial light sources) in Johns are often inoperative: they are embedded in metal or broken (*Lightbulb I* and *Lightbulb II*, 1958). Numbers are tools of measurement for establishing one's spatial position and the size of objects in the world, but Johns' numbers are useless. His monotonous repetition of numbers and alphabets (such as *Gray Alphabets*, 1956, or *Gray Numbers*, 1958) recalls the mutterings of a senile person who once learned in early childhood lessons of counting and memorizing the alphabet and who vaguely remembers that further lessons made sense of such exercises, but cannot recall anything more.

Johns never develops language meaningfully. The print is usually illegible in his encaustic-covered newspaper collage surfaces. The alphabet is left intact. Words dangle as objects from the canvas. Language is used pedantically to describe what we already know: for example, the objects labeled as "broom," "stretcher" and "cup" in *Fool's House*. Image and word contradict one another: in *False Start*, 1959, the surface is ridden with colors and their names, but the word for one color is written in another color and placed above yet a third color. For all Johns' employment of language, we can never "read" his messages with accuracy and trust.

The energy and despairing hope that Johns had invested in his search for a means to decipher the world began to fail. Before finally giving up and moving to safer ground, Johns embarked upon a series of works in the early 1960s, where the sense of search was heightened. *Land's End*, 1963, is a sober account of color words and a circle device is abruptly pierced by an upraised rigid arm: it is an anguished gesture. In *Study For Skin I*, 1962, a faint image of hands and face (Johns' own) are pressed against the paper as if peering out in order to prepare for an escape. In *Souvenir*, 1964, Johns himself again stares out with a Buster Keaton–like deadpan countenance. Light is reflected toward him obliquely from a flashlight shining onto an angled mirror, The work gives the disquieting impression of an interrogation of a person already brainwashed, from whom no further information will be drawn.

Johns shifted into safer, and ultimately less inventive areas in the 1960s, devoting much of his time to printmaking. Most of the other figures participating in the Indifferent Aesthetic made similar moves, announcing yet another stage in the evolution of indifference in art. Rauschenberg produced elegant silk-screen paintings and prints and expensive limited editions of objects. Duchamp's publicly known works in the 1960s were trivial—for example, his etchings of the *Large Glass*. Cage continued interesting, but less fresh, experiments with elaborate chance scores. In the meantime, the Aesthetic of Indifference had become a major influence on the art movements of the 1960s. Reading matter for a whole generation of artists was provided by Cage and Duchamp. In 1960, Duchamp's *Green Box* notes (to accompany the *Large Glass*) were translated into English for the first time, and the full range of Duchamp's ingenious and devious mind could be studied, while in 1959 the first monograph on Duchamp (by Robert Lebel) had been published. Cage's

*Silence* was a beguiling and playful account of many of the Indifferent Aesthetic's strategies; the book quickly became a poetic guide for younger artists when it first appeared in 1961.

The Aesthetic of Indifference was a dominant model for much of pop, and less directly, it had a strong influence on minimalism (with Johns as a major mediator). For Cage, Johns and Rauschenberg to have chosen, consciously or not, to advocate indifference and neutrality as a psychological and intellectual way out of the impasse of the McCarthy period was perhaps not a courageous stance but, in retrospect, was understandable in view of the paralyzing effect that the early 1950s had on so many intellectuals. But pop and minimal art developed in a time of far more radical hopes. The period in which these movements evolved was that of sit-ins and freedom rides, then marches, and anti-Vietnam demonstrations. Yet the artistic counterparts to such events were, for the most part, infrequent and bland: Roy Lichtenstein's comic-book war images and Andy Warhol's race-riot canvases. Usually pop avoided such loaded material and dealt rather with a Middle American world of affluence and materialism, a world of physical comforts and pleasures whose values were formed by advertising and business. Understandably, these works were immediately a big success with Middle America and sold well and easily. What minimalism did was similar: corporate-industry materials, clean-cut industrial design and scale were employed to produce large abstract sculpture and paintings which fitted in well with the decor and scale of corporate and public buildings. This art was being produced during the time of high hopes and angers: radicalism was a threat to Middle America, but "radical" avant-garde art was not, for there was virtually no politically radical art in the 1960s.

Yet many of the pop and minimal artists were actually sympathetic to radical causes, such as antiwar or Black Panther support demonstrations and the like. Why did they forget this when they went back to their studios to make art? Why this denial of commitment and feeling in art? Much of this bizarre discrepancy between life and art acts can be ascribed to the legacy of the Aesthetic of Indifference, together with formalist theories (which were stamped with their own brand of "indifference"). Clement Greenberg and his crew hated the Cage/Duchamp contingency but formalism and the Aesthetic of Indifference together provided a powerfully persuasive counsel to artists of the 1960s: play it cool. Formalist critics advocated a "cool" making and read-

ing of art: the focus on shape, color and relationship to space. As the Aesthetic of Indifference had been paralyzed by the politics of the McCarthy period, now the sensibilities of many artists of the 1960s were paralyzed by the neutral strategies prescribed by the Aesthetic of Indifference. Formalism, at least, only advocated coolness of form, but the Aesthetic of Indifference was a more potent and dangerous model for the 1960s; it advocated neutrality of feeling and denial of commitment in a period that otherwise might have produced an art of passion and commitment.

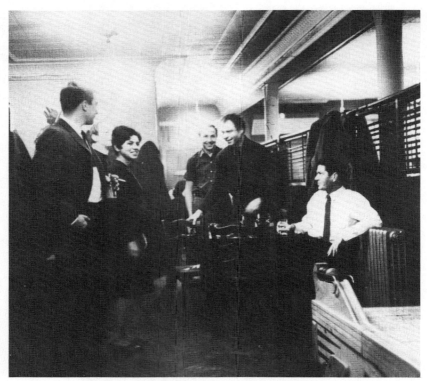

Attentive competitors in a serious game of Skee-Ball in Dillon's Bar (left to right):
Jasper Johns, Anna Moreska, Robert Rauschenberg, Merce Cunningham, John Cage.
November 10, 1959. Dillon's Bar at 80 University Place later became the *Village Voice*
office and is now a Japanese restaurant.

# identification

## jonathan d. katz

> He simply found that object, gave it his name. What then did he do? He found that object, gave it his name. *Identification.* What then shall we do? Shall we call it by his name or by its name? It's not a question of names.
>
> —John Cage,
> *A Year from Monday*

### shall we call it by his name or by its name?

It would be hard to overstate the importance of Moira Roth's celebrated essay "The Aesthetic of Indifference," published in *Artforum* in November, 1977. In the over twenty years since Roth published it, the essay has continued to be cited in nearly every new work on Cage, Cunningham, Johns, Rauschenberg and their

circle.[1] Though much has changed in the intervening years in both the discipline of art history and our state of knowledge of the figures she critiqued, her attempt to define and historicize what she understood to be a new Cold War aesthetic sensibility in American art has shown remarkable longevity and unmatched explanatory force.[2] "Marcel Duchamp in America: A Self Ready-Made," published only seven months earlier in *Arts* (May 1977), constituted a kind of historical and thematic predecessor to the "Aesthetic of Indifference," for she understood the practice of artistic indifference discussed in the later essay as originating in Duchamp—who was then taken up as a model by the group around John Cage. Together, the two 1977 essays set out a new approach to the history of art, one sensitive not only to questions of political valence, but to what had long been considered mere ephemera in the still-formalist critical context of the time—notably artistic personae, sexuality, and the social historical roots of identity.

I initially encountered Roth's essays as a first-year college student in Washington, D.C., in 1978. The discussion of sexuality in "The Aesthetic of Indifference" caught my eye, but—still deeply closeted—I nervously and rather too hastily dismissed it as irrelevant to my then rigidly formalist beliefs. Nevertheless, I loved the artists of the Cage circle she discussed and her references to their homosexuality and its import (the first I had ever seen) stayed with me. Slowly, almost without my noticing, the article worked as a solvent to my formalist orthodoxy. Roth had illuminated a means of connecting lived experience with intellectual and aesthetic preoccupations in a manner I took to heart both professionally and personally. She had shown why questions of sexuality *mattered,* what meanings such difference could carry. Between 1986 and 1995, now completely out, a gay activist and art historian in my thirties (and, concomitantly, no longer a formalist), I returned to the articles, and especially to "The Aesthetic of Indifference," determined to examine critically this proffered connection between sexuality and aesthetics. Prodded by Roth's claims, I completed my dissertation on the Cage circle, and have pursued a career in San Francisco writing and lecturing about what she termed "indifference" from a queer studies perspective.[3]

These two essays that I read in my first year of college—essays which I took so much to heart—are now nearly two decades old. As the discipline of art history has changed, increasingly coming into sync with Roth's then shockingly innovative approach, "The Aesthetic of Indifference" has itself been assured of its place in the canon. Thus, in tribute, it is time to take up the strengths and deficiencies of this landmark article in order to further its work.

Roth traced her trajectory of indifference from Duchamp through Cage and then into Johns, Rauschenberg, and pop art. I will follow that same trajectory, but with a different purpose in mind. In place of a baleful genealogy of indifference and domination within Cold War culture, I will read many of the same thematics as Roth, but now under signs of resistance and refusal. What Roth describes as apolitical I hope to rehabilitate as a particular species of politics, one specifically calibrated to survive Cold War America. Reading outward from this silence, I hope to recover it as a strategy of queer resistance to a social context of control and constraint within a culture that offered little room to maneuver, especially for gay men. Here the compulsory Cold War closet did double duty—it is at once a means of camouflage *and* contestation.

## indifference

The particular power of "The Aesthetic of Indifference" was its attempt to weave together for the first time—in opposition to the abstract expressionist histrionics of flung paint—a new "aesthetic" persona calibrated to the Cold War, together with notions of sexuality and difference. This is a heady thematic mix, but Roth's governing paradigm—the notion of indifference—helped tether it all together in a distinct and legible synthesis. Her governing thesis is that this indifference, this apolitical neutrality, was conditioned by McCarthyism and the policed consensus culture of the time. As she succinctly puts it, "the negativity and passivity of such works cannot be disassociated from the historical moment at which they were produced." [4]

Using a diverse array of Cold War cultural figures from Marshall McLuhan to John Cage, Roth seeks to show the ubiquity of this idea of indifference in American culture at the time, and explores how the notion transmogrified from a negative into a positive cultural value. Again and again, it seems that indifference is the *ur* form, the Rosetta stone required for understanding this period: it determines the artists' aesthetic choices and it conditions their results. Employing "neutrality as their springboard," she wrote, "These artists made and talked about an art characterized by tones of neutrality, passivity, irony and often negation." [5]

Roth connects this new "indifferent" aesthetic to a broad-based "paralysis" among Cold War intellectuals—itself a response to the highly policed

McCarthyite cultural context. She traces three distinct historical phases of the indifferent aesthetic: the coolness of Cage, Rauschenberg, and Cunningham; the "muted anxiety" of Johns; and finally the triumph of indifference in pop. In so doing, she not only ropes each of the major post–abstract expressionist artistic developments together, but also attempts to account for their unparalleled commercial and critical success. In what was the first reception theory proposed for these Cold War figures, she understands this art as "strangely appealing and acceptable to the very forces—governmental, corporate and middle-class powers. . . ."[6] that the genuinely radical political movements of the 1960s opposed. A cornerstone of her argument then, and one with wide cultural resonance, is that "the artists of the Aesthetic of Indifference were neither involved in real politics nor concerned about the vigorous defense of modernism."[7] Rather, they were indifferent, and it was this very indifference that was critical to their success.

From her assertion that Cage's work can be understood as an "acknowledgement of total paralysis" to her analysis of Johns's early painting as "a warehouse of Cold War metaphors," Roth insists on restoring a political context to work that, she argues, strives for neutrality. Unwilling to accept the indifference she sees as animating this art, she was the first to analyze its complicated synchronicity with the dominant tendencies of its time as itself a kind of politics. In a confessional postscript to "The Aesthetic of Indifference" she writes, "I have had a long, intense, and ambivalent history of attitudes toward Duchamp, Cage, Rauschenberg and Johns. Writing this essay has been a way of trying to write a partial intellectual autobiography, an accounting of my interests in these artists."[8]

What gives her analysis its unprecedented force is her nuanced and revelatory readings of individual artists and works. For all the broad and synthesizing scope of her theory, she never loses sight of the single subject. For example, to see in Johns "a dense concentration of metaphors dealing with spying, conspiracy, secrecy and concealment, misleading information, coded messages and clues" is to say something as new and revealing of Johns's painting as the broad cultural context in which it was made.[9]

Moreover, she quite specifically correlates the indifferent attitude she finds in these artists to their identity and sexuality, as when she asserts, "The machismo attitudes proudly displayed by the abstract expressionists were now countered by the homosexuality and bisexuality permissible and even common among the new aesthetic group."[10] The cool ironic distance cultivated by the

artists of the Cage circle in their work was mirrored in their deeply closeted private lives. These "indifferent" figures are even characterized by Roth as " a new breed of artists," physically and intellectually distinct from their abstract expressionist forebears, with a "dandylike elegance of body build and a manner which delighted in cool and elegant plays of the mind."[11]

What makes this analysis of a generational succession written through sexuality and art politics all the more compelling is its insistence on careful social history, specifically the backdrop of Cold War culture. In exploring the relationship between Cold War discursive modalities and these new aesthetic and erotic identities, Roth's essay points toward the possibility of a social history of the mappings of gay identity in postwar American art—the first such analysis ever published.

Yet her ascription of indifference to a group of gay artists has long troubled me, for the term implies the presence of a choice; her implication that they did not become involved assumes that they could have. But the fact is that queer artists and straight artists were not playing on a level field in Cold War America. On the contrary, this was arguably the single most actively homophobic decade in American history, and queers who hoped to survive it had to engage in a constant negotiation with the dangers of self-disclosure. Silence ensured survival. Grouping a number of these gay artists together under the rubric of indifference and then chastising them for remaining silent during some of the most acrimonious debates on homosexuality in American history thus seems a bit unfair.

Although compelled, these gay artists' choice of silence and indifference was moreover not exactly a mode of the closet, for the closet uncompromisingly demands that one ape the larger cultural requirements as seamlessly as possible. Truly closeted artists would have simply painted abstract expressionist canvases. Instead, Cage stood before the assembled abstract expressionist multitude in 1948 and gave his "Lecture on Nothing," with its famous tag line, "I have nothing to say and I'm saying it."[12] A few years later, Rauschenberg would complete his empty White Paintings and Cage his silence piece, 4'33''. And yet a few years later, Johns would create a painting called Disappearance II that featured two layers of canvas, one atop the other, the top one folded in on itself so as to obscure its inner surface. In all these works silence and absence is thematized, made palpable as a silencing. The argument I want to make here is that this is not silence at all, but rather the performance of silence, and that—we shall find—is a very different thing. To call this silencing indifference is to mistake cause and effect.

## duchamp and the dandy

Duchamp became the antimasculinist patriarch of what would turn out to be a most queer family—Cage, Rauschenberg, Johns, Warhol, and to a lesser extent, Cunningham and Twombly. In thematizing questions of gender and sexuality, audience and institutionality—in short, the whole complex we designate as identity—Duchamp presented a series of antiauthoritative queries in the guise of a dandified and indifferent aesthetic. While repeatedly proclaiming his indifference, Duchamp's work nonetheless constituted a series of highly charged but seductively soft-pedaled challenges to hegemonic art world culture and its central self-expressive paradigm. Until quite recently, that culture uncritically assimilated Duchamp's too-precious protestations of disinterestedness toward meaning, while remaining captivated by his intellectual and pictorial subterfuges. He was an artist who didn't care *and* he was a powerfully rebellious presence in the art world of his time. Seamlessly, Duchamp inhabited a paradox: he combined indifference with resistance.

Such successful duplicitousness would prove revelatory to this Cold War generation of queer artists, and Duchamp's modeling of indifference as resistance would have wide-ranging creative implications. There was something familiar to them about Duchamp's strategies, with its performative posture of studied indifference. After all, the performance of disinterestedness and the cloaking of personal investments had, on a more personal level, long been the price of maintaining the closet. Their elevation of Duchamp as prophet, however, came as fortuitous confirmation of these gay artists' strategic thinking; they did not set out to self-consciously follow him nor did they seek to perpetuate his legacy. And their involvement in evasive Duchampian strategies moreover read very differently in light of the abstract expressionist self-revelatory culture that then swirled about them. Without even the benefit of "Frenchness" (always a big advantage of Duchamp's) to conceal their difference, these gay artists had to work even harder to appear indifferent. Dressing in drag would hardly do.

Like Duchamp, these mid-century artists celebrated the role of audience in the construction of meaning in any work of art. But their recognition of audience as the requisite ground of meaning was perhaps not as playful and intellectualized as Duchamp's. Gay men in the violently homophobic culture of the fifties knew experientially the role that audience, here almost inevitably hostile, played. It mattered how you crossed your legs, how you spoke, and which pro-

nouns you let slip, under a scopic regime so brutal in its enforcements and ret-
ributions that the notion of an always observing audience was burned into daily
consciousness, to be ignored only at great peril. For them, meaning was con-
comitant with interpolation, the act of being read by another. Thus, these artists
knew well the limits on the self-expression that their abstract expressionist col-
leagues took as an open-ended imperative—and that Duchamp had earlier (and
much more amusingly) taken up as a theme.

If meaning was a construct imposed from without, then it follows that the
expression of self and identity in art were but hoary fictions. How can any artist
express the self if the meaning of the work is a product of the viewer? In the midst
of Cold War consensus thinking, Duchamp's play with personae gave courage. His
work offered a route around the autochthonous, white, heterosexual, bourgeois
male subject naturalized in abstract expressionism—the kind of subject that increas-
ingly defined what it was to be an "American" throughout Cold War culture at large.

In the face of this "commonsense" assumption of a naturalized subjectivity
(the pictorial subject of abstract expressionism), a number of gay artists were
instead charting a newly destabilized and de-essentialized construction of self.
As Johns is reported to have remarked, "'I think you can be more than one per-
son. I think I am more than one person. Unfortunately.'"[13] Identity, no longer
singular and transcendent, now ceased to inhere *in* the self, but was instead born
of audience and context, limitations and possibilities, history and constraint. In
short, identity was no longer a given fact of nature. Severed from its moorings
in the self, identity had become positively Duchampian, a performative con-
struct itself eligible for insinuation, however problematically, within the cate-
gory of art. As Andy Warhol put it years later in a codification of this new kind
of performative self, "'I'm sure I'm going to look in the mirror and see nothing.
People are always calling me a mirror and if a mirror looks into a mirror, what
is there to see?'"

### my selves

My quietness has a number of naked selves,
so many pistols I have borrowed to protect myselves
from creatures who too readily recognize my weapons
and have murder in their heart!

—Frank O'Hara, "In Memory of My Feelings"

For an artist at this time to define himself as a mirror, or to nominate ready-made objects as his art, is not to obscure or deny the self but to multiply it—times every viewer. Variously called de-essentialized, decentered, denaturalized or socially constructed, this new self is thus anything but monadic. In a poetic evocation of this new kind of self, the poet Frank O'Hara catalogs a range of performative identities that are contradictory yet no less "true" for that fact: "I am a Hittite in love with a horse. I don't know what blood's/ in me I feel like an African prince I am a girl walking downstairs/ in a red pleated dress with heels I am a champion taking a fall ..."[15]

In the sphere of the visual arts, Duchamp inaugurated this play with what O'Hara aptly calls "the scene of my selves" through his nomination of readymades. He has asserted that the process of choosing objects for inclusion as readymades was rigorously neutral—if he liked or didn't like something, it could not be chosen. Taste was eliminated as a vestige of an interiority at war with this idea of the de-essentialized self. In signing his fountain/urinal "R. Mutt," Duchamp reached a yet higher level decentering—now not only was the object anonymous, but so, too, was its creator. Yet an even more radical remaking was in the offing. As Duchamp remarked to Pierre Cabanne, "The first idea that came to me was to take a Jewish name. I was Catholic, and it was a change to go from one religion to another! I didn't find a Jewish name that I especially liked, or that tempted me, and suddenly I had an idea: why not change sex? It was much simpler. So the name Rrose Sélavy came from that."[16]

In the person of Rrose Sélavy, Duchamp's particular creative intelligence was now neither absented nor anonymous but quite specifically fictive—Man Ray's photos made sure of that. The very transparency of Duchamp's claim to femaleness, its very "unnaturalness" was here the point. Duchamp could plausibly take on another name—artists do it all the time—or operate in accordance with chance-derived principles, but he could not so easily take on another sex. Changing one's name is sanctioned by law; changing gender is of a different order entirely. Gender belongs to the realm not of law (which is to say of culture) but of nature. And nature has long operated as culture's trump card, the final arbiter and guarantor of cultural authority—hence, the appeal to "natural law" in the policing of cultural norms. Since the category "nature" has repeatedly served to suture cultural authority and naturalize its blatant wielding of power, denaturalizing the natural becomes a supremely subversive act in Duchamp.

Roth was among the first to understand the connection between Duchamp's creation of Rrose Sélavy, his obsession with chess, and his penchant

for playing the dandy. For Roth, these activities constitute a form of artistic creation in which "lives can be seen as *the* focus of their work."[17] Whether in the guise of a chess player, Rrose Sélavy or the dandy, Duchamp's performative selves, according to Roth, are at root a refusal of the more traditional artistic practice of object-making in favor of personae play as art.[18]

Yet Roth also attributes a deeper purpose to Duchamp's dandyism than mere avant-gardism. Dandyism, she argues, following Charles Baudelaire in his *The Painter of Modern Life* (1863), offered Duchamp a kind of screen or baffle against his own inner turmoil. To be a dandy was to engage in a self-conscious performance of a non-self-identical identity, a performance in which elegance and aloofness operated as a kind of shield against the recognition of painful self-truths.

Through this profound mistrust of dandyism—as if it is but an instrumental theatrical exercise concealing a "natural" self—Roth recuperates dandyism into the traditional view of identity as an authentic interiority.[19] Roth's discussion of Duchamp's dandyism is thus premised on a residual belief in an authentic, essentialized and natural self; hence her suspicion of its performative terms. Following Baudelaire, she finds in dandyism a thinly veiled whiff of failure and tragedy. She writes, "The iconoclasm of the readymades and his general role in New York Dada seem increasingly, from the perspective of the 1970s, to be a cloak drawn over Duchamp's more private, pessimistic, and hermetic thoughts."[20]

The dandy, in this view, is a tragic figure, whose tragedy presumably issues in part from an inability to embrace a public identity consonant with his natural self. Roth's dandy lives a lie. No wonder, in the popular imagination, dandyism bears an implicit and sometimes explicit relationship to homosexuality, presumably at least in part for its dramatization of selfhood as a pose set up for public consumption, as a lie concealing a truth. There is surely an element of validity to this; in the era of the closet, the domestication of nonnormative identity through its aestheticization as dandy served both as an avoidance of censure and a sure route to cultural power.[21]

But what if we were to take Duchamp's dandyism at face value, not as *cover* for a traditional, bourgeois concept of self, but as something totally different: evidence of a new, or at least different, notion of self? Could the patent constructedness of the dandy be understood not as an acknowledgement of a performative self obscuring the authentic core, but rather as a sign of the constructedness of *all* identities in the social? Could the dandy be a walking embodiment of a new social constructionist perspective, wherein the commonsense, essentialized self of old is not only vacated

but critiqued? There is thus no self here, but rather O'Hara's notion of "a scene of selves," deflecting our gaze back to us. Here the very construct "I" implies another.

Oscar Wilde, perhaps the most famous dandy of all, was eloquent on this count. He repeatedly delineated a self that was constructed in the social realm and whose most private needs and desires were in fact born of a highly performative social discourse. As he wrote in 1890, " Do you wish to love? Use Love's Litany, and the words will create the yearning from which the world fancies that they spring."[22] Even love, for many the most authentic and privatized emotion, is in Wilde's perspective merely a social construct with no core. Developing this idea further in the *Picture of Dorian Gray*, Wilde repeatedly structures key scenes by transposing the self and the social world. The self in Dorian Gray is quite precisely an unnatural thing. According to Wilde scholar Jonathan Dollimore, "That is why Wilde calls being natural a 'pose,' and an objectionable one at that, precisely because it seeks to mystify the social as natural."[23]

In short, I want to argue for a deeper sympathy between Rrose Sélavy and Duchamp's dandyism than mere personae play as art. Indeed, both forms of activity seem linked by the refusal of any simple notion of a natural or unmediated "interior" identity. Transparently performative, both social "identities" — drag and dandy—are now revealed as manifestly and quite specifically unnatural. Here the binary structures that enable and support the traditional bourgeois notion of self—public/private, interior/exterior, authentic/performative, natural/unnatural—break down, canceling each other out. According to this reading, Rrose Sélavy is then the ultimate dandy, her unambiguous and celebrated unnaturalness mounting a challenge to *all* identities rooted in a notion of authenticity. Duchamp in drag is quite simply unrecuperable to any discourse of the natural; he is pure, unmystified pose—and thus unavailable to any authoritative cultural usage rooted in a vision of nature.

Rrose Sélavy is only the most visible and notorious component of a larger Duchampian embrace of the unnatural. His interest in alchemy, which promised an overturning of natural law in turning base metal into gold, followed this pattern, no less than did his contributions to Dada and its fabled anarchic disruptions of the natural order. Indeed, in becoming the virtuoso of a performative antinaturalism, Duchamp repeatedly exploited its anarchic, and thus liberatory, possibilities.

But it is through the frustration of longing, perhaps the most persistent of all our desires, that the real depth of Duchamp's antinaturalism can be mea-

sured. If longing, as Wilde argued, is perhaps the most densely mystified of all our social constructs, then the frustration of longing may help demystify it, rescuing it from the realm of nature where it was shunted, unexamined. Duchamp transformed himself into the embodiment of frustrated desire: the artist who refused to make art, the lover whose ever-present eroticism never led to consummation (*Female Fig Leaf*), the sensualist in whose hands warm desiring flesh was made cold and mechanical (*The Bride Stripped Bare by Her Bachelors, Even*), the voyeur confined to a small peephole in a barred door (*Etant Donnés*). Nature in Duchamp's work—most often in the form of desire—was forever interrupted, disciplined and controlled by the artist: it could never follow its "natural" course.[24] Duchamp the dandy personified this deliberated unnaturalism—all artifice and construction—a figure born of a process of careful control, of the the blockage and frustration of erotic needs.

From the perspective of Cold War gay (which is to say closeted) culture, there is something deeply, resonantly queer here: this sense of interrupted or blocked desire; this unwavering, implacable self-control; this persona staged for public consumption; and most of all this consuming awareness of audience, of a life lived under a scopic regime. Duchamp is, figuratively speaking, very much in the closet, if the closet can be taken to signify a performative posture conceived with at least one eye on audience.[25] No wonder he became the guru for a post-war generation of queer artists.

The dandy, like the closeted queer, replaces "natural" longing with the narcissistic pleasures of performative fluency—the nuanced enactment of artifice. Dandy and queer share the self-consciousness born of being watched. But the carefully cultivated sensitivity of the dandy's identity to social expectations was something queers knew experientially and intimately; the closet demanded that identity change with circumstance (e.g., one self with family, another among gay friends, yet another among straights, etc.). In opposition to the frequently held white, male, heterosexist vision of identity, and its vision of a "deep," essentialized, and autochthonous nature, the Duchampian—and queer—sense of identity seemed more like a kind of sartorial fitting without end.

My point is that rather than seeing Duchamp's dandyism as "cover" or the falsification of a true or essential identity, viewed from a queer studies perspective, it may very well be that the dandy's performative selves are a kind of lie that tells the truth of identity, denaturalizing and uncentering the very notion of

identity itself. Or as Wilde once put it, " Only shallow people . . . do not judge by appearances."[26] Here, the majoritarian vision of self as a pure interiority can be revealed as complicit in hegemonic constructions of public and private, wherein the operations of culture in the regulation of identity are mystified as a mechanism of social control.[27]

Perhaps only those who traffic in the "unnatural" can fully appreciate the extent to which the discourse of the "natural" reinforces structures of domination. And equally, only those who are lucky enough to inhabit the category "natural" have the privilege of seeing their exercise of social power naturalized and thus made transparent (to themselves as well as others). In this sense, Duchamp's antinaturalism entailed a deep disidentification with his natural birthright as a straight white male—and, concomitantly, was to make him, especially in the fifties, a hero to closeted queer artists struggling under the weight of an abstract expressionist patrimony.[28]

In the Cold War cultural context, Duchampian antinaturalism could be used to devastating effect by queer artists against abstract expressionism and its presumptions. After all, it was to nature that abstract expressionism appealed, and from which it sought support.[29] Abstract expressionism had a lock on the natural—whether it was understood as the expression of natural emotion, the Greenbergian ideal of the nature of painting, or the Rosenbergian notion of an encounter between human nature and resistant materials.

Of course, few things are as unnatural as a discourse of the natural—it has to be continuously reinforced through reference to nature. The New York school's aggressively naturalized pictorial practice has tended to successfully obscure the manifestly constructed performativity of the abstract expressionists' attempts at nature.[30] The Cedar Tavern and other New York school venues were stage sets for the performance of abstract expressionism's peculiarly American references to a vision of nature—the rough and tumble naturalized masculinity of the frontier. The performative machismo now so blatantly in evidence in their mythic male personae helped promote this mystifying of the social as natural. But since masculinity, by definition, can't admit to its construction in the social, it must stand as the natural expression of maleness itself—an epic force which can only be channeled, never controlled. Thus the discourse of expressionism stood buttressed by a discourse of naturalized masculinity; that is, men as men can't help but forcefully enact what they feel. Abstract expressionism was the result.

Duchamp, as the walking deconstruction of the natural, would prove eminently useful to any form of resistance to this state of affairs in avant-garde culture. And not only was Duchamp alive in the 1950s, he wasn't, well, Wildean, despite his antinatural perspective and female alter ego. No wonder closeted queer artists found they could organize a mode of resistance to the naturalizing discourse of abstract expressionism under his aegis. In Duchamp, there is no longer possible that kind of expressionism requiring, indeed rooted in, a transcendent and naturalized authorial presence. If everything was constructed in the social, then the very notion of expressionism was meaningless. No matter what the authorial intention, meanings—even distinctly masculine (and hence naturalized) meanings—were revealed as an artifact of the social. As Rauschenberg once said, "Any material has its content and its independence from meaning. Meaning belongs to people."[31] Or as Johns wrote in one of his early sketchbook notes: "An object that tells of the loss, destruction, disappearance of objects. Does not speak of itself. Tells of others."[32]

What made Duchamp so useful to the Cold War generation of queer artists was then his ability to demystify and thus destructure the modes of meaning that the dominant avant-garde culture had sought to naturalize as "simple" expressions of the artist. In his brief against nature, Duchamp offered the example of a resistance organized around a seduction away from normative definitions of meaning as inherent *in* the artist/work toward a vision of meaning as something brought *to* the work. Since authoritative discursive constructions seek to hide their reliance on cultural mediation through trying to make meanings appear natural, it was to the negation of naturalism that Duchamp turned. The presumption of naturalness in the dominant discursive context is a product of repressions, as Ross Chambers points out, an attempt to " 'forget' and cause [the viewer] to 'forget' the role of mediation. It is only as a result of that inhibition that the discourse of power comes to seem (to be read as) literal."[33]

Abstract expressionism was the exemplary naturalist pictorial style, each brush stroke an exercise in automatic, spontaneous feeling. Yet, thirty years before its emergence into avant-garde prominence, Duchamp blazed a trail out of the still, uninterrupted fields of nature where abstract expressionism resided—fields where meaning clung to art works like leaves to trees—and on toward the shifting terrain of the social. In the process, the closed circuitry of meaning in this naturalized abstract expressionist discourse (artist to art and back again) was opened and made available and responsive to the surrounding outside world.

## the politics of indifference

Duchamp had found a way to critique the natural without marking himself off as its enemy. He offered a recipe for destabilizing the operations of power without recourse to any articulated form of direct opposition. This, too, would prove enormously useful to a subsequent generation of closeted artists. Duchamp was never *against* anything; he was, as Roth correctly asserts, merely indifferent to that which he did not like. In a context of extreme constraint, such as that suffered by gay artists of the Cold War era, this ability to enact an opposition without articulating or embodying it would prove highly useful.

Opposition without oppositionality served to camouflage the dissident, and surely Duchamp was the most polite, respectable radical around. In Duchamp's case, this politesse was a useful performative strategy; for the gay artists who came later, it would become much, much more. In a context of institutionalized homophobia—among other constraints—opposition without oppositionality spelled the difference between success and censure, liberty and interdiction. Gay artists couldn't be against the naturalized masculine expressivity of abstract expressionism, but they could be, and were, indifferent to it. As Cage said in his "Lecture on Nothing," "I have nothing to say and I'm saying it."

Moreover, because of this lack of oppositionality, the Duchampian model was able to secure a form of resistance to established power which did not enact or embody otherness. In the Cold War cultural context, otherness was useful to avoid, especially for gay men, who were moreover generally aligned with that ultimate other, the Communist.[34] And since the nomination of "otherness" has long proved useful to the solidification of domination and control—becoming the outside that allows the inside to look past all differences and cohere as a united front—in denying an other, dominant culture was robbed of one of its chief supports. Hegemony generally required an other in order to define itself in antithesis. Thus, within this highly policed Cold War society, straightforward resistance to power, especially for gay men, could result, paradoxically, in its reinforcement. It was better, then, to approach power with the stealthy indirection of a Duchamp.

Not surprisingly, this is precisely what gay artists did during the Cold War. In unexpressive expressionism, silent music, and white paintings, Johns, Cage, and Rauschenberg, respectively, made a statement of nonstatement. In their hands nothingness, emptiness, and silence grew articulate. Though music was

supposed to have arranged sound, painting organized color, and expressionism the manifestation of emotions, their work had none of these tropes. But just as Duchamp interrogated the conditions of meaning in art through an act of negation—substituting a purchased mass-produced commodity for the autographic intensity of the authentic creative act—so too did these gay artists negate, and accordingly interrogate, other normative conditions of art meaning.

Here the act of negation constitutes an active, political praxis. And the negations of this Cold War generation of queer artists were both purposeful and successful, ultimately seeding and nourishing a resistance to the masculinized, hence naturalized, "meaning-making" of the Cold War avant-garde. Through a seemingly indifferent aesthetic practice, these closeted artists nonetheless succeeded in destructuring hegemonic art world assumptions.

In short, I am arguing that what Roth refers to as "an aesthetic of indifference" can be more accurately termed "a politics of negation," wherein negation functions as an active resistance to hegemonic constructions of meaning as natural or inherent in the work. For negation to achieve this level of political engagement, it requires two preconditions: first, a context of extreme constraint such that direct opposition is both dangerous and ineffectual; and second, a practice so rigorously hegemonic that the negation of it would in and of itself signify. Surely, if ever these conditions occurred in the U.S., it was during the Cold War era. In navigating the distance between saying and meaning, these acts of negation opened up the process of signification for an audience-centered examination of the conditions of aesthetic statement.

For Roth, this negation of authorial meaning, standing in such marked contrast to a more activist oppositional resistance, may well have appeared like an act of political indifference. And Roth's reading is a powerful one, having served for over two decades as a dominant interpretation of this work. The question then is why a modality that I am claiming as powerfully and successfully resistant —negation—came to seem to her and many others like no more than sheer indifference.

I think that, at least in part, Roth's reading is structured by the particular feminist preoccupations of the late 1970s. At the moment when she was writing these two articles, the beleaguered Equal Rights Amendment was immersed in a battle for ratification and lesbian separatism was at its peak influence. Thus it is perhaps not surprising to see feminist theorists constructing a largely essentialized female subject engaged in directly oppositional modes of resistance like civil

disobedience, protest and political lobbying. Roth, accustomed to this form of direct, activist political resistance on behalf of a knowable and boundaried female subject, must have found the constrained subjectivity of seemingly paralyzed artists in the 1950s employing the indirection of a politics of negation unreadable in terms of political action. Invested in excavating praxis in the fifties as prologue for the sixties, she was clearly in search of a model for political engagement in the seventies. And she was surely not alone. (Indeed, despite their success at over-turning the codes of postwar avant-garde practice, the "politics" of Duchamp and the Cage circle have only recently come under analytical scrutiny).[35]

Queer artists found in negation a mode useful precisely for its ability to obscure its investments; indeed that was one of its central purposes. Its poten-tial invisibility is therefore not a flaw but a strength, and such camouflage would prove highly useful in the policed context of Cold War culture. But equally, as lit-erary theorist Ross Chambers argues, the act of negation brings a work so close to its target that it may seem hardly different from it at all. As Chambers sums it up, "negation shares with grammatical negation an inescapable feature . . . : negation necessarily 'mentions' therefore acknowledges the power of what it negates (whereas an affirmation does not have to have to acknowledge that which it is negating)."[36]

Silent music or empty painting—as in the work of Cage or Rauschenberg, respectively—depend for their signification on traditional music and painting. This dependence, which may from one perspective seem like a detriment, from another perspective yields great instrumental benefits, for it achieves two relat-ed and highly useful goals. First, negation avoids the recolonizing force of the oppositional—that which permits the opponent to solidify and suture through recourse to the excluded other. Second, negation operates as a closeted relation, mediating between the negating and the negated in such a way as to exclude all who are not already at the very least sympathetic to its case.

There is a remarkable symmetry between this analysis of the politics of negation and Derrida's notion of indecidability. Derrida has argued that the only exit from the binaries that structure and enable systems of knowing is through the use of what he called "indecidables." He named them indecidables because they operate like ball bearings in a binary system, overturning and negating first in this direction, then in that, so as to keep the binary itself from being reestablished. What makes something an indecidable is that it cannot be fitted into the totalizing oppositional economy of binarism. Indecidables do

not constitute or construct a third term in a traditional Hegelian dialectic, for that would only produce yet another binary logos. Instead they subject the binarism itself to scrutiny. This irritating resistance of indecidables to the polarizing either/or of our habitual epistemology is what makes them so effective in deconstruction.

I want to therefore substitute Derrida's term "indecidable" for Roth's "indifferent" as a way of restoring the particular political utility to this Cold War practice of negation. Fred Orton has elegantly defined indecidability as a strategic way "of using the only available language while not subscribing to its premises, a mode of operating according to the vocabulary of the very thing . . . " delimited.[37] The trope of negation is thus coterminous with the Derridian concept of indecidability; both depend on, and then negate, that which they oppose as the sole means of marking out their difference. Cage's silence, whether before the rowdy abstract expressionists at the Club or a formal concert hall audience, was just such an indecidable, dependent upon that which it sought to oppose—respectively, abstract expressionist aesthetic discourse and "music," among many other targets—in order to describe difference. In this context silence is a negation because an audience has gathered to hear something; of course in other audience contexts that would not necessarily be the case.

As with Cage's embrace of silence in his 1948 "Lecture on Nothing" at the Club, Rauschenberg, too, in his 1951 *White Paintings* chose silence as a means of refusal. When these paintings were finally exhibited in 1953, they were interpreted by critics as nihilistic, as a joke, as a Dada gesture, as, in Cage's words, "airports for light and shadow."[38] What wasn't noticed at the time was that these paintings are the absolute negation of abstract expressionism in terms of mood, surface, color; a silencing of abstract expressionism, if you will. The paintings are a sort of pure anti–abstract expressionism, and though of abstract expressionist scale, so without autographic or gestural content of any kind that Rauschenberg decreed they were to be painted by others, using a roller and housepaint.

The *White Paintings* thus ironically negated the broad outlines of the habitual abstract expressionist aesthetic universe. In this sense, the fact that these paintings were not discussed at the time as oppositional is evidence of their successful incorporation of a politics of oppositionality, for oppositionality here lies less in their legibility as acts of resistance than in their indecidable status. And they are indecidable because as absolute negations, there is nothing here, nothing *to* decide.

In this sense, they are absolutely indifferent, but that indifference in turn could, as was in fact the case, spark a wholesale reevaluation of hegemonic art practices.

In 1953, when the *White Paintings* were first exhibited in a gallery show, Cage wrote a statement in reaction to the controversy they engendered, amplifying their multiple negations: "To whom/ No subject/ No image/ No taste/ No object/ No beauty/ No talent/ No technique(no why)/ No idea/ No intention/ No art/ No feeling/ No black/ No white no (and)...."[39] In the face of the cascading litany of negations that these works initiated in him, Cage, like a Zen master, now found not terror but freedom and healing. Like Cage's so-called *Event #1* at Black Mountain College in 1952, in which the *White Paintings* had first been shown, these negations constituted an appeal to the observer for a new relationship to authority (in art and, surely, otherwise). This practice of negation engendered a conversion from a form of desire consonant with the structure of power and its imposition of meaning as literal and natural to a new form wherein " meaning" may be independently adjudicated by the viewer.[40]

Roth, on the other hand, reads this same early Cage text on the *White Paintings* as " . . . an unconscious tragic acknowledgement of total paralysis. The Aesthetic of Indifference had literally gone 'blank.'"[41] Our different readings here are, to some extent, my point. At Black Mountain, the *White Paintings* became, literally, screens for the projection of images made by others. And after *Event # 1* they continued in that capacity, as slowly their otherness to abstract expressionist discourse became more widely acknowledged. Indeed, no less a figure than Barnett Newman himself is reported by Harold Rosenberg to have said upon seeing these paintings, "Hmph he thinks it's easy. The point is to do it with paint."[42]

I am arguing that abstract expressionism and its traditionally modernist modality of a naturalized expressivity constituted the discourse of power that Rauschenberg was to negate so successfully in the *White Paintings*. As "expressivity" inaugurates a discursive relationship with the viewer premised on the transparency of its codes or signs within a presumptively shared cultural context, Rauschenberg, through his choice of negation, in turn made these codes opaque. In refusing this transparency, Rauschenberg not only refused complicity in this culturally mediated relation—which is to say, refused to be constructed as the discourse of power compelled—but moreover he seduced the observer away from this accustomed (and hence transparent) relation toward a new one. This new relationship was now no longer an artifact of power, for in

this "other" relation mediation was now wrested from the hands of authority. Indeed, in this new relation everything is otherness; there are no longer extant or available languages to translate experience into familiar (and complicit) forms. Torn from their moorings in the familiar, an audience may come to occupy an exegetical otherness we can term "queer," joining their author in a profound alienation from expectation.

Rauschenberg attempted to convince his one-time dealer to show the *White Paintings* by arguing, "It is completely irrelevant that I am making them—Today is their creator." His abdication of authority makes clear how self-conscious this attempt at decentering abstract expressionism's modernist voice really was. Not only did Rauschenberg disclaim responsibility, silencing his own authorial voice, he also, paradoxically, articulated his silencing. As in Cage's work, this is a *performative* silence, a manifestation of self-censorship within the context of expressionist discursive assumptions. These acts of negation are in fact restoratives, restoring individual cognition (as unauthorized a relation as exists) to an audience long used to yielding their autonomy to the artist.

Negation, such as that achieved through a silencing, requires an authoritative discourse (such as abstract expressionism) that has worked hard to make meaning appear continuous and seamless with its discursive functions. Through substituting silence for that authoritative discourse, a discursive opacity was foregrounded by Rauschenberg that moreover had the potential to reveal that all meaning is produced through the act of reading, most powerfully where it is most powerfully denied—as in the case of an authoritative discourse. Since silence has no meaning except as mediated, the same silence can be at one and the same moment refusal, negation, and emptiness, as well as openness, light, possibility, and plenitude, depending on the observer/audience. Thus mediating a silence is unmistakably underscored as an act of mediation (since a silence clearly "says" nothing in and of itself). Silence thus effectively interrupts the "transparent" authoritative relations of meaning-making without recourse to oppositionality.

Such divergent and often opposing meanings of silence were Rauschenberg's allies in these paintings; blank canvases are perhaps the ultimate indecidables in art. But in calling forth the act of reading, any potential for expression, abstract or otherwise, was forever foreclosed, replaced—and it is hardly as inspiring—by the numbing randomness of a multiplicity of individual mediations by a number of individual observers.

This epistemic shift away from a singular, authoritative form of knowing or meaning is perhaps best characterized in 1970 by yet another Frenchman, the gay critic Michel Foucault : "To all those who still wish to talk about man, about his reign or liberation, to all those who still ask themselves questions about what man is in his essence, to all those who wish to take him as their starting-point in their attempts to reach the truth, . . . to all these warped and twisted forms of reflection we can answer only with a philosophical laugh—which means, to a certain extent, a silent one."[44]

Well before Foucault wrote these famous words, Rauschenberg painted his empty *White Paintings*, Cage made music of silence and Johns offered an object that "Does not talk of itself. Tells of others" This negating laugh is Duchamp's, and Cage's, and Rauschenberg's, and Johns's. A laugh such as this—silent and philosophical—registers complexities. It is considered and dissident, powerfully resistant and hardly indifferent.

# part two

INTERVIEWS BY ROTH
ABOUT MARCEL DUCHAMP, 1973

"John Cage on Marcel Duchamp: An Interview" was originally published in *ART IN AMERICA*, Brant Publications, Inc., 61, no. 6 (November–December 1973): 72–79

An interview, coauthored with William Roth, in which Cage talks fondly about his encounters with Duchamp, and his understanding of him.

# john cage on marcel duchamp
## an interview

# moira roth
# and
# william roth

**When did you first meet Marcel Duchamp?**

I met him in the early forties. But I didn't know him except to see him now and then. I didn't want to bother him with my friendship. Then, towards the end of the forties, I wrote the music for his sequence in *Dreams That Money Can Buy.*[1] Afterwards I ran into him on MacDougal Street. He had heard the music and liked it. Then I met him later when he was with Mary Reynolds.[2] The conversation turned toward dope. Someone in the group asked whether he thought that dope was a future problem. He said he didn't think so; it would never be any more serious than the drinking of liqueurs. Marcel took very little alcohol or food; he would simply eat what was given him. No one gave him a lot because everyone knew he didn't eat very much—two or three peas and one bit of meat. But he did smoke cigars.

**Did he seem to change much during the time you knew him?**

No, I would say not.

**So becoming more celebrated in the 1960s didn't affect him?**

He must have enjoyed it. When I wrote *A Year From Monday*,[3] I told him I had written about him, but hadn't wanted to bother him with it before the book was published. He said rather plaintively, "But I would have enjoyed it."

**Did he say anything about it when it was published?**

Very little. I think I asked him once what he thought of the text that has his name in the title, and he indicated that he liked it. But then he was very nice about everything, including what Arturo Schwarz wrote about him.[4] Marcel's attitude was that Schwarz's book wasn't about *him*; it was *by* Schwarz.

**Do you feel it doesn't matter what people say about you?**

Of course it doesn't matter. Because it is their action at that point. I learned very early to pay no attention to criticism. A review of a concert I gave in Seattle was to the effect that the whole thing was ridiculous. I knew perfectly well it wasn't. Therefore, the criticism was of no interest. In fact, it taught me that if people like what I am doing, I should look out. It's important that I live as I did before society became involved in what I am doing.

**Do you resent society?**

I think society is one of the greatest impediments an artist can possibly have. I rather think that Duchamp concurred with this view. When I was young and needed help, society wouldn't give it, because it had no confidence in what I was doing. But when, through my perseverance, society took an interest, then it wanted me not to do the next thing, but to repeat what I had done before. At every point society acts to keep you from doing what you have to do.

**When you say society, you don't mean an audience?**

I'm objecting to society as an audience. But I like society as what you might call an ecological fact.

**So you are deeply concerned with people and unconcerned with the audience. You want the audience to turn into people.**

I'm out to blur the distinctions between art and life, as I think Duchamp was. And between teacher and student. And between performer and audience, etcetera.

**Do you think of yourself as teaching?**

I like to think of myself as either having graduated or as going on studying, and I like to think of the music that interests me as being "after school." In other words, having no message in it; not teaching but rather celebrating. Or as Duchamp might have said—cerebrating.

**Do you think Duchamp had no message?**

He was interested in ideas; they recur and permit, with regard to his work, a certain scholarship. This is true of Jasper Johns also.

**Do you think you need a lot of scholarship to see Duchamp's work?**

I don't feel I need much scholarship to enjoy Duchamp as I enjoy him.

**How do you enjoy him?**

The way I do. Whether the way I enjoy him is the same way he intended, I have no way of knowing. I could have asked questions about that, but didn't.

**Because you weren't interested?**

No, no. I didn't want to disturb him with questions. Suppose he had not been disturbed by some question I had asked, and had answered it. I would then have had his answer rather than my experience. Furthermore, he left the door open by saying that observers complete works of art themselves. Nevertheless, there is still something hermetic or inscrutable about his work. It suggests scholarship, questions and answers from the source. I spoke to Teeny Duchamp once about this. I said, "You know, I understand very little about Marcel's work. Much of it remains very mysterious to me." And she said, "It does to me, too."

**What questions come to mind when you think about Duchamp?**

The things I think about him don't lead me to ask questions, but rather to experience his work or my life. At a Dada exhibition in Dusseldorf, I was impressed that though Schwitters and Picabia and the others had all become artists with the passing of time, Duchamp's works remained unacceptable as art. And, in fact, as you look from Duchamp to the light fixture (pointing in the room) the first thought you have is, "Well, that's a Duchamp." That's what I think, and that doesn't lead me to ask any questions. It leads me to the enjoyment of my life. If I were going to ask a question, it would be one I really didn't want to know the answer to. "What did you have in mind when you did such and such?" is not an interesting question, because then I have his mind rather than my own to deal with. I am continually amazed at the liveliness of his mind, at the connections he made that others hadn't, and so on, and at his interest in puns.

**Would he pun when you talked to him?**

He tried to every now and then. He liked it in conversation. He was very serious about being amused, and the atmosphere around him was always one of entertainment.

**Would he talk to you about your work?**

We really never talked about his work or my work.

**He talked mainly about chess and food?**

And the people we knew. I was very careful to do that. If, for instance, you go to Paris and spend your time as a tourist going to the famous places, I've always had a feeling you would learn nothing about Paris. The best way to learn about Paris would be to have no intention of learning anything and simply to live there as though you were a Frenchman. And no Frenchman would dream of going to, say, Notre Dame.

**So you managed to do that with Duchamp, live in Paris and not sight-see?**

That was my intention; to be with him as often as circumstances permitted and to let things happen rather than to make them happen. This is also an oriental notion. Meister Eckhardt says we are made perfect not by what we do, but by what happens to us. So we get to know Marcel not by asking him questions, but by being with him.

**What happened when you played chess?**

I rarely did, because he played so well and I played so poorly. So I played with Teeny, who also played much better than I. Marcel would glance at our game every now and then, and in between take a nap. He would say how stupid we both were. Every now and then he would get very impatient with me. He complained that I didn't seem to want to win. Actually, I was so delighted to be with him that the notion of winning was beside the point. When we played, he would give me a knight in advance. He was extremely intelligent and he almost always won. None of the people around us was as good a player as he, though there was one man who, once in a blue moon, would win. In trying to teach me how to play, Marcel said something which again is very oriental, "Don't just play your side of the game, play both sides." I tried to, but I was more impressed with what he said than I was able to follow it.

**He taught like a Zen master?**

I asked him once or twice, "Haven't you had some direct connection with oriental thought?" And he always said no. In Zen, the student comes to the teacher, asks a question, gets no reply. Asks a second and third time, but no reply. Finally he goes off to another part of the forest, builds himself a house, and three years later runs back to the teacher and says, "Thank you." Well, I heard recently that a man came to Marcel with a problem he hoped Marcel would solve. Marcel said absolutely nothing. After a while the problem disappeared and the man went away. It's the same teaching method as the oriental one, and it's hard to find examples of it in the West.

**So he got it from himself?**

There weren't any specific oriental sources. But there may have been other sources we'd have to know thoroughly in order to decide whether they had any connection with the Orient—Emerson, or Thoreau, who said yes and no are lies, or Schopenhauer, who said that the highest use of the will is the denial of the will. The only true answer is that which sets all well afloat, so to speak, free of one's likes or dislikes. Duchamp says he wants to make a readymade to which he is completely indifferent. That's the same idea. Now in his case, it didn't come from the Orient directly, but perhaps indirectly.

**So that was one reason you felt close to Duchamp?**

Well, I always admired his work, and once I got involved with chance operations, I realized he had been involved with them, not only in art but also in music, fifty years before I was. When I pointed this out to him, Marcel said, "I suppose I was fifty years ahead of my time."

**Was there any difference between his idea of chance and yours?**

Oh, yes. I hear from people who have studied his work that he often carefully chose the simplest method. In the case of the *Musical Erratum*,[5] he simply put the notes in a hat and then pulled them out. I wouldn't be satisfied with that kind of chance operation in my work, though I am delighted with it in Marcel's. There are too many things that could happen that don't interest me, such as pieces of paper sticking together and the act of shaking the hat. It simply doesn't appeal to me. I was born in a different month than Marcel. I enjoy details and like things to be more complicated.

**Duchamp wasn't uncomplicated though?**

He was less complicated than someone else doing the same thing would have been. I think the difference between our attitudes to chance probably came from the fact that he was involved with ideas through seeing, and I was involved through hearing. I try to become aware of more and more aspects of a situation in order to subject them all individually to chance operations. So I would be able to set a process going which was not related to anything I had experienced before. In the case of Duchamp—and Johns and others—there is something closer to the development of a language which the person is learning to speak. So in both Johns and Duchamp things recur. He would like us to believe, I think, that the *Etant Donnés* is a translation of the *Large Glass*—the same work restated in a way which is very uncomfortable for us, because we had grown to like the transparency for one thing. In *Etant Donné* he does the exact opposite, imprisoning us at a particular distance and removing the freedom we had so enjoyed in the *Large Glass*.

**Etant Donnés was his last work. Did you know about it?**

Oh, no! The only thing he said in the last years, and it was almost like a refrain in his conversation, was that he thought it would be interesting if artists would prescribe the distances from which their work should be viewed. He didn't understand why artists were so willing to have their works seen from any position. Of course, he was referring to the *Etant Donnés*, without my knowing that the work existed.[6] He had two studios in New York, the one people knew about, and one next door to it, where he did his work, which no one knew about. That's why people were able to visit his studio and see nothing going on. As he expressed it later, it was a way of going underground.

I am very impressed with his craftsmanship. I recently saw a show by Picabia, who was so close to Duchamp. But though it was a large show, very few paintings were well made, or as beautifully made as a Duchamp. There are no Duchamps which are made poorly. He spoke of the function of the artist as that of an artisan, someone who made things.

**How does that go with the idea of letting things happen?**

Well, I would say it would keep one from *just* letting things happen. When he did notice things that had already happened, as in the readymades, he was extremely cautious. He didn't do what we have since done—extend the notion of the

readymades to everything. He was very precise, very disciplined. It must have been a very difficult thing for him to make a readymade, to come to that decision. But then later in life, while he was making the *Etant Donnés,* he would sign anything that anyone asked him to.

### Why did he change?

I think he thought other people were being just a little bit foolish. I hesitate to say that, because he did it in such good spirits. The only thing I ever asked him to sign (and I asked him to do so twice because of the circumstances) was a membership card. I had become a member of the Czechoslovakian Mushroom Society, and when I received my membership card—there were various signatures—I thought what a pleasure it would be to have Marcel's signature too. And so I gave it to him; it amused him and he signed it immediately and very beautifully. By beautifully, I mean in an interesting place. It looked as though he was one of the Czechs. Then, to raise money for the Foundation for Contemporary Performing Arts, I was able to sell the card for five hundred dollars to increase our fund. I regretted selling it, of course. But in the mail, the very same day that it was sold, came next year's membership card. I was delighted. I pointed this coincidence out to Marcel and he said, "There's no problem; I'll sign it, too."

### Why did he allow the expensive edition of the readymades done by Schwarz?

In an interview late in life, an interviewer asked the same question: "Why did you permit that, because it looks like business rather than art," and so forth. Marcel admitted it could be so interpreted, but it didn't disturb him. He was extremely interested in money. At the same time, he never really used his art to make money. And yet he lived in a period when artists were making enormous amounts of money. He couldn't understand how they did it. I think he thought of himself as a poor businessman. These late activities were like business. The *Valise* is the rather feeble attempt of a small businessman who tries to act in a businesslike way in a capitalist society, who had an idea of how to make a small company, but has no notion of how to become a big corporation. He couldn't understand why, for instance, Rauschenberg and Johns should make so much money and why he should not. But then he took an entirely different life role, so to speak. He never took a job. Both Rauschenberg and Johns, before their paintings were accepted, worked in the field of advertising. Duchamp never did any work. He viewed the bourgeois business of having a job and making money and so forth as a waste of time.

**Is it too personal to ask how he lived, if he didn't work?**

It would be too personal of me to answer the question. Let me simply mention that at the beginning of the dialogues with Cabanne[7] he says that his life has always been extremely pleasant and that it became more and more so as time went on.

**Is that true of your life?**

I was brought up to worry. I am very good at worrying. I think if left to myself I wouldn't have much to worry about, but I manage to connect myself with many other people whose problems worry me. I'm very worried, for instance, about the Merce Cunningham Dance Company, because it seems to be almost impossible to make a physical situation which is reasonable and comfortable for so many people and to make it work economically.

**Did Duchamp also worry about people he loved?**

He didn't give that impression. The only time he disturbed me was once when he got cross with me for not winning a game of chess. It was a game I might have won; then I made a foolish move and he was furious. Really angry. He said, "Don't you ever want to win?" He was so cross that he walked out of the room, and I felt as though I had made a mistake in deciding to be with him—we were in a small Spanish town—if he was going to get so angry with me.

**He couldn't understand that you wouldn't care about winning?**

He thought it was stupid, absolutely stupid. That night I could hardly sleep. And the next day he was just bubbling over with friendship. I think he had discussed the matter with Teeny, and she had seen that I had been very hurt and had explained this to Marcel. And then he went out of his way to be friendly.

**Did you subscribe to the belief that he had stopped working?**

He never stopped working. He was working constantly all the time he led us to believe that he wasn't working. And he did just what he had done with the *Large Glass*; he made a large work and a number of offshoots from it. He did two works that it was peculiar to see him doing at the time. But now that I come to think of them, they were very closely related to the *Etant Donnés*. One was a windbreak. He had an apartment in Cadaqués with a terrace outside from which

you could look down and see the bay. But the wind, when it came from the hills, was very unpleasant. So he designed and constructed a very ingenious method of breaking the wind with glass and wood. It was difficult to get it to hold against the wind because there was no material to which it could be attached. That kind of problem is no different from those he had to solve in *Etant Donnés*. Then another thing, which was even more peculiar, was his decision to put in a fireplace (when they moved from one apartment to another). He designed the fireplace very carefully. It was extremely uninteresting looking, but it was very detailed and exactly made, and he was delighted when the fireplace was finished. It's not essentially a different project than the stone wall of *Etant Donnés*, which is absolutely boring. In other words, he continued his work until the end. All he did was go underground. He didn't wish to be disturbed when he was working, so he didn't want anyone to know he was working. And none of us, at the time, connected the fireplace or the windbreak with art.

**He made a real distinction between his life as craftsman and artist and his social life?**
Yes, you might say that.

**But isn't a readymade supposed to make you feel that this kind of distinction doesn't exist?**
I would say so. I rather think, though, when we think of the readymades, we think of something other than what Duchamp thought of. I'm not sure if my experience is the same as his. Anything I look at is a Duchamp, just anything. I wouldn't say, as he did, that I must be indifferent to it to begin with.

**Is the impression of Duchamp saying art and life are one really obtained through people like you?**
Yes, but if you put that with the last work, what do you come up with? We have gotten from Duchamp this concern which interests us more than anything else: the blurring of the distinction between art and life. I would say this is true of Rauschenberg and myself more than of Johns. And in this sense, Johns may be closer to Duchamp than Rauschenberg and myself. Because *Etant Donnés* doesn't have any of that fusion of art and life. It has, rather, the most exact separation.

**Do you think it is a mistake to see people like yourself and Rauschenberg as the logical heirs of Duchamp's notion of blurring art and life?**

I think that if you observe something, and then want to make connections between work now and some other work that preceded it, you can make—if you are clever—any connections you want.

**Did you learn anything about the blurring of art and life from Duchamp? Was it all there before you met him?**

These are very difficult questions to answer. He is one of the artists whom I admire the most, and whom I had the privilege of getting to know. Another one whom I admired very much was Mondrian, whom I met but didn't know very well. Then in the late forties, I became involved in oriental thought, and in 1960 I collected my writings under the title *Silence*.[8] However, in a recent book which has my name as title, edited by Richard Kostelanetz,[9] you see me in high school at the age of fourteen proposing that the best thing that could happen to the United States in a world sense would be to become silent. That was before I knew anything about Duchamp.

**Do you think your idea of silence has anything in common with Duchamp's?**

Looking at the *Large Glass,* the thing that I like so much is that I can focus my attention wherever I wish. It helps me to blur the distinction between art and life and produces a kind of silence in the work itself. There is nothing in it that requires me to look in one place or another or, in fact, requires me to look at all. I can look through it to the world beyond. Well, this is, of course, the reverse in *Etant Donnés.* I can only see what Duchamp permits me to see. The *Large Glass* changes with the light and he was aware of this. So does a Mondrian. So does any painting. But *Etant Donnés* doesn't change because it is all prescribed. So he's telling us something that we perhaps haven't yet learned, when we speak as we do so glibly of the blurring of the distinction between art and life. Or perhaps he's bringing us back to Thoreau: yes and no are lies. Or keeping the distinction, he may be saying neither one is true. The only true answer is that which will let us have both of these.

**Duchamp seems so much less physical in his art than you do.**

A contradiction between Marcel and myself is that he spoke constantly against the retinal aspects of art, whereas I have insisted upon the physicality of sound

and the activity of listening. You could say I was saying the opposite of what he was saying. And yet I felt so much in accord with everything he was doing that I developed the notion that the reverse is true of music as is true of the visual arts. In other words, what was needed in art when he came along was not being physical about seeing, and what was needed in music when I came along was the necessity of being physical about hearing. However, with *Etant Donnés*, we feel his work very physically, not abstractly, and in a way which can be deeply felt. Music is more complex, I think, than painting, and that's why chance operations in music are just naturally more complicated than they would be for painting. There are more questions to ask about a piece of music than there are about a painting.

**Would he come to hear your concerts?**
I wouldn't ask him. If he came, that was his concern, but I don't think he particularly enjoyed music. He and Teeny performed with me in the chess piece in Toronto.[10] I turned to him during the performance. I said, "Aren't these strange sounds?" He smiled and said, "To say the least." The game I played with him, he won quite quickly; then I played with Teeny and he stayed on the stage. The game went on and on; finally about eleven-thirty we looked up and everyone in the audience had left. We continued the game the next morning in the hotel. I lost.

I don't feel in Duchamp any interest in events that are not interesting. What interested him were connections he had not previously noticed or puns that made things glance off in curious directions. He wasn't interested in some elementary aspect of chess. What interested him were the elaborate details. He wrote a fabulous book on the end game. The end game which he chose was simply that with the kings and a few pawns. He made a most elaborate study of this and never tired of trying to explain it to you. It was so complex I never did understand it, even though he gave me the book. When I asked him to write something in it, he wrote: "Dear John, Look out! Another poisonous mushroom."

Our ideas of blurring the distinctions between art and life have led in some instances to works that turn us stupid. But not even children are stupid. I've read that four-year-old children are capable of learning several languages and inventing new ones. Inventing a new language is precisely what would have interested Marcel. We ought to use our ideas not in order to coddle ourselves as though we were infants who hadn't even learned a single language, but in order to stretch ourselves to the limits, both in art and in life.

**Did Duchamp ever talk to you about problems aside from art?**

Yes, he did. And quite early in the century he proposed the use of private cars for public transportation—people driving cars wherever they liked and just leaving them; other people would take the same cars and drive on. He was opposed to politics. He was opposed to religion as is Zen. He was for sex and for humor. He was opposed to private property. There is a lovely story about this. Before he married Teeny, he went to visit her on Long Island. Bernard Monnier, her future son-in-law, went to meet Marcel at the station. He said. "Where is your luggage?" Marcel reached into his overcoat pocket and took out his toothbrush and said. "This is my *robe de chambre.*" Then he showed Bernard that he was wearing three shirts, one on top of the other. He had come a for a long weekend.

**He must have been a beautiful friend.**

Oh yes. His death was a great loss. I notice that Teeny even now frequently uses the present tense with regard to him. She says, "We do this," or "We don't do that," or "Marcel and I always do this."

I can tell you another story about him. Once we were in Cadaqués and we were invited to lunch on a little island off the mainland—just a hop, skip and a jump off the mainland. The hostess was a mediocre painter, but she and her husband owned the island and they were Spanish. Marcel didn't always accept invitations; he was quite choosy about ones he would accept. But he was always willing to go to this house. Well, I had been told the lady was a painter, but there were no paintings on the walls. We had lunch in this bare-walled room, and afterwards she asked us if we would look at her paintings. She brought them out of the closet, one after another, and put them against the bare wall. I kept wondering what Marcel was going to say, because the paintings were all hideous. I knew he wouldn't say they were hideous, but I just didn't know what he would do. After seeing quite a number, he said, "You should hang them on the wall," and she said she couldn't stand to look at them, and then he said nothing.

He was friendly with Dali. Isn't that strange? Dali lived in Cadaqués, and if you go into a stationery shop or a post office there, there are postcards showing Dali's house and portraits of him and so on. There were never any postcards of Marcel, to my taste a vastly superior artist and man. The first year I went to Cadaqués, Marcel asked me whether I would like to meet Dali, and I said I would rather not. And so he didn't press the matter. Then, another year, he asked me again, and said he thought I should whether I wanted to or not. So we all drove

over to Dali's, and I was astonished to see that Marcel took a listening attitude in the presence of Dali. It almost appeared as if a younger man were visiting an old man, whereas the case was the other way around. Dali, of course, talks all the time, and wants to show what he's doing—absolutely the reverse of Marcel.

**He doesn't have a hidden studio?**
No, no, he has enormous vulgar paintings. Marcel went in and admired them. There were several other occasions when I was together with Dali and Duchamp, and then, after Duchamp's death, with Dali alone. I haven't changed my mind radically about Dali, but I notice that there is something in his eyes which is very convincing, a very undisturbed honesty in the man, something I had not expected.

**And that's what Duchamp saw?**
I don't know, but I was looking for something that I could see. An edition of the dialogues with Cabanne has been published here.[11] Unfortunately, it is very poorly translated; it includes a ridiculous preface by Dali. At least I find it so. A preface that has the effect of drawing attention to Dali, rather than to Marcel, and yet Marcel in the presence of Dali always sent the attention to Dali. That's an oriental action of self-effacement. Over and over again, at most any point. I find correspondence between Duchamp and the Orient.

**"Robert Smithson on Duchamp: An Interview,"** *Artforum* 12, no. 2 (October 1973): 47

An interview in which Smithson talks about his criticism of Duchamp and Duchamp's negative influence on American art.

# robert smithson
# on duchamp
## an interview

## moira roth

*THIS INTERVIEW WAS TAPED SHORTLY before Robert Smithson's tragic death in an aircraft accident, before the artist had an opportunity to revise or edit his spontaneous views. However, the interview as it stands is characteristic of Smithson's independence of outlook.*

**Why did you say you were interested in talking about Duchamp?**

Well, for one thing, I think in America we have a certain view of art history that comes down to us from the Armory Show, and Duchamp had a lot to do with that history. There is a whole lineage of artists coming out of the Armory Show. And the notion of art history itself is so animated by Duchamp. The prewar period was dominated by Matisse and Picasso and the post–World War II period was dominated by Duchamp. Hard-core modernism is Picasso and Matisse and T. S. Eliot and Ezra Pound. Then, in the postwar period, we get Duchamp coming on very strong. Duchamp is really more in line with postmodernism insofar as he is very knowledgeable about the modernist traditions but disdains them. So, I think there is a kind of false view of art history, an attempt to set up a lineage. And I would like to step outside that situation.

There has been a kind of Duchampitis recently, beginning with Duchamp's being rediscovered in Jasper Johns. But Johns is less French and more ratty, you might say. Johns has taken the aristocratic stance and given it a more sordid edge. Then you have this influence pervading Robert Morris's work. But there is no viable dialectic in Duchamp because he is only trading on the alienated object and bestowing on this object a kind of mystification. Duchamp is involved with the notion of manufacture of objects so that he can have his little valise full of souvenirs I am not really interested in that kind of model making: the reiteration of the readymades. What I am saying is that Duchamp offers a sanctification for alienated objects, so you get a generation of manufactured goods. It is a complete denial of the work process and it is very mechanical too. A lot of pop art has to do with this—the transcending in the readymades. In a sense, Rosenquist is transcending billboards, Warhol is transcending canned goods, and Jim Dine is transcending tools that you buy in hardware stores—Duchamp's influence is quite pervasive on that level. Duchamp is trying to transcend production itself in the readymades when he takes an object out of the manufacturing process and then isolates it. He has a certain contempt for the work process and here I think he is sort of playing the aristocrat. It seems that this has had a great deal of effect on New York artists.

**Do you think of him as a dandy in a Baudelairean sense?**
Yes, I think there is some of that. I think that it has always had a certain appeal because the artist to a certain extent is always trying to transcend his class, and I think Duchamp is involved in that. At one point, he even said that he would rather kings were patrons, so that he indicated that he considered art fascistic.

**You said there was no viable dialectic in Duchamp; is there one in your work?**
Yes, I think so. In my early works I was not really minimal; the works were more related to crystallized notions about abstraction. So there was a tendency toward abstraction, but I never thought of isolating my objects in any particular way. Gradually, more and more, I have come to see their relationship to the outside world, and finally when I started making the *Nonsites,* the dialectic became very strong. These *Nonsites* became maps that pointed to sites in the world outside the gallery, and a dialectical view began to subsume a purist, abstract tendency.

I don't think Duchamp had a dialectical view. In other words, I am saying that his objects are just like relics, relics of the saints or something like that. It seems that he was into some kind of spiritual pursuit that involved the commonplace. He was a spiritualist of Woolworth, you might say. He seemed dissatisfied with painting or what is called high art. Somebody like Clement Greenberg is opting for high art or modernism from a more orthodox point of view, but Duchamp seems to want to be playful with that modernism. He doesn't see it as absolute. It is like a mechanistic view. He also strikes me as Cartesian in that respect, and I think he once mentioned in an offhand way that he was. Duchamp seems involved in that tradition and in all the problems of that tradition.

Duchamp was suspicious of this whole notion of mechanism, but he was using it all the time. I don't happen to have a mechanistic view of the world so I really can't accept Duchamp in terms of my own development. There is a great difference between a dialectical view and a mechanistic view. Andy Warhol saying that he wants to be a machine is this linear and Cartesian attitude developed on a simple level. And I just don't find it very productive. It leads to a kind of Cartesian abyss.

Duchamp's involvement with da Vinci—his putting a moustache on the *Mona Lisa*—seems to be an attempt to transcend another artist who is very close to his view. They both have mechanistic ideas of nature. But in Duchamp's mechanistic view, there is nothing pragmatic or useful in the way there was with da Vinci. In Duchamp, it leads to a kind of Raymond Roussel. Of course, Duchamp was influenced by Roussel and it is more or less taking the mechanistic view to an almost fantasy level. Take *The Large Glass,* which seems to be an attempt to try and mechanize the sex act in what you would call a witty way.

Conceptual art too is to a certain extent somewhat mechanistic though the whole conceptual situation seems rather lightweight compared to Duchamp. Sol LeWitt coined the term "conceptual" and Sol LeWitt says ideas are machines. So this mechanistic view permeates everything. And it seems that it is just reducing itself down to a kind of atrophied state. A lot of it just evolves into what Mel Bochner might call joke art; playing little jokes like the Dadaists. But you see, the Dadaists were setting up their own religion, thinking that everything was corrupted by commercialism, industry, and bourgeois attitudes. I think it is time that we realized that there is no point in trying to transcend those realms. Industry, commercialism, and the bourgeoisie are very much with us. And this whole notion of trying to form a cult that transcends all this

strikes me as a kind of religion in drag. I am just bored with it, frankly. In that there is a kind of latent spiritualism at work in just about all of modernism. There is the guilt even about being an artist. To return to Duchamp, at bottom I see Duchamp as a kind of priest of a certain sort. He was turning a urinal into a baptismal font. My view is more democratic and that is why the pose of priest-aristocrat that Duchamp takes on strikes me as reactionary.

**You said you sometimes talked with Carl Andre about Duchamp?**
Yes, Andre's view is more a Marxist one. Andre himself seems to want to transcend the bourgeois order, and Carl more or less sees Duchamp as responsible for the proliferation of multiples and this sort of thing. Where I tend to agree with Andre is when he says that Duchamp is involved in exchange and not use value. In other words, a readymade doesn't offer any kind of engagement. Once again it is the alienated relic of our modern postindustrial society. But he is just using manufactured goods, transforming them into gold and mystifying them. That is where alchemy would come in. But I see no reason to extrapolate that in terms of the arcane language of the Cabala.

**Then you are not interested in the occult interpretations of Duchamp by Jack Burnham and Arturo Schwarz?**
I am just not interested in the occult. Those kinds of systems are just dream worlds and they are fiction at their best and at worst, they are uninteresting. By the way, I met Duchamp once in 1963 at the Cordier-Ekstrom Gallery. I just said one thing to him, I said, "I see you are into alchemy." And he said, "Yes."

**How do you feel about Duchamp's chess playing?**
Well, it has aristocratic connotations. It is also a luxury that I wouldn't really be too inclined to pursue myself, anymore than I would want to sit around and play Monopoly.

**What do you think Duchamp's attitude toward America was?**
I think Duchamp is amused by a certain kind of American naïveté, and he constantly makes references to certain functional aspects, like the statement about his being impressed by American plumbing and that sort of thing. That seems to me a kind of inverted snobbism. And I find his wit sort of transparently French. French wit seems to me very different from an English sense of humor.

If the French have any wit at all, I don't really appreciate it. They always seem very laborious, opaque, and humorless so that when you get somebody like Duchamp who is putting forth the whole art notion of the amusing physics or the gay mathematics, or whatever you want to call it, I am not amused. It is a kind of Voltairean sarcasm at best.

## Unpublished Interviews with Vito Acconci and George Segal about Marcel Duchamp

Between 1971 and 1973, I conducted some forty interviews and exchanges with contemporary artists and critics in the United States concerning their reactions to Duchamp.[1] These interviews were a primary aspect of my dissertation research for "Marcel Duchamp and America, 1913–1973," (University of California, Berkeley, 1974). At the time, I published three of them—the two with John Cage and Robert Smithson that are reprinted in this book, and one with Ivan Karp.[2] In early 1973, I spent a month or so in New York in order to interview artists and critics on the East Coast, including Vito Acconci and George Segal. Both of these interviews are published here for the first time.

# interview with vito acconci
## january 31, 1973, new york city

# moira roth

**You said you felt forced to do homage to Duchamp.**

Yes. Since it has been assumed that Duchamp has established the context in which everyone is working, it is like being forced to answer questions about the boss. It's very strange. When I say forced, I don't really mean being forced by you, but almost that each person is forced to acknowledge, finally, the position that he has found himself in over the past few years and is now going to talk about—

**The boss?**

Yes, and even worse than that—talk about something he is stuck in, a kind of mire. I guess I have always felt in a funny relation to Duchamp, because so much of Duchamp seems about the end of something. He has established himself as a kind of almost snob figure, whose work talks about the future state of art—everyone who comes into that future has to have him as a skeleton in the closet. Not so much a father figure, but almost a kind of snicker. A snicker you can't avoid, that you are born with—a kind of Duchamp twitch. Practically every book you see on Duchamp has more pictures of him than of his work; one thinks of Duchamp in terms of photographs of him, for example, playing chess with a nude. There is an establishment of a facial and body image of

Duchamp, and on the surface of that image is a kind of dandy. So much of Duchamp's achievement seems to be that he set himself up as a final image, not a working model that should be discarded or changed by future use. The Duchamp image can't be discarded.

**Who did the setting up?**

I think he did this even more than his critics. Not Jasper Johns, however, because if anything, he seemed to have retooled Duchamp back into a kind of working artist. What probably interests me the most about Duchamp is his sneak value—the "I am not doing art, yet here is a piece." Johns could rework Duchamp more directly than I could, because Johns and Duchamp are both concerned in their work with points of things rather than the whole space.

**Does Duchamp require gallery space as opposed to studio space?**

Yes, he definitely needs exhibition space more than working space—or rather the exhibition space *becomes* his working space. That's not true for me, as exhibition space is a kind of field, every corner of which has to be examined in regard to my person, whereas for Duchamp, exhibition space is a kind of pedestal space.

But that last piece (which I saw for maybe only three minutes) really interests me. Before I saw the piece [the *Etant Donnés*] I had made a decision that I wasn't going to spend any more time delving into Duchamp. But the relationship of that piece to everything else seems so unclear to me. That's why I could feel tremendously interested in it, but also, that may be only because I haven't really examined it. It seems to be set up as an old man's piece, consciously designed as a sort of last novel.

**Do you often think about Duchamp in terms of novels or language?**

No. I think more of Duchamp in terms of showing and display.

**Are you drawn to *The Large Glass*?**

*The Green Box* notes constantly interest me, and I used to read them a lot, but *The Large Glass* itself is out of my realm. It is concerned with a kind of mythifying—with establishing worlds and myths—and I thought I wasn't involved with that at all.

**And now you are concerned with this?**
When I stopped writing, I decided I wasn't interested in metaphor anymore. But lately, I have become more concerned with metaphor and things like mood—words that I never would have used a year ago. And it seems to me that *The Large Glass* is also about such things, about a sort of subjunctive mood in language—notions like "might" and "would," rather than the kind of indicative statement mood of the readymades. *The Green Box* notes seem less finished than the rest of Duchamp.

**How does the secretive side of Duchamp relate to this notion of finish?**
Something secret doesn't seem necessarily the opposite of something finished. For something to be secret almost implies that something is finished but not yet revealed—that you must search for it. In other words, it is the viewer's work that isn't finished. I guess I think of Duchamp as very controlled.

**Does it interest you that Duchamp was a European living in New York?**
Yes. If he had had only a European space, that would have meant too much of a context. This way, it is appropriate that he loosens his context and becomes a rarefied person. I often wonder why I haven't come across anyone talking about that nonspatial emphasis in Duchamp. Is it something that just I am picking out? It seems so clear to me, and at this point also so important.

**How do you feel about Duchamp's art dealings?**
It is appropriate that he chose Brancusi rather than someone else, as much of Duchamp's work is also concerned with gallery exhibition display. He can remain pure and rarefied as an artist, but have solid ground as an art dealer— dealing in Brancusi, who is himself pretty pure and rarefied.

**When did you first encounter Duchamp's work?**
I don't remember when I first heard about him, but I thought about him most during the transition phase between my poetry and later stuff.

**Didn't that make him a working model for you?**
Yes, because I was coming then from a context where I was trying to concern

myself with words as points, so Duchamp meant a lot to me. Also, I was obviously troubled about where I was, what my context was, and Duchamp really interested me because of such questions of context.

**What about Duchamp's body fragments?**
That is a part of Duchamp that I never really examined very closely. I almost refused to believe they were there.

**Does that include Rrose Sélavy?**
She was a definite concern of mine — not really for any transformational or sexual reasons, but because of the wordplay.

**But isn't Rrose Sélavy to do with transformations, and don't you deal with that too?**
You seem to want to put me in this position of the self-reliant American! Duchamp's transformational interest in Rrose Sélavy has more to do with switching labels than switching processes.

**Do you switch processes?**
Well, probably not, but the desire is there. I always get the feeling in Duchamp of a really finished and fixed essence, yet around it is this veneer of changes, transformations, and floatings. But there is the hidden essence, beautifully formed and beautifully fixed, and that fascinates me at the same time that I feel really alienated from it. What is fixed seems to be that Rrose Sélavy doesn't really matter that much.

**Because she only had a studio life, so to speak?**
Yes, she is a kind of window display—although that sounds more disparaging than I mean. But in a way that makes it very different from what I could feel concerned with.

**Do you see yourself as a future Duchamp?**
[*Laughter*] I like that question. I do like that question because it is so pointed and malicious.

**Given that you see Duchamp contriving his own myth, do you think of myth-making yourself?**

Sure. I guess I do, although I would at the same time claim all sorts of nonmyths. Duchamp's myth is involved with a kind of dandy who has secrets, but obviously at this time, such a myth no longer has any force. The myth that I would be interested in developing would have to allow drifts into different kinds of persons. But whatever myth I am building doesn't have to do with the 1970s. Whatever myth I am building seems to have to do much more with obsessiveness, a kind of last gasp, a frantic kind of apocalyptic 1960s quality, like Dylan, and that kind of thing.

# interview with george segal
## february 26, 1973, east brunswick, new jersey

# moira roth

**Did you meet Duchamp?**

I knew him mostly as a legend and myth. I met him once long after I had start-
ed doing my own sculpture, when Bill Copley invited both of us to his house for
dinner—it was shortly after the New York blackout and we spent all our time
talking about that.

Duchamp was quite important to me. Recently Hilton Kramer wrote an arti-
cle about the death of the avant-garde and portrayed Duchamp as the destructive
villain, but for me, Duchamp's ideas were not destructive but exactly the opposite.

We have to remember that I and my contemporaries started out as young
art students at the height of abstract expressionism, which was a metaphysical
and religious movement. Temperamentally, I couldn't accept the ever-length-
ening list of rejections in abstract expressionism. You had to leave out more and
more in the work in order to arrive at an essence. Temperamentally, it was
impossible for me to accept that in my early years and that's where Duchamp
was so important for me.

Marcel's legend as the man who stopped painting, the man who played
chess, the dilettante, the mocker—those aspects of Marcel never appealed to me
in the least. But that was just his public face. Underneath, he was really a
chameleon, untrappable. He was always somehow returning to the reality of the

world. All his references were to natural forces and to medieval alchemy—to sets or systems that were almost occult and quasi-religious, the things Jack Burnham writes about. For me that was very positive and constructive, although Duchamp's work is couched in abstractions, obscurity, layers, and palimpsests — that's just the way he chose to do it.

I have to examine Leonardo as much as Marcel. Leonardo was always involved in trying to decipher the forces of nature; it was almost a religious occupation for him. He had these incredibly vivid drawings, but the abstract meaning and the patterns were indecipherable, not accessible to someone who had not gone through his intensely disciplined process. His voluminous notes in mirror writing were totally mysterious to an untutored person. In Marcel's *The Large Glass* and notebooks, there is exactly the same sort of thing.

It had bothered me for the longest time why Duchamp was making strange abstractions with all those references to nature and natural forces. When I saw the *New Piece* [*Etant Donnés*] in Philadelphia, it cleared up a lot of things for me. First, it had a startling resemblance to the conception of my own work, and I never knew that Marcel was involved in doing what he was doing in that way. The *New Piece* for me completed a necessary circle in Duchamp. He had started with nature, examining its forces, but being complex and intelligent, he had turned these examinations into mathematical equations that were inaccessible unless you knew the language buried under the layers of allusion. Yet he ends his life with that peephole and the woman—this plaster of paris woman covered with pig skin in a setting of real twigs and a landscape. At first, I couldn't figure it out. I spoke to John Cage, who was furious because he loved the abstractions of Duchamp, and what was this? Finally, I tried to describe the piece to someone. I said, "Why should someone as smart as Marcel, who had worked twenty years on it, have made such a ridiculous anatomical mistake? He had placed her vagina to one side until the vagina looked like it was smirking. So here is this marvelous blonde woman with her legs spread apart, apparently welcoming you, and yet you know that damn vagina is laughing at you. Where did I see this before? Goddamn it, that's the *Mona Lisa!*"

Much earlier, Marcel had drawn a mustache on the *Mona Lisa*, ascribing male characteristics to a female who is a vast container of the universe. Why, then, couldn't he, in this last work have enfolded to himself all of Leonardo's subject matter? Everything we do is a different aspect of the same truth.

**Was there a lot of talking about Duchamp with Allan Kaprow and other people at Rutgers in the 1950s?**

Yes. That period was a rich time for us all. Kaprow was teaching at Rutgers, and a bit later Lichtenstein was at Douglass. Samaras and Whitman were students there. Kaprow and I became friends—we ran in to New York together and talked art till all hours of the night. We went to see Cage concerts and Cunningham performances.

**Did you talk with people like Cage and Cunningham?**

I was very shy and was the observer standing against the wall. By that time, Dine and Oldenburg had come to New York and had shown some work at the Judson Church. All of us gravitated somehow to the Reuben Gallery. It was dirty expressionist time, full of German-type angst. I'd gone through German expressionist novels—Thomas Mann and Hesse—when Baziotes, my painting instructor, turned me on to the cold, rational French. He told me: "You straighten your head out and go read Romaine Roland." So I started reading Sartre and Camus on my own. I was doing a lot of reading—a lot of talking, too—and many of the ideas were very much connected. We understood what was going on and knew all about the sources of what was called Neo-Dada. We knew about Kurt Schwitters and his Merzbau, and we knew what Picabia was doing, and had read Robert Motherwell's Dada anthology. I never went to Europe until years later, and I felt jolted back into the past because I met young European artists who had drunk from the same sources we had, and I was surprised at both the discrepancies and differences. They were more socially oriented. They believed in "screw the bourgeoisie," and wanted to mock the system out of existence.

**You yourself didn't go to Cage's classes at the New School?**

No. Many of the people I knew picked up on Marcel via Cage, and that had to do with a tradition of jagged, discontinuous collage elements, where everything was a flash and flicker. In order to be a good member of the club, you had to make work like that.

Kaprow went to Cage's classes, but I never did, although I once went on a mushroom walk with them. You know, when I met Marcel, he reminded me physically of John Cage, who reminds me physically of Kaprow—a kind of slender, cerebral, philosophic, iconoclastic type.

**A dandy type?**

Possibly. I understand the dandy with a certain elegance of lifestyle, precision of movement and manner. Here I am, my belly sticks out too far, and I'm sort of squat and thick-necked, heavy and visceral. But there really is room for all kinds of temperaments and mine is connected with a Jewish protestant work ethic. I'm still involved in that and I'm still very physical. I must make physical objects that I can touch.

I'm more comfortable as a three-dimensional sculptor than I ever was as a painter, and yet I couldn't be without those dandies, those cerebral dandies like Duchamp, Kaprow, and Cage. There are so few people in the world who respond to the same sorts of things I do, so I find them precious.

I had moved out of abstract expressionism because it demanded a certain kind of conformity. You had to accept their ground rules and premises, and behave in a certain way — complete to the corduroy jacket, drooping mustache, a certain kind of loft, and that machismo stance. If you had an education, you had to hide it and sound like a New York cab driver. But then, I was not introduced to the highest echelon of that group until a long time later, so there is an irony in my description. The conformity in the Duchamp/Cage thing, on the other hand, had to do with the rejection of the possibility of meaning; every move was a move to shatter meaning or to mystify it, and that boggled my mind. How many years do you spend disarranging the building blocks before you start putting them together again?

Several friends have called me a lone wolf because for a long time I have been incapable of conforming to either group: neither the abstract expressionist nor the Cage/Duchamp group. But when I started my own sculpture, my first act was to make a complete form and I refused to chop up a chair. Looking back on it, I think it was critical for me personally *not* to shatter things into fragments, not to deal with collage, and *not* to deal with disintegration of meaning. The philosophical situation was so complex with ultimate meanings being questioned all the time that I felt I had to tackle the question of meaning.

When I went to an abstract painter's loft, it was like Balzac's *Unknown Masterpiece*. I'd walk up these dark stairs and come into the whitewashed loft. The place was stripped bare, no furniture, and the guy was on a three-legged stool. There was one painting up against a white wall and the place looked like a monastic temple. There was nothing on the painting that was recognizable. I had no idea of the theory or terminology when I first saw those things, and all I

was aware of was the intensity in the man's eyes, the way he was hunched on the stool, and the purposefully poor life. I got the radiations of monastic urgency, religious necessity, and absolute dedication. Did I get it from the painting? It really bothered me. Was I getting it from the poverty of the space—the way it was stripped and transformed? Or from the attitude of the man and the expression in his eyes?

Later, I learned how to read these paintings, just as you learn to read Chinese or whatever; and their meaning absolutely meshed with my earlier intuitive but ignorant encounter with the loft and the man. Wasn't that a legitimate clue for me to find that something in the real world—the way a figure gestured and moved— was absolutely one with the abstraction of the painting itself? For me, that meant the marriage of spirit and flesh. I absolutely had to get the answers to those questions and the only place I could go after that was into religious reading. Every bit of religious reading had exactly the same kind of connection with Leonardo that I had noticed. They all dealt with the spirit, light and exultation, layers of mystery and ultimate formlessness, but in every religion there was also this complete dealing with the real world. In religious texts, there are always phrases like "the wine needs the jar" or "the spirit needs its garment."

**Then when you started doing sculpture, you wanted metaphorically to encompass both the canvas and the actual painter in his loft environment?**
Yes. My figures *are* the painter in his loft. Everything contributed. It was a great relief—finally, here was the marriage of spirit and flesh.

# part three

ESSAYS AND PERFORMANCE TEXTS
BY ROTH, 1991—1995,
COMMENTARY BY KATZ, 1998

"The Voice of Shigeko Kubota:
'A Fusion of Art and Life, Asia and
America. . . .'"
In *Shigeko Kubota: Video Sculpture*, ed.
Mary Jane Jacob (New York: American
Museum of the Moving Image, 1991),
76–85.

Born in Japan in 1937, Shigeko Kubota
created her early work in Tokyo and then
settled in this country ("I came, flying in
a Boeing 707, on July 4th in 1964, drawn
to the glittering Pop Art world of New
York"[1]), immediately becoming involved
in the Fluxus movement. For almost
three decades now, she has worked in
what she calls "video sculpture" (i.e.,
video installation) as well as making
single-track videos.

This text is excerpted from the longer
essay originally published in Mary Jane
Jacob's *Shigeko Kubota: Video Sculpture*.
What follows here are the essay's sections
on Kubota's early relationship with both
Cage and Duchamp (she photographed
them at their legendary chess game in
Toronto in 1968) and her later protracted
dialogue with Duchamp in her video
installations. The last section is on
Kubota's *Adam and Eve* (1989–1991),
two life-size robots made of wood and
mirrors with miniature monitors, and
their relationship to Duchamp, to the
Japanese novelist Yukio Mishima, and to
her hybrid Japanese American culture.
The endnotes retain their enumeration
from the orginal published text.

# the voice of
# shigeko kubota
## (excerpts)

moira roth

### A Chess Game in Toronto, 1968

IN 1968 KUBOTA, STILL ACTIVE IN FLUXUS circles, and a recently appointed Japanese art journal correspondent,[27] traveled to Toronto to attend Cage's *Reunion*. For this event Cage had had a chessboard constructed with circuits so that "moves on the board transmitted or cut off sound produced by the several [attending] musicians."[28] The public listened and watched as Cage played a long, leisurely game, first with Marcel and then with Teeny Duchamp (Marcel's wife). This chess game became a last public reunion (for Duchamp died within a few months) between these two old friends, whose works and personalities were so pivotal to the European and American avant-garde.

Not only had Kubota first met Cage while in Japan, but it was also there that she had first learned of Duchamp. From the start she was drawn to the elegant, intellectual approach and restraint of Duchamp's "productions"; most of all she found herself admiring their underlying concepts. She became even more inspired by him when she saw his actual work in 1967 in the brilliant Duchamp installation

by Pontus Hulten housed in the Stockholm Museum. The next year (1968), Kubota finally met Duchamp himself. As she vividly tells the story,[29] they met on a plane that was rerouted to Rochester, New York, due to a blizzard. Finally, they managed, now firm friends, to make their way via bus to Buffalo to attend the opening of Merce Cunningham's *Walk Around Time*, based on Duchamp's *The Large Glass*, with its extraordinary set by Jasper Johns. A few months later, Kubota was to meet Duchamp again when she attended Cage's *Reunion*.

Kubota photographed Duchamp and Cage, together with Teeny Duchamp, as they performed in *Reunion*. With this series of photographs, plus material acquired later, she slowly formed two works: a book (1970) and a videotape (1972), both entitled *Marcel Duchamp and John Cage*. The limited-edition book contains Kubota's photographs, a Cage text (*36 Acrostics re and not re Duchamp*), and a 33 1/3 rpm phonograph record of the *Reunion* sounds. In contrast to this exquisite publication was Kubota's 1972 videotape, a long, meandering, yet oddly riveting tape which draws on a range of footage—Cage telling stories, chanting, meditating, playing the piano, and, with his head bandaged, sitting while Nam June Paik measures his brain waves. In the tape, Cage speaks about Duchamp, and we also see images of Kubota herself in France at Duchamp's grave. In 1972–73 she created a final work on this Duchamp-Cage chess game when she had her 1968 Toronto photographs transferred—keyed, matted, and colorized—to video, with an accompanying soundtrack. In the *Video Chess* installation, the viewers/players look down at a video monitor through a transparent chessboard containing transparent chess pieces. As Kubota points out, in any chess game played on this board, "you are accompanied by the videotape of the two great masters playing from the other side of this world."[30] Kubota was to choose one of them, Duchamp, as her companion in a prolonged and highly original dialogue—one that has parallels with both an artistic chess game and an artistic voyage.

For Kubota, the Toronto event and her subsequent explorations of those "two masters" provided her with new content which she would shortly begin to juxtapose with video. The results transformed her art and allowed her to shape for herself an original, significant, and independent artistic arena. Beginning with a portapack she bought in 1970, Kubota turned to the fresh medium—at that time—of video. Unlike film, whose whole process she views as "very chemical," she saw video as "organic, like brown rice . . . brown curd, very oriental, like seaweed, made in Japan."[31]

## Dialogues with Duchamp, 1968—1990

Dialogue. n. I. A conversation or discussion. 2. The words spoken by characters in a play or story.

—"Dialogue," *Oxford American Dictionary*

For over twenty years Kubota has made a series of art offerings to her adopted "ancestor," starting with the Duchamp-Cage pieces. She has constructed a script for herself and Duchamp as two "characters" in a strange, often cryptic, play-story of her making. In a series of call-and-response pieces, Duchamp's side of the dialogue is represented by ideas and gestures that Kubota has extracted from his work. The exchange between these two artists of such disparate backgrounds and times appears surprisingly fresh and lively, suggesting a conversation between two friends in the present rather than a dialogue constructed by only one of them.

What exactly did Duchamp—now the elder spokesperson of the New York art world of the later 1960s—have to offer young artists? Duchamp was, as we all know, one of the most legendary of contemporary artists. A consummate maker of his own legend, he had been as deeply invested in the creation of his persona as in his readymades, or his two most singly ambitious works, *The Bride Stripped Bare by Her Bachelors, Even* (commonly known as *The Large Glass*) and the last major work, *Etant Donnés*. Duchamp died in November 1968, shortly after *Reunion*. Within a few years an avalanche of literature appeared on him, together with a series of exhibitions culminating in the major retrospective staged in 1973 with much fanfare at The Museum of Modern Art in New York and the Philadelphia Museum of Art. In 1973 Vito Acconci, the poet–performer–conceptual artist, wittily commented on Duchamp's new role, saying he felt forced to do homage to Duchamp, "since it has been assumed that Duchamp has established the context in which everyone is working. It's sort of like being forced to answer questions about the boss."[32]

For Kubota too, as for Acconci and so many other young American artists, Duchamp clearly represented the new "boss." Yet now this "boss" ironically stood for art, rather than antiart, for Duchamp had played a major role in legitimizing a set of art values and forms once viewed as nonart, but now

institutionalized in the history of the twentieth-century avant-garde. By the 1960s, albeit in an ironic, slightly self-deprecating tone, Duchamp represented dominant art history, one that was both male and European.

For Kubota, however, Duchamp was not only the art world "boss," but he had also held the more complex and less authoritative role of the male muse whom she sought out not only in life but, literally, in death. In 1972 Kubota, taking along her newly acquired portapack, made a pilgrimage from Paris to Duchamp's grave in Rouen. She remembers her feelings as she stood by Duchamp's grave: "Despite the cool unsentimentality of Duchamp's own attitude toward death, I was very moved."[33] Three years later Kubota drew from this experience and the Rouen video footage to create her first ambitious experiment in video sculpture.

Kubota installed *Marcel Duchamp's Grave*, a shrinelike video sculpture, in a specially constructed white room at the well-known New York space The Kitchen. It was composed of a tall plywood column,[34] containing some twelve monitors and two long mirrors—one on the floor in front and another on the ceiling. On each of the monitors appears Kubota's footage of the grave and the Rouen cemetery surroundings, partially colorized and generally much manipulated by postproduction editing. While we watch, she places her *Marcel Duchamp and John Cage* book on the flat gravestone as an offering, and on the soundtrack we occasionally hear her quavering, poignant, grief-stricken voice combined with the sounds of wind and birds. The floor and ceiling mirrors reflect these video images in a seemingly endless progression. As Cindy Neal has aptly described it, the "totem of monitors" and the two mirrors of *Marcel Duchamp's Grave* work as metaphors to express "the extension of life into eternity through the reflection of the monitors into infinity."[35]

*Marcel Duchamp's Grave* also reveals a conceptual connectedness between Kubota's Japanese and Duchampian "roots." Because of the monastic association of her father's family, Kubota as a child had frequently witnessed funerals. Also, she recalls, "I often did homework inside a temple room where fresh bones were stored. How I played with ghosts ... all these childhood memories flashed back into my head. I put my *Duchamp and Cage* book on his grave, as in the oriental family custom of putting rice cookies on the dead ancestor's altar."[36] In a text entitled "Twenty Questions About My Work," she mused, "Are we dancing on the grave of Duchamp like an American Indian Sun Dance? Ghost Dance?"[37]

Kubota expanded her Duchampian dialogues in her two one-person exhibitions at Rene Block's New York art gallery in 1976 and 1977.[38] She worked closely with Block not only on the installations but also on their conceptual framework. Together they decided to entitle the shows *Duchampiana: Video Sculpture* (1976) and *Meta-Marcel* (1977). It was in these two exhibitions that Kubota staked out some fundamental artistic and theoretical terrain for herself. She has quite rightly maintained that with these works she became responsible for the introduction of the term "video sculpture" and contributed to the lexicon of contemporary art history the concept of "appropriation."[39]

In a 1981 text, Cindy Neal, one of the most astute commentators on Kubota's Duchampian works, discusses Kubota's innovative role in the development of video art. Neal reminds us that the works of early video artists such as Peter Campus, Frank Gillette, Bill Viola, Ira Schneider, Dan Graham, and Nam June Paik were primarily "models of video systems illustrating ideas about communication, or experiments with perceptual intake and feedback."[40] Kubota's work, on the other hand, not only "communicated a concept (in this case, that video can perpetuate life after death) but also was created specially as an art object itself (hence a video sculpture)."[41]

Between 1976 and 1990 Kubota created five major pieces in dialogue with works and gestures of Duchamp: his painting *Nude Descending a Staircase*; two readymades, *Bicycle Wheel* and *Fresh Widow*; photographs of his Paris studio "trick" door; and the 1924 Paris tableau *Adam and Eve*. Should these encounters with Duchamp be read as acts of appropriation? Absolutely, and indeed as early examples of this now all-too-fashionable mode. But they are also springboards for concerns that are clearly unique to Kubota.

*Nude Descending a Staircase* consists of a single plywood construction of four stair forms with a monitor concealed in each step. An identical tape plays in each, showing kaleidoscopelike images of a nude woman on a staircase who, in Kubota's words, "descends slowly/ rapidly/ flying in many colors and exposures."[42] Here Kubota's introduction of literal movement transforms Duchamp's painted abstracted image. But, perhaps even more importantly, the presence of a real woman model (the filmmaker Sheila McClaughlin)—coupled with the fact that it is a female, not male, artist who has made the work—transforms the subject into a dialogue about female subjectivity and its relationship to the conventional female objects of Western art.

Kubota also restores the elements of motion and playfulness to Duchamp's *Bicycle Wheel* (1913)—a bicycle wheel set atop a kitchen stool and the first of his

readymades. Originally installed casually in Duchamp's prewar Paris studio, where the artist liked to watch the wheel turn, it appeared to him like the mesmerizing flickering flames of a fire. In time, recontextualized within the confines of the museum and art history, the bicycle wheel became stilled, an icon rather than an object of play. In Kubota's *Bicycle Wheel,* the wheel can be turned again—this time by the action of the viewer's foot on a pedal which activates the spinning. Attached to the wheel is a miniature video monitor displaying footage of landscapes, flowers, and mountains. Like *Duchamp's Grave,* Kubota's *Bicycle Wheel,* with its slowed-down circular pace, also offers itself—if one devotes sufficient time to it— as an object of contemplation. All in all, this combination of meditation and playfulness, together with its poetic evocation of nature and its elaborate construction and technology, removes Kubota's *Bicycle Wheel* light-years away from Duchamp's original one with its stark juxtaposition of a physically simple form and the conceptually complex framework surrounding his readymades.

It is tempting to read Duchamp as the trickster/escape artist, a Houdini who always escapes from the box in which we attempt to place him. His art itself often contains allusions to tricking the eye, escaping from the expected, and leaving art confines behind. He once designed a door for his one-room Paris apartment at 11 rue Larrey in which two frames placed at ninety-degree angles allowed the door to be simultaneously open and shut. (It was made in 1924 at the time when he seemed most determined to "disappear" as an artist and become the chess player/engineer.) Kubota's construction of a room with this door however, has ironically enshrined Duchamp. Inside the room she installed two video monitors showing a combination of beautiful blue, purple, and pink footage of Yellowstone Park's Old Faithful geyser erupting with a superimposed photograph of Duchamp's head as he serenely smokes a cigar. The soundtrack is a collage of his utterances about art and life. His voice fades in and out as he makes comments such as, "I don't want to be a prophet ... I never intended to stop work ... I don't believe in art ... art is a mirage." They are the remarks of an Old Faithful spouting into eternity.

In a poetic, eccentric, but also systematic way, Kubota has created a series of portraits of her muse, weaving into the artistic narrative tales of Duchamp's presence in life and death and her responses to selected aspects of his art and attitudes. During the years 1968–75, she, like an impresario, had presented the live Duchamp in one of his major roles: the trickster/artist-turned-chess player. This trickster figure appeared again (though now more like an aging guru) in *Door.* In

*Marcel Duchamp's Grave,* the dead Duchamp is summoned up as the subject of an extraordinary video sculpture which combines restless flickering electronic messages to and from the grave with a formal stability and emotional tranquility. As with many of Kubota's other video sculptures, the longer one spends with this work, the more one is aware of its meditative powers. This is certainly true of the four versions of *Window,* a play on Duchamp's *Fresh Widow* with its French windows made of black leather. Kubota replaced the leather first with the "snow" of a character generator, and, in two later versions, with elaborations on video footage of flowers and stars; a fourth version combines snow with computer writing. Thus, that which cannot be seen, that which is obscured in Duchamp's original becomes the site for the production of images in Kubota's version.

Last summer in Venice, I spent several hours looking at Kubota's "snow" version of *Window,* the *Bicycle Wheel,* and *Nude Descending a Staircase* in a large Fluxus retrospective on the Giudecca. Outside the exhibition building was the canal, and the constant sound of church bells and water lapping against the island's buttress wall. In the exhibition space, itself a melange of cobbled floors and brick walls, a cacophony of different Fluxus voices vied for attention. I was struck by the distinctness of Kubota's sensibility. The longer I spent with the three pieces, the less I thought about Duchamp.

What I experienced most strongly was the works' meditative ambiance and their cyclical nature. The *Bicycle Wheel* began to conjure up in my mind the image of a Tibetan prayer wheel. The *Window* became a mantra for meditation. And what I was most aware of in the *Nude* was ritual movement that had no conclusion, and an almost relentless repetition of images in the footage. Kubota's *Nude,* a work by a woman artist with a woman as her subject and the movement of the video medium, swept aside memories of Duchamp's static painted object. As I sat there amidst the Fluxus world, I speculated about the splendid bravado of a young female Japanese artist taking on the European sophisticate, Duchamp—and managing to make the works her own.

### Adam and Eve, Kubota and Robbins, Duchamp and Mishima

In the summer of 1990, I visited Kubota's Mercer Street studio in SoHo to see her newest work, *Adam and Eve.* Here again, so characteristic of her work from the

1968 Duchamp-Cage footage onward, she employs an inventive frugality in combining old and new material, recycling, so to speak. But it is in *Adam and Eve,* however, that for the first time Kubota's Duchampian and Japanese "roots" intertwine directly.

Adam and Eve are two life-sized robots made of wood and mirrors. Imbedded into various parts of their bodies and faces, for example, the cutout shapes of Adam's heart and a fig leaf, and Eve's breasts, are miniature monitors that previously composed *Video Relief.* The figures stand in a "Paradise" garden of plastic mylar—rocks the components of *Dry Mountain, Dry Water.* Elaborate colored lights and footage from *Video Byobu II (Cherry Blossoms)* play on this landscape and the figures. I sat for a long time in the studio watching, and sometimes accompanying the sculptures as they rotated—Adam larger and more stately in his movements, and the smaller, faster Eve. At first, the quirky, somewhat science fiction–like figures and their world merely charmed me. Gradually, however, I became moved by the hynotic, meditative state that Kubota, at her best, creates for the patient viewer/participant.

On one level *Adam and Eve* stand as Kubota's latest evocation of Duchamp. The figures' stances and gestures are modeled on those of the nude Duchamp and Brogna Perlmutter as they appeared briefly and motionless on the stage as Adam and Eve. Their "act" was a segment in the ballet *Relâche,* Francis Picabia's flamboyant Dada event in 1924 Paris. Commenting on her appropriation's convoluted nature, Kubota reminds us that Duchamp himself had taken the 1924 performance gestures from a sixteenth-century German painting of Adam and Eve by Lucas Cranach. In Gertrude Stein fashion, Kubota writes that her *Adam and Eve* is "an appropriation of an appropriation of an appropriation."[62] Thus, in Kubota's work, we have archetypical biblical figures, allusions to German Renaissance painting, and the Dada escapades of Picabia and Duchamp.

On another level *Adam and Eve* is a memorial for the dead, as was the 1986 *Video Byobu II (Cherry Blossoms),* which it incorporated. (This earlier work was dedicated to two Chicago friends of Kubota's who had recently died: Lyn Blumenthal, artist and cofounder of the Video Data Bank, and Barbara Latham, a video artist who taught at The School of The Art Institute of Chicago.) Adam and Eve pays homage to Al Robbins, a close friend of Kubota's who had unexpectedly died in 1987. She described him as "an architect, a poet, a video artist, and the carpenter who built my video sculpture."[63] When Kubota saw the photo of Duchamp as the young Adam, she was reminded of Robbins, "with that intre-

pid body and wild beauty ... [and] I decided to make a video sculpture called *Adam and Eve*. This is my tribute to Al. This is how I want Al to live forever."[64] In Adam's body and head are videos displaying rough, casual footage of Al Robbins talking, and climbing up and down a ladder in a studio.

On yet another level *Adam and Eve* is about Japan, about its beauty and the need to quell its seductive, threatening power. Footage of Kyoto's Golden Pavilion are displayed in Eve's monitors. The video footage is shot, as is almost always true of Kubota, with the deliberate jerky zoom movements characteristic of early video. While we were watching the tapes together this summer, she commented that such zooms were, for her, "like natural movement, whereas editing is more artificial." The footage is deliberately raw, but the associations that the image of the Pavilion conjures up are subtle: thoughts of Japanese Zen and of history, and, for many, the famous novel by Yukio Mishima.

Mishima's novel, *The Temple of the Golden Pavilion*, is roughly modeled on the real-life episode of the monk who in 1950 burned down the famous Kyoto temple. Toward the end of the novel, Mishima's young, stuttering, neurotic Zen acolyte again confronts the golden beauty of the pavilion: "that beauty was taking a last chance to exercise its power over me and to bind me with that impotence which had so often overcome me in the past."[65] To inspire him in his rash act, he recalls the advice of Rinzai, a famous Zen master: "When ye meet the Buddha, kill the Buddha. When ye meet your ancestor, kill your ancestor. ... Only thus will ye attain deliverance."[66] Mishima's protagonist then sets fire to the temple and watches its destruction from a distance: "all that I could see was the eddying smoke and the great fire that rose into the sky."[67] Though he had planned to commit suicide, he discards a bottle of arsenic and a knife, and instead smokes a cigarette. The novel ends with this sentence: "I felt like a man who is settling down to smoke after finishing a job. I wanted to live."[68]

Mishima's *Confessions of a Mask* (1949), *The Sound of Waves* (1954), and *The Temple of the Golden Pavilion* (1956) established him as the preeminent Japanese novelist of the immediate postwar period. Kubota has read his writings avidly for many years and there are interesting parallels between her work and his. Like Kubota, the characters of his novels are torn between their Japanese roots and their fascination with the West. Both Mishima and Kubota vacillate— though the writer's expression of this is far more overtly obsessive than Kubota's—between a sensuous delight in beauty and the body, and a need for its denial, its destruction.

Kubota's comments on her *Adam and Eve* stress the persistence for her of this Japanese beauty. She writes, comparing Robbins's young lovers to her old Japanese Eve, "But my Eve is the Temple of the Golden Pavilion, which stands in sublime beauty . . . . [yet] was destroyed by arson, by a demented acolyte priest. But it rose again, finished in gold. That's my Eve."[69]

In *Adam and Eve* a mechanized woman and man move side by side in a strange Paradise garden of Zen rocks. These dualities, be they male and female, technology and nature, life and death, or the West and Japan, are the stuff from which Kubota makes her art. The dynamic tensions of her world generate an artistic vitality that has helped shape the particular, original, and multilayered-multicultured nature of her "voice." Only in the three 1972–75 single-channel tapes do we hear her literal voice; since then, except for the two more recent *Broken Diaries*, she has ceased to include her voice in her art, although she writes eloquent texts to accompany her works. Over the intervening years, however, Kubota has slowly invented a language for herself, a visual, not verbal, language through which she speaks her mind. Kubota's Eve is stalwart and resilient as is Kubota's present art and her sense of artistic self. Hers is a much valued voice in American art of the last twenty-five years as—with clarity, wit, imagination, and certainty—she speaks to us about her ongoing endeavors to fuse art and life, Asia and America.

Marcel Duchamp

## LETTER TO MOIRA ROTH

No. 4

Dear Moira,

I seem to recall that in 1977 you wrote "The
Aesthetic of Indifference." I forget exactly
what it was about—something to do with
me, John Cage, Jasper Johns, Robert
Rauschenberg and McCarthyism? . . . How
you felt that we were distancing ourselves
from politics by irony and indifference . . .
and that you thought we had made it diffi-
cult for younger artists in the 1960s to be
politically engaged. Something like that,
wasn't it? By 1977, of course, you had
been involved in feminism for some time.
But surely you must have continued to
enjoy Rrose Sélevy as you were always
preaching about women artists. And there I
was, yours for the asking. You know I have
always found you charming. She does, too.

*Moira Roth*

LETTER TO MARCEL DUCHAMP

*No. 4*

*Dear Marcel,*

*Yes, it was a temptation. I did so much want to continue the love affair with you. In a way, Rrose might have been the feminist solution for our affair. I could have had my male genius cake, so to speak, but eaten it, also, with lesbian relish.*

**Exchange of letters between Marcel Duchamp and Moira Roth, October 1995.**

## "Talking Back: An Exchange with Marcel Duchamp"

Simultaneously forthcoming in *Women Artists and Modernism*, ed. Katy Deepwell (Manchester: University of Manchester Press, 1998).

On October 28, 1995, I spoke in "generating lines and engendering figures: a symposium on and about Marcel Duchamp" at The Museum of Contemporary Art, Los Angeles, organized by Naomi Sawelson-Gorse. The speakers at this all-day symposium were Amelia Jones, David Joselit, Christine Magar, Sheldon Nodelman, Marjorie Perloff, Dickran Tashjian, and myself. What follows is an edited version of my twenty-five-minute performance. When first invited to participate by Naomi Sawelson-Gorse, I was reluctant. She assured me, however, that I could do whatever I wanted, and that I could literally have the last word, that is, be scheduled as the final speaker in the late afternoon. She also suggested that I should address head-on the reasons for my original reluctance to talk about Duchamp.

Over the course of two weeks—in the midst of other projects—I worked intensely on this. I found the process heavily exhilarating—psychologically as well as intellectually—and equally unnerving as clearly there was a real risk of public failure (although, in fact, my presentation was received very well at the symposium). What evolved rapidly and

easily was the performance structure and the focus of the piece: I would address my changing relationship to Duchamp and the shifts in tone of my writings on Duchamp over the years. What I never could decide on, however, was a suitable ending. Part of the ground rules I had set for myself when composing "Talking Back" was that I would allow the performance text to develop organically, and see where it led over time. On the day before the event I asked Faith Ringgold in a phone conversation whether she often thought about Duchamp. When she replied casually, "very little," I knew immediately how I would end my text.

The performance consisted of a back-and-forth play among the following components:

1. Exchange of letters between Duchamp and myself. These were slides of texts from an imaginary correspondence that I read out to the audience. My letters were in white type on a blue background; Duchamp's were on a red background and written in his own hand. (I had found a computer font based on Duchamp's actual handwriting.)

2. Slides of works of art by Duchamp, Shigeko Kubota, and Faith Ringgold.

3. Three video clips. These consisted of an invented exchange between Lynn

Hershman and Duchamp (the Duchamp footage came from a real interview with him) from her 1982 video, *The Making of a Very Rough and (Very) Incomplete Pilot for the Videodisc on the Life and Work of Marcel Duchamp*, together with short excerpts from videos I had shot of Shigeko Kubota's video sculpture in Venice and New York.

4. Musings to the audience. I delivered these fairly quietly while gazing reflectively at the audience.

5. On the floor beside me was a large leather-bound book that I picked up from time to time and read from in a dramatic tone. I had begun these diary entries on October 16 and wrote the last entry on October 27, the day before the symposium.

# talking back
## an exchange with
## marcel duchamp

## moira roth

*For Naomi Sawelson-Gorse,*
*with many thanks*[1]

**Moira Roth, Letter to Marcel Duchamp, No. 1**

October 15, 1995

Dear Marcel,

I want to let you know that Naomi Sawelson-Gorse has invited me to participate in her "generating lines and engendering figures: a symposium on and about Marcel Duchamp." I was reluctant to get engaged in this at first because for years we have been drifting apart, as you probably realize, but people tell me that you are rather restless these days, so perhaps an exchange would amuse you? Certainly, it would interest me as I have always felt that there is some unfinished business between us. Anyway, if you wish, you can respond for I have installed a font of your handwriting on my computer. You'll have a choice as to whether to use True Type or Postscript formats and there is also a Bold version.

Moira

**Marcel Duchamp, Letter to Moira Roth, No. 1**

Dear Moira,

How amusing and how modern. Perhaps Postscript would be best? By the way, I looked down at the program for today's symposium, and noted your title, "Talking

Back: An Exchange with Marcel Duchamp." Talking Back?

Marcel

### Moira Roth, Letter to Marcel Duchamp, No. 2

Dear Marcel,

You probably don't know of bell hooks—she was after your time—but she wrote an essay entitled "Talking Back."[2] It's had a great influence on me. hooks writes that "in the world of the southern black community I grew up in 'back talk' and 'talking back' meant speaking as an equal to an authority figure. It meant daring to disagree and sometimes it just meant having an opinion."

### Musings to the Audience, No. 1

I've been getting myself in the mood to talk back to Duchamp for quite some time, but I didn't start that way.

When I was writing my dissertation on Duchamp, way back in the early 1970s at the University of California, Berkeley, I had a positive crush on him.[3] It was the oedipal moment many of us experience as graduates—totally in love with one's subject, unable and unwilling to differentiate between oneself and the beloved.

I remember going to parties in Berkeley and telling so many stories about my beloved that people would come up and ask if they could meet my interesting friend. I also remember a particularly crazy time when I had been writing a draft of my dissertation for ten days straight, morning, noon, and night, including a preface—and actually handed this in to my advisor—in which I fantasized about having a love affair with Duchamp. I remember it ended with, "she stroked his thigh and asked, 'what does *The Large Glass* really mean, Marcel?' Smiling, he began to explain."

### Marcel Duchamp, Letter to Moira Roth, No. 2

I remember your dissertation, Moira. You went around New York asking people about their reactions to me. It was quite interesting, including those amusing comments by Robert Smithson.

### Musings to the Audience, No. 2

Actually, the first cracks in my relationship with Duchamp—who had died in 1968—came around 1973, especially triggered by a conversation with Robert Smithson.

I was in New York, taping interview after interview about Duchamp with the likes of Leo Castelli, Vito Acconci, and George Segal. For example, I talked to Acconci who said he felt forced to do homage to Duchamp, "Since it has been assumed that Duchamp has established the context in which everyone is working, it's sort of like being forced to answer questions about the boss."[4]

Then, just before I was to fly back to Berkeley, I stumbled onto a group of artists who disliked Duchamp for a variety of reasons—among them Sol Lewitt, Carl Andre, and Robert Smithson. I remember being surprised—shocked in a way, but also experiencing a little frisson of excitement at this "talking back"—really the first I'd encountered since I started research on my dissertation.

I talked to Smithson, shortly before he died, in the early spring of 1973. (The edited version of the exchange was published in *Artforum* later that year.[5]) Visiting Smithson in his well-organized New York loft, I found that he had prepared for the interview, assembling a pile of books on Duchamp with little markers for certain texts. It was as if he were another scholar rifling through the pages for this or that reference.

Clearly he and his friends didn't like Duchamp or Duchamp's influence on American art. He commented that Duchamp's objects are "just like relics, relics of the saints. . . . It seems that he was into some kind of spiritual pursuit that involved the commonplace. He was a spiritualist of Woolworth, you might say."[6] Smithson ended our exchange with, "I find his wit sort of transparently French. . . . If the French have any wit at all, I don't really appreciate it. They always seem very laborious, opaque and humorless so that when you get someone like Duchamp who is putting forth the whole art notion of the amusing physics or the gay mathematics, or whatever you want to call it, I am not amused. It is a kind of Voltairian sarcasm at best."[7]

## Marcel Duchamp, Letter to Moira Roth, No. 3

As the 1970s progressed, Moira, there began to be a slightly critical edge to your tone, although I quite enjoyed your "Duchamp in America: A Self Ready-Made."[8]

## Moira Roth, Letter to Marcel Duchamp, No. 3

Dear Marcel,

You do realize, don't you, that this 1977 *Arts* essay was the first time in print that I

had tried to position you in American modernism (as well as to explore your personae and role playing with the New York art world as a theater set) and to talk about how indebted you were to that ambience? Sheldon Nodelman helped me edit the essay.[9] By the way did you hear Sheldon's talk today?[10] I know it amuses you to read critics' interpretations of your oeuvre. I used to worry as to what you thought of mine. I remember being so relieved when you once told me that you liked this 1977 *Arts* portrait of you as the *flâneur*/occult scholar.

### Readings from My Diary, No. 1, October 16, 1995
Dear Diary,
I have decided in preparation for this Los Angeles presentation that I really need to address two basic questions.

1. Why do I find myself so increasingly critical of Duchamp, indeed impatient with him?

2. Why, despite that, do I find myself returning to him? Why does he seduce, myself included, so many scholars into a reinvestment in him?

The answer to the first question is fairly easy  Today, rereading the *Arts* article, which I hadn't looked at for years, helped me think through why I have become so impatient with Duchamp these days.

I still like my essay's conclusion:
"Duchamp's choice of America in 1915 was the right one for a man obsessed with the making of his own image, the perpetuation of that image, and the total control over its reading. Duchamp and America served one another well. Duchamp wanted fame and got it. America wanted to establish its place in the history of art more firmly and it used Duchamp for this purpose. The New York Dada movement and Duchamp's art, together with the more genuinely American contributions of the Stieglitz group, built the edifice of American modernism. Duchamp was in on the ground floor."[11]

Surely that is at the heart of my growing impatience with Duchamp.

Not only did he have such a stranglehold over American art history with its insistence on modernism, and its kowtowing to European models—which these days is causing us American revisionist art historians so much trouble—but recently he has

insinuated his way into postmodernism.

Now he's on the top floor of postmodernism.

The man's too much.

He keeps popping up just when you think he is dead.

He just has too much influence for my liking and he's taking up too much space and time at the moment when we should be, I believe, moving on.

## Marcel Duchamp, Letter to Moira Roth, No. 4

Dear Moira,

I seem to recall that in 1977 you wrote "The Aesthetic of Indifference."[12] I forget exactly what it was about—something to do with me, John Cage, Jasper Johns, Robert Rauschenberg, and McCarthyism? . . . How you felt that we were distancing ourselves from politics by irony and indifference . . . and that you thought we had made it difficult for younger artists in the 1960s to be politically engaged. Something like that, wasn't it? By 1977, of course, you had been involved in feminism for some time. But surely you must have continued to enjoy Rrose Sélevy as you were always preaching about women artists. And there I was, yours for the asking. You know I have always found you charming. She does, too.

## Moira Roth, Letter to Marcel Duchamp, No. 4

Dear Marcel,

Yes, it was a temptation. I did so much want to continue the love affair with you. In a way, Rrose might have been the feminist solution for our affair. I could have had my male genius cake, so to speak, but eaten it, also, with lesbian relish.

## Musings to the Audience, No. 3

[accompanied by a slide of Rrose Sélevy]

This talk of Rrose Sélevy is making me think of those uneasy but heady days in 1980. I had not only been involved in feminism for some ten years, but was deeply involved in performance art and had just discovered punk performance.

At the beginning of 1980, I returned from a South Sea island escapade with Crown Point Press—with a group of avant-garde superstars, including John Cage, Chris

Burden and Laurie Anderson—and was on leave from the University of California, San Diego (UCSD), teaching at Hayward State. I was in the Bay Area, and had plunged into nightly visits to punk clubs. I met the editor of *Damage,* a punk magazine, and he asked me to write for it. I had just received tenure at UCSD and was feeling rebellious. For a couple of months I toyed with the idea of presenting Rrose Sélevy for *Damage,* and of writing under a pseudonym, Regina Smut.

### Readings from My Diary, No. 2, October 17, 1995

Dear Diary,

That's it! Endless alternatives offered by the father and endless seductions by the lover.

Here we all are in the heady days of postmodernism, denying authorship and authority.

And here is Duchamp saying smilingly, of course, he agrees with us—indeed anticipated all this, and so early on, too.

So we can, therefore, continue to have such an interesting, and such an intelligent, indeed such a postmodern and fashionable father—Duchamp.

Psycho-authorization.

Not easy giving up the search for the father. Not easy even if you are an ardent feminist.

How cheaply psychoanalytic I'm becoming, but it's true.

It's the answer to my second question—why do I—we—always return to Duchamp?

### Marcel Duchamp, Letter to Moira Roth, No. 5

Dear Moira,

Does your friend, Amelia Jones, find me interesting?[13] I see that she is one of the presenters of this conference. Not that I really care, you understand, but I was mildly curious as to what she has to say with all her talk about "en-gendering" me. I thought she sounded rather clever. You know, Moira, I really do—I must confess—like to be included in what's going on. It's a little boring up here, and it's pleasant to be includ-

ed in art conversations about postmodernis n.

### Moira Roth, Letter to Marcel Duchamp, No. 5

By the way, Marcel, I've always wanted to ask you if you ever saw the 1982 interview that Lynn Hershman, the feminist San Francisco-based multi-media artist, did with you?

### Marcel Duchamp, Letter to Moira Roth, No. 6

No, Moira, you must be mistaken. I was never interviewed by Miss Hershman. After all, by 1982, I had been up here for some twelve years.

### Musings to the Audience, No. 4

[accompanied by a three-minute video clip from *The Making of a . . . Life of Marcel Duchamp* (1982) by Lynn Hershman, in which Hershman is seen interviewing Duchamp.]

Actually there is such a tape by Hershman in which she took an interview with Duchamp made during his lifetime, and inserted herself as the interviewer. It is a part of *The Making of a Very Rough and (Very) Incomplete Pilot for the Videodisc on the Life and Work of Marcel Duchamp*—an account of her attempt to create an interactive videodisc which was to include Duchamp's heartbeat. There was some sort of dispute on the set over money, and a member of her video crew held the tapes of Duchamp's heartbeat "for ransom." The result was that Hershman never made the videodisc. She once said that she knew Duchamp would have loved the idea of his heart being held for ransom.[14]

An interesting metaphor—a heart held at ransom. How does one get one's heart back, and at what price? Did I get mine back from Duchamp, and what was the price?

### Moira Roth, Letter to Marcel Duchamp, No. 6

Dear Marcel,

Did you ever read the long essay on Shigeko Kubota that I wrote in 1991 for her retrospective at the American Museum of the Moving Image?[15] You remember, Marcel, that you met her in 1968 just before you passed away? She had come to Toronto to photograph you and Cage playing chess. She was—and is—such an admirer of yours. At the time, she had been in New York for four years and from the start she had been deeply involved there in Fluxus circles. Later she made a series of videos and video installations responding to you—among them works about *The Nude Descending a Staircase, Bicycle Wheel, Fresh*

*Widow,* your 1924 nude tableau of Adam and Eve, and the trick door you had had made for your Paris studio. She also made a video sculpture after she visited your grave in Rouen.[16]

## Readings from My Diary, No. 3, October 20, 1995

[accompanied by footage I shot in 1990 of Shigeko Kubota's sculptures— *Duchampiana: Bicycle Wheel* (1976), *Duchampiana: Nude Descending a Staircase* (1976) and the *Meta-Marcel: Window* series (1976–1991)—in *Ubi Fluxus ibi motus, 1990–1962,* a Fluxus show in Venice.]

Dear Diary,

Today I've been looking at the videotape I made in 1990 of three of Kubota's Duchampian pieces and I've also been amusing myself by copying passages from my Kubota catalogue essay into this diary. One section described my reactions to a pro- longed session of sitting and looking at Kubota's work in a big Fluxus exhibition in Venice on the Guidecca.

It's quite a meditative exercise in itself—writing out by hand something that was once a printed text.

"The longer I spent with the three pieces, the less I thought about Duchamp. What I experienced most strongly were the works' meditative ambience and their cyclical nature. *The Bicycle Wheel* began to conjure up in my mind the image of a Tibetan prayer wheel. *The Window* became a mantra for meditation. And what I was most aware of in *The Nude* was ritual movement that had no conclusion, and an almost relentless repetition of images in the footage. Kubota's *Nude,* a work by a woman artist with a [live] woman as her subject and the movement of the video medium, swept aside memories of Duchamp's static painted object. As I sat there amidst the Fluxus world, I speculated about the splendid bravado of a young female Japanese artist taking on the European sophisticate Duchamp—and managing to make the works her own."[17]

## Musings to the Audience, No. 5

[accompanied by a slide of *Adam and Eve* by Shigeko Kubota]

There was another work which I saw later that summer in Kubota's studio —her

*Adam and Eve*, inspired partially by the famous photograph of Duchamp's 1924 tableau of a nude Adam and Eve with himself as Adam.

Kubota once told an interviewer that "Duchamp is the root of my art memory and my work. My human root is my being Japanese from a small country, an island."[18] For Kubota this *Adam and Eve* piece was the first time in which her Duchampian and Japanese roots had intertwined directly. She made two life-sized robots of wood and mirrors mounted on revolving platforms, and placed them in a garden of plastic mylar rocks—originally part of an earlier installation, based on Japanese rock gardens. Video footage of cherry blossom images played over the landscape and the rotating figures.

Adam moved slowly in a stately fashion, the smaller Eve was faster. Embedded in various parts of their bodies and faces were miniature monitors.

In Adam, the monitors showed rough footage of a man talking and climbing up and down a ladder in a studio. In Eve's monitors was footage which Kubota had taken of Kyoto's Golden Pavilion—jerking up and down and zooming in-and-out-of-focus.

### Readings from My Diary, No. 4, October 26, 1995
[accompanied by Kubota's video footage of the Golden Pavilion]
Dear Diary,
I now realize that for me leaving Duchamp—and I did not write on him again after this 1991 essay on Kubota—was, in effect, leaving modernism.

Kubota was, perhaps unwittingly, my guide in this, just as years before Smithson had first instilled in me a desire to "talk back" to Duchamp.

By the time I wrote on Kubota, I had become intensely involved in cross-cultural art, activism and experimental writing. In retrospect, I now see the American Museum of the Moving Image catalogue essay as an expression of my parting of the ways with Duchamp, a rueful and affectionate but necessary parting.

For me Kubota supersedes Duchamp as a paradigm for postmodern negotiations. She makes Duchamp's insular ways seem a little old fashioned, a little outdated.

Certainly, Kubota is a model in how to negotiate with Duchamp. She uses him as a springboard, enjoys him, generally makes peace with her seductive paternal ancestor—and then moves beyond him.

But I also now recognize more fully why I was, and am, so deeply drawn to Kubota's work. In her art, Kubota offers much more than advice on how to deal with Duchamp.

Duchamp arrived in this country fully formed, and was remarkably insular to any encounter with this new culture. Kubota was not.

Kubota was and is interested in cross-cultural journeys, in cultural transitions, divides and hybrid states of identity—and this is what increasingly has fascinated me, as an immigrant to this country, in American art and life.

In *Broken Diary: Video Girls and Video Songs for Navajo Sky*, Kubota listens to the Navajo language and relates it to Japanese. Her video, *Broken Diary: My Father* oscillates between Kubota sitting mourning in her New York studio, and footage of an earlier visit to her dying father in Japan.

In the United States, Kubota lives consciously in a hybrid world, a world governed—as Guillermo Gomez-Peña has written—by a new paradigm, the "Multicultural Paradigm."[19]

### Musings to the Audience, No. 6
[accompanied by a slide of Duchamp's *Paris Air*]
Kubota's work is light years away from, for example, Duchamp's *Paris Air*, a work I still enjoy—that charming, witty present that he made in Paris in 1919 to bring back for his American friends, Louise and Walter Arensberg.

### Readings from My Diary, No. 5, October 27, 1995
[accompanied by a slide of Faith Ringgold's *Dinner at Gertrude Stein's*]
Dear Diary,
Until today I have not known how to end this presentation—and it's for tomorrow. A little unnerving.

Now I've got it, a runaway ending of The French Collection Series by Faith Ringgold, a wry homage to French modernism, and a great example in art of "talking back."[20]

Ringgold appreciates French modernism but she's decided to revise it more to her liking.

In her *Dinner at Gertrude Stein's*, from The French Collection Series (a twelve-part story quilt of images and handwritten texts), she presents a narrative about a fictional young African American, Willia Marie Simone. Ringgold's heroine moves to Paris at the beginning of the twentieth century, and for the rest of her life lives there, an expatriate artist—model—café owner.[21]

In order to learn how to be an artist, Willia Marie models for Picasso and Matisse, and finds out more about modernism by attending a dinner party at Gertrude Stein's.

In the text of *Dinner at Gertrude Stein's*, Willia Marie—who stands in white to the left of the group—writes to her Aunt Melissa about this evening: "I was being listening and quiet and standing so that I would not miss anything from sitting."[22]

What she listens to are exchanges between different dinner guests.
"Of the six men being and talking with Gertrude, three of them, Richard Wright, James Baldwin and Langston Hughes, were being colored and three of them were not [Pablo Picasso, Ernest Hemingway and Leo Stein]. . . . My favorite event of the evening was Zora Neale Hurston reading from her comedic play, *Mule Bone*. Zora is being and making a classic of the black folk culture and language we are always being so ashamed of . . . Zora was being and telling the story of the 'bama nigger' who struck his rival with the hock bone of an ole yaller mule."[23]

Willia Marie ends the account of this evening by telling her Aunt Melissa, "Then speaking to myself only saying, 'I leave here with this thinking—a "bama nigger" is a Mississippi pickaninny, is a jewel, is a rose, is a hock bone, is an old yaller mule—and a man is a man is a woman, and there is no there, here.'"[24]

In an interview I did with Ringgold about this story quilt, she states:
> My process is designed to give us "colored folk" and women a taste of the American dream straight up. Since the facts don't do that too often, I decided to make it up. It's important, when redressing history as I am doing here, not to be too literal or historical. It will spoil the magic. Who knows what could have been? I can only dream what we would have done if those of us

who were closed out of the mainstream of American life here
and abroad could have had our choice—who we would have
known and been close to. It is worth thinking about and pictur-
ing certain people together, like the ones in *Dinner at Gertrude
Stein's.* Whether they were or not, they should have been. In the
process it makes me feel included. That is the real power and joy
of being an artist. We can make it come true. Or look true.[25]

Ringgold is currently planning her sequel to The French Collection Series. Its
title is The American Collection and it's the story of Marlena, Willia Marie's
daughter, who lives in America. Like her mother, Marlena is an artist. Recently
I asked Ringgold if she was going to include Duchamp among The American
Collection's cast of characters. She said she hasn't quite decided yet but that she
might. But then again, she might not. Marcel Duchamp is not an artist Ringgold
finds particularly interesting.[26]

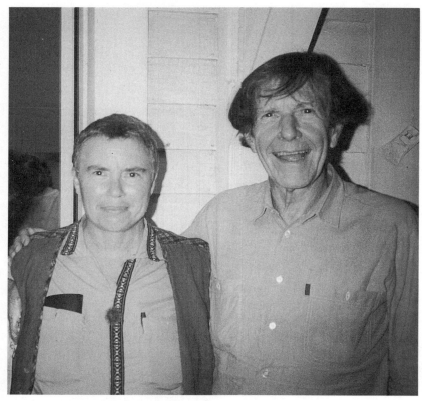

Paulina Oliveros and John Cage, New York, ca. 1977.
Photo: Susan Quasha

## "Five Stories about St. John, Seven Stories about St. Pauline, Surely There Is Trouble in The John Cage Studies Paradise, and Readings from Today's Headlines of the *New York Times*"

In November 1995, I was part of a conference/festival, "Here Comes Everybody: The Music, Poetry & Art of John Cage," at Mills College, Oakland, California. Organized by David Bernstein, this five-day event consisted of lectures, panels, and concerts. I was to give a fifteen-minute presentation on November 19 in the last plenary roundtable, entitled "Here Comes Everybody: John Cage and Fin-de-Siècle Politics, Culture and Society." (The other members of the panel were Maryanne Amacher, Charles Hamm, George Lewis, Marjorie Perloff, and Joan Retallack.) What follows is an edited version of my four-part performance text.

A month before, I had written down a series of short memories about Cage ("Five Encounters in Four Minutes and Thirty-Three Seconds") but decided to attend the conference before completing my presentation. Despite the interesting gathering of people from both Europe and the United States and the vast range of material and information, I became somewhat restless and impatient, as the days progressed, with the

recurring hagiographic tone of many of the lectures and exchanges. As I sat listening in one session, I found myself thinking: well, if we are going to talk about saints, why not something about St. Pauline? Later that day, I wrote seven stories about Pauline Oliveros, a composer whom, like Cage, I had known for many years. Early on the morning of my panel, I composed a manifesto-like, nine-part litany ("Surely There Is Trouble in The John Cage Studies Paradise"). I also decided at that time to end the performance with a reading of the *New York Times*'s headlines—regardless of what was in them. I read the texts in differently modulated voices: gentle (the Cage stories), slightly more intense tone (the Oliveros stories), and a staccato rhythm (the Cage Studies Paradise section). For the dramatic finale—holding up the bulky pages of the *New York Times*—I read their headings like a TV news announcer.

# five stories about st. john,

## seven stories about st. pauline, surely there is trouble in the john cage studies paradise, and readings from today's headlines of the *new york times*

## moira roth

part 1. five encounters in four minutes and thirty-three seconds (written early one morning in october 1995)

1. My memory of first meeting Cage is a mortifying one. In the spring of 1951, I had escaped from my strict father in Washington D. C., and was staying for a month in New York. I was involved with a student from Black Mountain College, and we would spend evening after evening visiting Cage and his friends. I had wanted to meet "real" artists and composers and so felt concerned about this waste of my valuable eighteen-year-old time in the city. Later when writing on Cage, I desperately looked for a diary from this time but realized that I hadn't kept one.

2. During the spring of 1969, while teaching for the first time in Bloomington, Indiana, I heard that Cage was doing a big concert in Urbana, Illinois, with eleven harpsichords, strobe lights and all sorts of slide and film projections.[1] I decided to bring over some hundred students by bus. Among them was a young man so painfully shy that he never looked up at me and would stutter when asking ques-

tions. That evening, I saw him laughing wildly, balling up the concert programs and tossing them up in the air like a juggler. People had formed a circle around him to watch. Toward the end of the evening the young man saw me at a distance and bounded over to hug me. He talked excitedly and I saw his eyes for the first time.

3. In 1971 I was working on my dissertation about Marcel Duchamp and decided to do a series of interviews. Cage was one of Duchamp's closest friends, so I did the first interview with him. As I had neither conducted an interview before nor ever used a tape recorder, I was very nervous. I kept repeating my questions in an agitated voice, not giving Cage a chance to think about his responses. I couldn't stand the silence. When the edited version of the interview was published, Cage liked it so much that he chose it as his text to read at a symposium for a big Duchamp retrospective.[2] I heard about this and wondered how he had read out my questions. Calmly?

4. I once went to a Cage concert in the late 1970s. I had often seen him perform, and was daydreaming when I suddenly heard laughter. Cage had said something funny, and the audience responded. When everyone had stopped laughing, one person in the back still continued. Like a bird responding to a mating call, Cage laughed back. A duet ensued between them. It is all I remember of the evening's music—the laughter of Cage and that of the unknown man.

5. I spent a week or so in Ponape, in the South Sea islands, in 1980 with a group of artists and critics, among them Cage.[3] Each evening, one or more artists gave a twelve-minute presentation, and Cage was often the first to respond to the speaker. He would ask brilliant questions in a soft voice. During the day he would wander around in the tropical landscape. Wearing an old-fashioned bonnet to protect his head from the sun, he looked for all the world like the nurse in an illustration from an old-fashioned English children's book that I had had as a child.

### part 2. wanting to say something about pauline oliveros (written on november 17, 1995)

1. In her lush garden in Encinitas, there was a poisonous plant, and one day it spat at Oliveros. She ended up temporarily blind in the emergency room, but never had

the plant pulled out. As time went by, I began to think the plant's continued presence in her garden was a way for Oliveros to learn how to pay attention.

2. One weekend I was visiting San Francisco and so was Oliveros. She offered to give me a ride back to southern California and when we returned, everyone asked me enviously what we had talked about for those eight hours. Money, I said, just money. Oliveros had recently gotten into investments, and wanted to teach me everything she knew.

3. I remember Oliveros visiting me in Chicago in 1980 where I was living in a rather dangerous neighborhood. Each morning she would get up early and go into the street to practice her karate. I worried. Not for her but for anyone foolish enough to attack her.

4. Oliveros became restless with being overly consulted on all matters by her students at the University of California, San Diego, and decided to do a performance. It involved a flagpole with large cloth flags inscribed with letters of the alphabet. A lot of people gathered around Oliveros, who sat meditating. Every fifteen minutes she would haul up a single letter. The event went on for several hours. Finally the full message appeared, I AM NOT YOUR MOTHER.

5. I persuaded Oliveros to play the part of Queen Victoria in a large theatrical banquet for one of my art history classes. Awed by her, the students were too shy to measure her carefully for her crinoline. The result was that it was far too small, and she could hardly breathe, let alone move in the costume. Oliveros is a polite and considerate woman. For an hour or so she sat motionless and silent at the table. Finally, increasingly concerned about splitting the rented costume, she left. The students asked me worriedly if she had been angry or bored. No, I said, just constricted.

6. Oliveros once told me how much she enjoyed getting commissions. I decided to contact friends around the country, and each sent her a dollar and a request for a piece. She greatly enjoyed this mysterious mail, and finally did a *Cheap Commission* for one of them. I wanted to commission a work, too, but felt that I should pay more for mine so I offered her five dollars. Oliveros wrote me a text, "Singing in Private Places," as she knew I had been labeled a "non-singer" in my English progressive school, and had never sung in public after that. For the next

few weeks I spent a lot of time singing loudly in cupboards, baskets, and the shower. The neighbors must have thought I was mad.

7.  For Christmas in 1976, Linda Montano made a small book, *Pauline's Proverbs*, which cost $3.25. I often consult it. Among my favorite proverbs are:

> The first principle is knowing what you want to do and proceeding to do it until somebody pays you for it.

> If you get one thing, the universe will come along and show you something else.

> I'd rather be a guru than a disciple.

> Keep your feet on the ground. Take Vitamin B. And breathe deeply.

> People always forget about maintenance and prevention.

**part 3. surely there is trouble in the cage studies paradise (written early in the morning of November 19, 1995)**

1.  I find canonization of any artistic persona not only deeply disturbing but deeply questionable.

2.  I find equally unconvincing the notion of the all-liberating and "above-it-all" avant-garde.

3.  Mostly, I am concerned with what is erased in order to erect these fictions.

4.  I see John Cage as an extraordinarily inventive, interesting, durable, seductive, charming, lovable and controlling figure, confined and focused—as are we all—by his various contexts.

5.  Not all of his contexts have been aired at this conference. Notably missing among them is his relationship to gay culture in his life, work, and career. To me this is astonishing—the almost total lack of discussion concerning the context of gay politics and any recognition of queer theory.

6. I am equally surprised by the presentation of him for the most part as being—I don't know how else to describe it—above gender. I gather that there are feminist scholars, Jann Pasler, for example, in music history and theory concerned with gendered readings of Cage but they are not here. That's a great pity as I think we would have benefited from their readings.

7. Although I abstractly love the conference's title, "Here Comes Everybody"— it's so festive—I don't think everybody has either come here literally, or metaphorically, or that Cage has indeed things to offer "everybody." In the desire to present Cage as a universal genius, there has been too little recognition of his own cultural focus, tastes and biases. There have been by my count—with the exception of George Lewis—no people of color on any of the panels, and there are thirty-six participants. The audience is also almost exclusively white. Why? Surely something to be acknowledged, but it hasn't been until now.

8. My sense is that the panels and the audience are made up, for the greater part, of people who knew Cage personally—were either close friends or at least colleagues who worked with him. In a conversation with Ray Kass yesterday, he said that he felt this conference was a special opportunity for people to gather to mourn the loss of Cage collectively, and to celebrate all the things they loved in him.[4] Certainly there are many reasons to love John Cage as well as to celebrate his great intelligence and inventiveness—but why the overall singularly uncritical tone to all this?

This is, after all, a conference and not a memorial. Also I've always thought a love affair with a saint would have rather a lot of drawbacks—too many relics around, not to mention devotees—and that flawed human beings with an edge (and Cage certainly had an edge) are more interesting. This "edginess" of Cage seems to be disappearing with his elevation to sainthood.

9. In yesterday's panel on "Cage's Influence" someone talked about his relationship to the world, using the metaphor of freeway sounds. I myself would never turn to Cage's sense of "politics" for guidance, anymore than I would ask a blind man to direct me across a busy thoroughfare.

But that aside, I thought it might be salutary to conclude by reading aloud a few of the headlines in today's New York Times. After all the title for this last panel is "Here Comes Everybody: Fin-de-Siècle Politics, Culture and Society," and here

we are together at the end of the twentieth century. What's going on in politics, culture and society these days?

part 4. readings from today's
headlines of the *new york
times,* november 19, 1995

HAITIAN LEADER'S ANGRY WORDS SET OFF NEW WAVE OF VIOLENCE

ARE WELFARE CUTS A FOSTER CARE BURDEN?

CONGRESS CANCELS PLANS TO TAKE OFF FOR WEEKEND;
NEW BUDGET HOPES FADES

VATICAN SAYS THE BAN ON WOMEN AS PRIESTS IS "INFALLIBLE" DOCTRINE

WITH A HANDSHAKE, RABIN'S FATE WAS SEALED

CULTURE AND RACE: STILL ON AMERICA'S MIND

*Morphine,* from Fin again(s) Wake series, 1988

Borrowing from John Cage's borrowing of *Finnegan's Wake,* by James Joyce, Lemcke, a San Francisco artist, repositions chance operations into an expressly political context in his fourteen-part pencil-on-paper series. The Cagean acrostics here spell out the name of AIDS drugs, using words carefully selected from Joyce's text.

**Difference:** 1. condition, quality, fact or instance of being different 2. the way in which people or things are different, esp., a determining point or factor that makes for a distinct change or contrast 3. the state of holding a differing opinion; disagreement, also, the point of issue; point of disagreement 4. a dispute; quarrel 5. a discrimination or distinction—**make a difference** 1. to have an effect; matter 2. to change the outlook or situation 3. to discriminate or differentiate; give different treatment.
—"Difference," *Webster's New World Dictionary*

# difference

## jonathan d. katz

### Where To Make A Difference

IN THE FALL OF 1995, MOIRA ROTH GAVE
two lectures on Duchamp and Cage, her
first work in over fifteen years to focus
solely on these figures. She'd been writ-
ing, working in diverse local and national
coalitions and networks, and teaching for about a decade at Mills College, a
women's college in northern California. That spring, I had just completed a dis-
sertation entitled "Opposition, Incorporated: The Homosexualization of
American Art." In 1995, too, I assumed the chair of the Department of Gay and
Lesbian Studies at City College of San Francisco, still the only such department
of gay and lesbian studies in the United States. Moreover, and at around the same
time, I founded what would soon become known as the Harvey Milk Institute,
a center of community-based lesbian/gay/bisexual/transsexual higher educa-
tion, organized to offer a range of classes that would have been impossible to
offer in a more formal academic climate.[1]

Needless to say, my plate was full.

By now, Roth had for a considerable time successfully modeled a way of

negotiating similar conflicting demands. Indeed, in 1994 she received an honorary doctorate from the San Francisco Art Institute for her art activist work. Her scholarship at the time tended toward short but pithy engagements with the work of American artists, primarily women, of highly diverse backgrounds — in both written and lecture formats, and often in a diaristic mode.

In my scholarship, I was exploring the connection between the social historical terrain of the 1950s and the unlikely dominance of white gay men in the American post–abstract expressionist avant-garde. My goal was to historicize what is now increasingly understood as an originary moment in the development of postmodernism in America through reference to the trials and survival strategies of queer artists under McCarthyism. In querying the work and critical success of such "blue chip" figures as Cage and Cunningham, Johns and Rauschenberg, Twombly and Warhol, I wanted to reposition gay studies from a position at the periphery of art historical discourse to a central place at the table.

Roth, on the other hand, happily spent the year at other tables. She had just finished editing Faith Ringgold's *We Flew over the Bridge: The Memoirs of Faith Ringgold.* She also wrote an essay entitled "A Meditation on Bearing/Baring the Body" for the anthology *Reframings: New American Feminist Photographies* and her 1991 essay, "Reading between the Lines: The Imprinted Spaces of Sutapa Biswas" was reprinted in *New Feminist Art Criticism.* Consequently, her forays into Duchamp and Cage studies played a relatively limited role in her intellectual life at the time.

I can remember little more of 1995 beyond a feeling of constant exhaustion but, as I reflect back, I am struck by the sheer hubris of taking over as department chair, writing a dissertation, and starting a community institution all in the same year. But I felt strongly then, and I still do, that these activities were all linked, that I genuinely couldn't do one without the other, despite how different each of these endeavors may seem. Grassroots organizing, scholarly intervention and the challenging of academic strictures—these have long constituted the triad of my attempts to make a difference.

Moira Roth's, too. In 1995, she organized volunteers for an international conference on The Names Project AIDS memorial quilt, and coorganized a national panel on "Developing a Culturally Diverse Curriculum" at the College Art Association's annual meeting in San Antonio. On October 18, she cochaired "(Dis)oriented: Asian American Women's Artists Conference," and then, less than two weeks later, she was in L. A. talking back to Duchamp.

It all feels a little schizo, this combination of activism and scholarship. The idea of the academy is often constructed precisely in opposition to this sense of community-based organizing. Yet, there are a substantial number of academics who straddle what have been presented to us as opposing worlds, unconvinced of their polarity. It sometimes takes a lot of awkward juggling to do this, but then it's never easy to speak two languages at once. Nonetheless, they are but two languages. What they describe, we are convinced, remains unchanged.

Despite our different subjects and different strategies, as I see it, Roth and I had a lot in common that year. We were both in the middle of long-standing attempts, along with many other colleagues, to challenge North American art histories—in similar ways and for similar reasons—despite our very different routes toward achieving that goal. The rest of this essay will explore our common purposes and our differing modalities as we pursued what some might call the paradox of academic activism.

We share an interest both in strategic interventions into the mainstream of scholarly discourse and the somewhat more archaeological project of expanding the field of knowledge through unearthing the unknown. My unknowns involve new readings and new evidence about some of the most famous and talked-about artists in American cultural history. I work within the canon trying to reform it. Roth stakes a place outside, unconcerned with canonical authority.

Over the course of many months and a continuously developing friendship, we have begun to consider what we have in common and what—given our different generations and alliances—we don't. In areas and approaches where we agree to differ, we are nonetheless glad each other is doing what (s)he is doing. The following is an account of our strategic differences and our common imperatives.

## difference: 5. a discrimination or distinction

In any discussion of strategies, I find myself thinking about theory. Theory for me here simply means the modeling of how something works in the social. So strategies, as far as I am concerned, require a grasp of theory, though theory need not necessarily operate strategically—and often doesn't. For all they share, I am inter-

ested in drawing a distinction between theory and practice because there is a prominent argument going on at the moment that asserts that theory is a form of practice.

Partisans to this theory consequently understand theoretical interventions as an activist and engaged social practice, arguing that the theory/practice binary is ripe for deconstructive redefinition. Within this theoretical framework, Cage has been "discovered" as a prescient progenitor, his voluminous writings on the unity of art and life now classical prefigurings of the postmodernist sensibility. Years before Derrida, Cage seems to have been engaged in the deconstruction of the kind of polar relationship between theory and practice that postmodernism would come to endorse. And his oft-stated desire to make art and life (read: theory and practice) the same thing is now regularly invoked as evidence of a new, distinctly antimodernist, antiphallocentric, antiauthoritative approach to meaning. After all, Cage sought, in his words, "to just erase the difference between art and life."[2]

Through the trope of silence, Cage thought he had found one such eraser. But if we examine closely the validity of his claim, we will find that it didn't quite work out as Cage would have us believe. The efficacy of Cage's silence as an aesthetic trope is in fact entirely dependent on its distinctly artistic context. Outside the concert hall, silence just doesn't sound the same. Given that in art and life there are separate signifying environments for silence, it follows then that we have to recognize a distinction between Cage's theory of silence and the everyday practice of it—art, in short, is different from life.

While it is certainly true that Cage advocated an erasure of this distinction, it is equally true that he didn't succeed. As I see it, he couldn't have; no one can. Context seems to be a determinant, and art, even art that claims its identity with life, simply can't will it away.

Now, as a good student of the postmodern, I could easily deconstruct these art/life, theory/practice binaries, and argue, as have so many of my colleagues, in favor of the mutual implicativeness of these terms. Indeed, this has become an almost routine exercise. But what would be the point? The fact is that binaries like art/life and theory/practice do important work, helping to describe and distinguish significant differences among a range of possible contexts for meanings, even if they ultimately produce an effect of power and control. In other words, I could contest these binaries, but to do so would be disingenuous since I use them myself, as do we all, and for good reason.

Equally we could try to mitigate this art/life distinction through reference to Cage's works themselves. For example, a careful reading of his published texts might offer firm ground for arguing that his work cannot be properly confined to the realm of art in the first place, that he very much understood his aesthetic as never less than a form of social practice. I have made precisely this argument myself.[3] But again, what would be the point of making such an argument here, when it seems quite clear from an even glancing acquaintance with Cage studies that his work was very much confined to the realm of what we can agree to call, with suitable embarrassment, "high culture," a term used precisely for its ability to mark a difference from everyday life. Indeed, even most of us seriously engaged with Cage's ideas on a regular basis do not bring them into our daily life—despite our familiarity with the master's assertions. They remain a form of thinking about art.

Thus in the face of our objections—themselves inspired in part by Cage's own visions—is it the case that his art does remain ineffably different from life and his theory from his practice? Or at least, in the ordinary world where all of us actually live? And is any attempt to deny this difference at best false consciousness, and at worst a seduction away from the materialist realities of an often inequitable social practice toward that seductive phantasm of an art utopia?

In 1995 Moira Roth sought to intervene and make trouble in the settled calm of the Duchampian and Cagean hagiographic projects by asking these sorts of questions. Her goal was to adumbrate the series of exclusions implicit in assuming the successful erasure of difference between art and life, theory and practice. And one way of doing so was to force the spurned or overlooked partner in this utopia—life—back into the discussion. She did so through auditioning precisely the kind of materialist realities the art world (a term itself denoting a separate structure from the life world) denies. Through reading headlines, or talking back to the master, Roth sought to restore to this work a sense of context and contingency that the larger postmodernist critical culture seemed to her invested in denying.

Taking potshots was thus a carefully considered policy of resistance. You have to be able to stand outside of something in order to shoot at it. And Roth very much wanted, for all her earlier work, to stand outside the contemporary critical situation, to challenge the authoritative Cagean discursive context without serving it. To have done otherwise (to have given a traditional academic paper) would have risked suturing precisely what she sought to disrupt, allowing

the art world to set itself up as the sole arena in the contestation of meaning and value in the work of these artists. Reading the headlines of the *New York Times* broke through that contextual limitation and injected a powerful real world imperative to the discussion of art and life. The fact is that headlines signify differently when read on the A train or inside a university-sponsored symposium. Roth wanted to make that difference clear.

**difference: 3. the state of holding a differing opinion; disagreement, also, the point of issue; point of disagreement**

I do a very different kind of work. I'm not in the least interested in taking potshots, at least not in this scholarly arena. On the contrary, I have pursued a more traditional academic approach in sustained exegetical project. But in raising issues of sexuality, identity, and audience in a social-historical consideration of the Duchamp and Cage circle, I hope for what Roth wants as well: a recalibrating of our critical apparatus to include precisely the kind of questions that the celebrated seamlessness of art and life has nonetheless successfully occluded.

In my first commentary earlier in this book, I criticized Roth's notion of indifference as perhaps too unnuanced to adequately account for the particularities of queer resistance within the policed context of Cold War America. I drew that critique from my personal experience as a gay man, and I further claimed that Roth didn't see certain things because of her own experiences with, and immersion in, feminist resistance in the 1970s. In arguing that certain forms of personal experience prepare one for certain forms of knowledge, I thus personalized the scholarly modality in a rather direct, although I hope unessentialized, way —unessentialized because this relationship between experience and knowledge is neither absolute nor necessary. And my point is that not only is theory separate from practice, but moreover, that life or practice influence theory even at its point of origin, through the person of the originator.

There are relatively large numbers of academics for whom the seemingly isolated production of scholarship constitutes a mode of active engagement with the social. That's true, up to a point, for Roth and myself as well. But that's not all we do, and if it were, I'm not sure we could properly claim the title

"activist-academic," especially if theory and practice are the largely distinct realms of engagement I'm claiming they are. But remember, feminism didn't produce the women's movement. It was the other way around. And queer studies *followed* developments in queer liberation.

Despite our different competencies, I understand our academic activism as complementary. Although Roth comes out of a feminist academic tradition, and I am in queer studies, I consider myself an heir, and I learned from feminists and assimilated certain modes of feminist analysis from my earliest days in graduate school. Indeed not only am I unwilling to cede feminism to women, moreover I want to claim feminist insights (both lesbian and not) as foundational to the development of queer studies.

### difference: 1. condition, quality, fact or instance of being different

We were just talking about activism, Cage, and Duchamp. The question then is what's in that discussion for us? For Roth, taking potshots originated out of an increasing irritation with the uncritical assumption of Duchamp and Cage into the pantheon of the American cultural firmament. But it was a heaven built just for them—too rarefied for her liking. And the problem is that if heaven looks like Duchamp and Cage, then the admission requirements were forged, at best, during mid-century, with all manner of exclusions in force. To hear the guardians of heaven tell it, however, their standards are at the cutting edge— though anyone talking about identity and exclusion at the pearly gates is automatically remanded back to the 1970s.

We need to thus think critically why it is that Duchamp certainly has, as Roth indelicately puts it, a tendency to "keep[s] popping up just when you think he is dead."[4] And the answer is, at least in part, that he's been very useful to the gatekeepers.

Despite what today seems like a general Duchampian white noise as the requisite accompaniment to so much twentieth-century American art history, these reappearances from the grave have hardly been continuous. Rather somewhat locust-like, it is as if Duchamp returns from his underground stasis at regular intervals, seemingly—and conveniently—reappearing when he has a job to do.

And by my accounting, he has been back three times in U.S. art history, which is to say that three distinct periods of Duchampian presence stand marked above the rest for the extraordinary power he wielded within the art and art critical worlds. The first appearance coincided with the heyday of New York Dada, of which he was, of course, a prime architect—between 1915 and the early 1920s. Here his appearance helped to solidify American claims to presence in the modernist avant-garde. The second is his reemergence into discursive prominence through, among others, the efforts of the Cage circle in the early 1960s, perhaps best capped by Merce Cunningham's performance of *Walkaround Time*, to a set designed by Jasper Johns after Duchamp's *The Large Glass*. In my first response to Roth, I suggested some of the reason's why Duchamp appeared so useful to queer artists from this mid-century perspective.

Then he died, and this third period of his influence, roughly the contemporary moment, is marked by the increasing power and prominence of a postmodernist artistic discourse, one in which meaning is increasingly decentered from artist to audience. For an account of Duchamp's utility today as the paradoxical postmodern papa of an antipatriarchal, antiauthorial practice, let me suggest Amelia Jones's excellent book, *Postmodernism and the En-gendering of Marcel Duchamp*.[5]

To note Duchamp's appearance at each of these historical junctures is to witness the remarkable malleability of his creative legacy and its uncanny utility to a wide range of cultural concerns and contexts. Remember, he turns up rather chattily in conversation with Roth herself in "Talking Back." So, in order to frustrate the highly agreeable nature of Duchamp and his acolytes, and their concomitant tendency to co-opt any strategy of resistance into their own oppositional postures, Roth made a series of strategic decisions in the mid-1990s. In her "Talking Back" and "Five Stories about St. John," she sought to bring to bear only a certain kind of engagement with the subjects of her analysis, to keep them at arm's length.[6]

**make a difference: 1. to have an effect; matter**

Duchamp and Cage, it seems, are going to be around a while this time. They are just so endlessly useful. And so I am less interested in performative style

interventions than in a sustained academic reassessment—in part because, unlike Roth, I can now use this current reemergence to my purposes. At first, I didn't know how to write on Duchamp here, mostly because I tend not to write on people who aren't queer. But I came to realize that there were in fact a number of queer readings available to me of the work of Duchamp, even though he was from almost all accounts straight. And I found that I could piggyback a lot of my issues on Duchamp's and, of course, Cage's broad shoulders. What better vehicle for the discussion of sexuality and identity than some of America's most salable artist-intellectuals? And so, let's use them.

## make a difference: 2. to change the outlook or situation

Many of the dominant theoretical voices involved in the decentering of author-ity and meaning from authors to audiences were themselves queer. Theorists like Roland Barthes, Michel Foucault, Craig Owens, and Susan Sontag all con-tributed to the construction of new analytical foci no longer concerned with questions of truth and authorship. This has occasionally been noted before, but what has not been discussed is the importance of this seeming connection between postmodernist theoretical precepts and sexuality. It is also, of course, no accident that a number of the "proto-postmoderns," too, were queer—that is Cage, Rauschenberg, Johns, Warhol, and others. Nor is it mere happenstance that many of the chief theoretical voices in the formulation of postmodernist practices were also queer.

This is a topic beyond my scope here. But I nonetheless want to suggest that in part, this queer presence in postmodernist discourse reflects a historic recognition that categories like "truth" can, in the wrong hands, become weapons against queer people, among others. As queer people we have histor-ically never known the prospect of holding and owning our own meanings. This implies that meanings have always quite palpably come from the outside and were imposed—occasionally violently—upon us. The shared experience of the closet has moreover made very clear the fluidity of signification: identity (and thus meaning) was made entirely situational and thus, without any authentic core.

make a difference: 3. to dis-
criminate or differentiate; give
different treatment

In the present postmodernist moment when Duchamp and Cage, like Virgil in the *Inferno,* have been brought back from the dead to guide us into our own future, all such readings are now authorized: queer readings of Duchamp, queer readings of Cage, feminist readings of Duchamp, feminist readings of Cage and others. In the free play of a decentered readerly relation to meaning, authority and authorship are freely shared.

But Moira Roth would point out that this is hardly a freedom. The parameters of the discussion are nevertheless profoundly circumscribed. We are after all still just talking about Cage and Duchamp, no matter what the interpretative frame, and their power and presence remains undiminished as they continue to occupy such a significant portion of our intellectual and interpretative energies.

How then to move from a discussion of Duchamp and Cage in which they still dominate and control the discursive context toward one which broadens the frame to include all those figures who stand beside, behind, and even in front of them? The question at hand is whether we want our postmodernism, our decentering discourses, to include an understanding of the civil rights movement, feminism, lesbian and gay liberation, and a host of social activist movements that challenged dominant cultural narratives without reference to text. Uncentering can also mean voting rights, can mean affirmative action, can mean the ERA, can mean antigay and antilesbian discrimination ordinances and domestic partnerships. But so far our postmodernisms have been too narrowly conceived.

Unlike Roth, I want to keep talking about Duchamp and Cage. But I want to begin by pointing out what it meant that Duchamp wore a dress, and that John Cage loved Merce Cunningham. And to do that, I must make reference to social history and social actors, to political movements and shifting identities, and all the other stuff of culture that operates on authors and audiences alike. And I want others to make Duchamp and Cage theirs, to read exclusions and opportunities in them I didn't see. We should talk it out, using all the resources and venues once closed to the kind of work we do. But we have a long row to hoe before we can even think about erasing the distinction between art and life. First we have to get them talking.

# appendix

## "Duchamp Festival, Irvine, California, November 1971"

In 1970, I left Berkeley to teach at the University of California, Irvine, in southern California, where I taught until 1972. Among my courses was a seminar on Duchamp; the students and I met off campus in the spring of 1971. During the semester, the seminar's participants, Barbara Rose (who was teaching intermittently at U.C.I. at the time) and I began to design a "Festival" about Duchamp, which consisted of an exhibition, conference, and a series of happenings and events done by artists and students. Over the months preceding the festival, the students also created various events around the campus.

Many scholars and artists participated in the three-day conference: David Antin, Susi Bloch, Nina Bremer, Jack Burnham, Willis Domingo, Richard Hamilton, Walter Hopps, Robert Hughes, Allan Kaprow, Alison Knowles, Annette Michelson, Robert Pincus-Witten and Peter Selz. Anne d'Harnoncourt of the Philadelphia Museum of Art and Kynaston McShine of The Museum of Modern Art, who were working together on the major 1973 Duchamp retrospective, were in the audience. Charlemagne Palestine and Simone Forti contributed a collaborative performance, and Tony Delap,

an amateur magician as well as sculptor, created a levitation piece.

Due to the informal style of the festival, the documentation was not preserved. In 1990, however, Hannah Tandeta, a then-student participant, and I recorded our memories of the festival. These, accompanied by Robert Pincus-Witten's diary entries and comments by Tony Delap, were published in *West Coast Duchamp*, edited by Bonnie Clearwater (Miami Beach: Grassfield Press in association with Shoshana Wayne Gallery, Santa Monica, CA, 1991). For this book, I have further edited our text.

# duchamp festival
## irvine, california, november 1971 (excerpts)

# moira roth
# and
# hannah tandeta

**Hannah Tandeta:** People came up with a lot of ideas for the event that were not specifically for an exhibition; that's why *festival* was a more appropriate name for the activities than *symposium*. Many of the best projects involved the *Mona Lisa*. We reproduced the painting on cheap 8$^{1}$/2-by-11 inch paper and printed up pencils with Marcel Duchamp's name in gold, which we attached by string to the paper. We pasted these reproductions with the pencils all over campus and people could draw in mustaches [as in Duchamp's *L.H.O.O.Q.*] or whatever. I remember the penciled-in contributions to the *Mona Lisa* as being very effective. In one, someone had very beautifully inked out the image except for the face and hands.

**Moira Roth:** And someone planted Duchamp's name in seeds on the hillside opposite the gallery. Another student went into classrooms and would whisper things about Duchamp to people and then leave the room mysteriously.

**HT:** What we were doing in our art classes at the time was conceptual art, and the beginnings of performance. And Duchamp, that charming, magnetic figure, was important as a source and justification for such ideas.

**MR:** Irvine was a school that had a stream of very influential visitors. At the time of the festival, Lotte Lenya, the German singer of Weimar fame, was there to perform Brecht's *Mother Courage*. The campus was in the center of experimental art in the early 1970s. Chris Burden was there as a graduate student, as were Nancy Buchanan and Barbara Smith. There was F-Space, which housed private performances by students with other students as their audiences. Some of the most significant early performances in Southern California were done there.

Because U. C. Irvine was that kind of school, it made the collective spirit of the festival easy. For example, Barbara Rose and I discussed how to do things without funding, as there was none! Barbara got free airline tickets for people to come from the East Coast. To our enormous pleasure Richard Hamilton flew out from England, and not only spoke, but volunteered to help on the exhibition's installation.

The exhibition was a relatively minor event. I went to the Pasadena Art Museum, for example, and borrowed the *Green Box*. We also collected various minor works by Duchamp and related works by contemporary American artists from the 1950s and 1960s.

A pivotal 1967 piece was contributed by Alison Knowles (who was then at CalArts)—one that deliciously posed many questions about authorship and the difference between an artwork and a gesture. Knowles was trying to reproduce exactly (for the cover of a book by Emmett Williams) Duchamp's 1936 *Cahiers d'Art* design in which red and blue "fluttering hearts" appeared to vibrate. A year before Duchamp's death, Knowles visited him in New York with several color swatches on black paper. While they were having tea, Teeny Duchamp noticed the color swatch that Duchamp had selected, and asked if it was a new work of his. Duchamp smiled and immediately picked it up and signed it. No one discussed this "act," and shortly afterwards Alison left.

This object was taken home by Alison, who later consulted Teeny Duchamp, Richard Hamilton, and Arturo Schwarz. They, and Alison, felt it was a gesture and that it wasn't an actual work by Duchamp, but rather a memorabilia piece. (Incidentally, at the time, Dick Higgins, then Alison's husband, thought it should be insured as a Duchamp work.)

I put this "art gesture" in the exhibition. Because of the perplexities about whether it was or wasn't a work by Duchamp, however, I never got around to putting a label on it. Thus, for the duration of our exhibition, it hung unlabeled. Today I would find that somewhat unscholarly and would write a long

analytic label about the story of the work's origin, and about the "problematics" it presented. I think, however, this was typical of the period—that in 1971 I would feel perfectly comfortable including an unlabeled work.

**HT:** The invitation for the festival read: "You are invited to attend the opening of 'DUCHAMP IS . . .' on November the sixth [1971]. There will be a 6 P.M. cel-ebration on the grass at the Art Gallery. Perhaps you could bring bread and cheese to share. Opening ceremonies 8 P.M., Concert Hall."

The phrase "perhaps you could bring bread and cheese to share" takes me back to those early times because it was so casual an approach, so unstructured . . . a kind of "hippie" esthetic. You depended upon the egalitarian instincts of your friends. It didn't need to be orchestrated, it would just happen.

# notes

## note *to* foreword

1  Jonathan Katz, "John Cage's Queer Silence or How to Avoid Making Matters Worse," from a forthcoming book, "*Here Comes Everybody*": *John Cage*, edited by David Bernstein.

## notes *to* introduction

1  Among the recent publications on Duchamp are Martin Bushkirk and Mignon Nixon, eds., *The Duchamp Effect* (Cambridge, Mass.: MIT Press, 1996—an expanded edition of the 1993 *October* issue on Duchamp); Thierry de Duve, *Kant after Duchamp* (Cambridge, Mass.: MIT Press, 1996); Amelia Jones, *Postmodernism and the En-gendering of Marcel Duchamp* (New York: Cambridge University Press, 1994); Dalia Judovitz, *Unpacking Duchamp: Art in Transit* (Berkeley: University of California Press, 1995); Jerrold Seigel, *The Private Worlds of Marcel Duchamp: Desire, Liberation, and the Self in Modern Culture* (Berkeley: University of California Press, 1995); and Calvin Tomkins, *Duchamp, A Biography* (New York: Henry Holt, 1996).

Among the recent publications on John Cage are Richard Kostelanetz, *John Cage (ex)plain(ed)* (New York: Simon & Schuster Macmillan, 1996); Marjorie Perloff and Charles Junkerman, eds., *John Cage: Composed in America* (Chicago: University of Chicago Press, 1994); James Pritchett, *The Music of John Cage* (New York: Cambridge

University Press, 1993); Joan Retallack, *Musicage: Cage Muses on Words, Art, Music* (Hanover, N.H.: Wesleyan University Press, 1996); and David Revill, *The Roaring Silence. John Cage: A Life* (New York: Arcade, 1992).

2  See my first story about Cage in "Five Stories about St. John, Seven Stories about St. Pauline, Surely There Is Trouble in the John Cage Studies Paradise, and Readings from Today's Headlines of the *New York Times*," reprinted in this book.

3  Calvin Tomkins, *The Bride and the Bachelors: Five Masters of the Avant-Garde* (New York: Viking, 1965), 109.

4  John Cage, *A Year from Monday* (Middletown, Conn.: Wesleyan University Press, 1967), 133.

5  Revill, *The Roaring Silence*, 102.

6  Moira Roth, ed., *Rachel Rosenthal* (Baltimore, Md.: The Johns Hopkins University Press, 1997).

7  Alexandra Grilikhes, "Taboo Subjects: An Interview with Rachel Rosenthal," *American Writing* 10 (1995). Reprinted in Roth, *Rachel Rosenthal*.

8  Moira Roth, "Two Women: The Collaborations of Pauline Cummins and Louise Walsh, or International Conversations among Women," in *Sounding the Depths: A Collaborative Installation by Pauline Cummins and Louise Walsh* (Dublin: Irish Museum of Modern Art, 1992), 8.

9  Among the most interesting analyses of this complex period are Max Kozloff, "American Painting during the Cold War," *Artforum* 11, no. 9 (May 1973): 43–54, and Serge Guilbaut, *How New York Stole the Idea of Modern Art: Abstract Expressionism, Freedom, and the Cold War* (Chicago: University of Chicago Press, 1983), together with the recent writings of Jonathan D. Katz.

10  Moira Roth, "The Aesthetic of Indifference," reprinted in this book; this citation is from pages 36–37.

11  See the section in Seigel, *The Private Worlds of Marcel Duchamp*, in which the author discusses the possibilities of Duchamp being bisexual or homosexual; Seigel concludes: "if Duchamp were a closeted gay, his secret was very well kept" (198–99).

12  "The Western Round Table on Modern Art, San Francisco, 1949," Appendix A, in *West Coast Duchamp*, ed. Bonnie Clearwater (Miami Beach: Grassfield, 1991), 110.

13  The most direct "gay" discussion with Cage was recorded by Thomas S. Hines and took place just before Cage's death. See Hines, "Then Not Yet 'Cage': The Los Angeles Years, 1912–1938," in Perloff and Junkerman, eds., *John Cage: Composed in America*. See also Caroline A. Jones, "Finishing School: John Cage and the Abstract Expressionist Ego," *Critical Inquiry* 19, no. 4 (Summer, 1993): 643–47.

14  Jonathan D. Katz is in the process of studying a broad spectrum of cultural history in this country through a queer theory lens. He mapped out many of his ideas during the course of research for his dissertation, "Opposition, Incorporated: On the Homosexualization of Postwar American Art" (Northwestern University, 1995), and has begun to write a series of essays on aspects of this vast topic. The first two to be published were "The Art of Code: Jasper Johns and Robert Rauschenberg," in *Significant Others: Creative and Intimate Partnership*, ed. Whitney Chadwick and Isabelle de Courtivon (London: Thames and Hudson, 1993) and "Passive Resistance: On the Success of Queer Artists in Cold War American Art," *Image* 3 (December 1996): 119–42. "John Cage's Queer Silence or How to Avoid Making Matters Worse," from a

forthcoming book, "*Here Comes Everybody*": *John Cage*, edited by David Bernstein.

15  Moira Roth, "Toward a History of California, Part 1," *Arts* 52, no. 6 (February 1978): 94–103. In this essay I wrote that "political energy and political theater of the 1960s are central to an understanding of Northern California Performance.... Political and social protests merged and, in the process, produced visually and theatrically vivid, often strident symbols, images and events that fired the imagination and activated ethical convictions among artists" (94).

16  Moira Roth, "Marcel Duchamp in America: A Self Ready-Made," reprinted in this book.

17  Moira Roth and William Roth, "John Cage on Marcel Duchamp: An Interview," reprinted in this book; this citation is from page 72.

18  In "Marcel Duchamp in America" I attempt to juxtapose Duchamp's American stage with the European traditions of the dandy and the femme fatal, together with his interests in alchemy, in order to develop the notion of Duchamp's fabricated selves.

19  The event's title, *HPSCHD*, was an abbreviation of "harpsichord," as the work had initially been commissioned by Antoinette Vischer, who was deeply committed to commissioning new music for harpsichord.

20  Richard Kostelanetz, "HPSCHD (1969): Environmental Abundance," in his *John Cage (ex)plain(ed)*, 99.

21  As a finale to the last class I taught in Bloomington, my teaching assistants and I created a huge performance for some 250 students: typewriters onstage, boxes for messages and objects, and a medley of slides, films and tapes of student rallies, combined with a reading of Edward Gibbon's *Decline and Fall of the Holy Roman Empire* and Dylan Thomas's "Do Not Go Gentle into That Good Night." A day later, most of us assembled in an outdoor area of the campus to open the huge cardboard box that now contained, among other things, draft cards, photographs, and letters (often poignant) to one another. During the 1970s, I continued with my love of "happenings" and increasingly worked with an interdisciplinary approach in my classes. For example, in 1971, Barbara Rose, students, and I put on the Duchamp Festival at UC Irvine (see an account of this in the appendix to this book). In 1974, at UC Santa Cruz, a group of us organized an all-night candlelit performance of Erik Satie's *Vexations*—a piano piece, one much admired by Cage, to be played 840 times—in the campus gallery as part of an exhibition I had curated of fin-de-siècle art, complete with heavily-scented Easter lilies.

22  Marcel Duchamp, "The Creative Act," in *Salt Seller: The Writings of Marcel Duchamp* (*Marchand du Sel*), eds. Michel Sanouillet and Elmer Peterson (New York: Oxford University Press, 1973), 138, 140. The printed form of this talk was first published in *Art News*, Summer 1957. The original talk was given by Duchamp at a meeting of the American Federation of the Arts, Houston, April 1957, where he participated in a roundtable with William C. Seitz, Rudolf Arnheim, and Gregory Bateson.

23  Roland Barthes, "The Death of the Author" (1968), reprinted in *The Rustle of Language*, trans. Richard Howard (New York: Farrar, Straus, Giroux, 1986), 55. Michel Foucault, "What Is an Author?" reprinted in *The Foucault Reader*, ed. Paul Rabinow (New York: Pantheon, 1984).

24  I taught in a visiting capacity at the University of California, Irvine, 1970–1972, and at the University of California, Santa Cruz, 1973–1974, before assuming a regular

position on the faculty of the University of California, San Diego, in 1974.

25  Among the artists and historian-critics I interviewed for my dissertation, "Marcel Duchamp and America, 1913–1973" (University of California, Berkeley, 1974), were Vito Acconci, Arakawa, Arman, Rudi Blesh, Mel Bochner, Jack Burnham, Nicolas Calas, Leo Castelli, William Copley, Merce Cunningham, John Cage, Salvador Dali, Walter de Maria, Anne d'Harnoncourt, Arne Ekstrom, Henry Geldzahler, John Gibson, Hans Haacke, Richard Hamilton, David Hare, David Hayes, Sidney and Carroll Janis, Donald Judd, Allan Kaprow, Joseph Kosuth, Max Kozloff, Julian Levy, Sol LeWitt, Kynaston McShine, Robert Morris, Kenneth Rexroth, William Rubin, Irving Sandler, Robert Scull, George Segal, William Seitz, Richard Serra, Robert Smithson, and Calvin Tomkins.

26  Peter Urban, *Damage* 1, no. 6 (May 1980), n.p.

27  Moira Roth, "Robert Smithson on Duchamp: An Interview," reprinted in this book; this citation is from page 85.

28  Duchamp played a pivotal role in two public lectures that I gave at various venues around the country and in Canada during the 1980s: "The Dandy, Duchamp and Personae" and "The Mirror, The Mask and The Door."

29  Moira Roth, "Visions and Revisions," *Artforum* 19, no. 3 (November 1980): 36–45. Mary Jane Jacob, with Lucy R. Lippard and myself as consultants, curated a nation-wide exhibition, "A Decade of Women's Performance Art," at the Contemporary Arts Center, New Orleans, in 1980. For the next three years, I edited the material collected by Jacob of the work of thirty-eight individual artists and performance groups, collaborated on an extensive chronology, and wrote a long introduction for *The Amazing Decade: Women and Performance Art in America 1970–1980, A Source Book* (Los Angeles: Astro Artz, 1983).

30  In addition to consulting for this series of symposia, I also participated in them (including in April 1990 delivering a manifesto on a panel entitled "A Critical Agenda for the 1990s: Hopes and Fears") and later wrote the foreword for the symposia's publication, *Worlds in Collision: Dialogues on Multicultural Art Issues,* eds. Reagan Louie and Carlos Villa (San Francisco: San Francisco Art Institute and International Scholars Publications, 1994).

31  The conference was organized by the Institute of International Education, The Cini Foundation, Venice, Italy, in June 1990.

32  Achille Bonito Oliva, *Ubi Fluxus ibi motus 1990–1962* (Milan: Mazzotta, 1990), the exhibition catalog for this Venice Fluxus show that included Kubota's work.

33  In 1989, I was a founding member of the Asian American Women Artists Association (AAWAA) in the Bay Area and a cosponsor of a Korean American women's art conference at Mills College; in 1990, I put on two exhibitions of Asian American artists at Mills College—Carlos Villa and Theresa Hak Kyung Cha—and wrote "Making/Taking over American Art" for a catalogue of six Chinese American artists for the exhibit *Completing the Circle: Six Artists* at the Triton Museum of Arts in Santa Clara, California. In 1992, Margo Machida and I cochaired the first panel on Asian American art history to be held at the College Art Association's annual meeting.

34  Norma Broude and Mary G. Garrard, eds., *The Power of Feminist Art: The American Movement of the 1970s, History and Impact* (New York: Abrams, 1994).

35  I have huge archives of material on feminist performance, women artists of color, and Asian American art and artists; with Elaine Kim, Sharon Mizota, and Margo Machida, I am coediting a forthcoming publication, *Fresh Talk: Contemporary Asian American Art and Culture* (Berkeley: University of California Press). I also have, of course, large archives of material on Duchamp, including transcripts and tapes of many unpublished interviews about him. These I treasure and feel responsible for, as I do my other archives.

36  Gayatri Chakravorty Spivak, "Bonding in Difference: Interview with Alfred Arteaga (1993–1994)," in *The Spivak Reader*, ed. Donna Landry and Gerald Maclean (New York and London: Routledge, 1996), 25.

37  See Faith Ringgold, *We Flew over the Bridge: The Memoirs of Faith Ringgold* (Boston: Little, Brown, 1995) and my *Rachel Rosenthal*. The autobiography of Rose Hacker was privately printed in England (*Abram's Daughter: The Life and Times of Rose Hacker*, 1996).

38  See the reprint of this 1985 text in Landry and Maclean, eds., *The Spivak Reader*.

39  Spivak "Bonding," 28; emphasis mine.

40  Both revised texts are included in this book; they are also scheduled for future publication elsewhere: the Duchamp piece in *Women and Modernism*, ed. Katy Deepwell (Manchester: Manchester University Press, 1998) and the Cage piece in "*Here Comes Everybody*": *John Cage*, edited by David Bernstein.

41  See bell hooks, "Talking Back," in *Out There: Marginalization and Contemporary Cultures*, eds. Russell Ferguson, Martha Gever, Trinh T. Minh-ha, and Cornel West (New York: The New Museum of Contemporary Art, and Cambridge, Mass.: MIT Press, 1990), 327–40.

42  From the start, Saul Ostrow and I conceived this book as the first of a two-volume collection of my writings. The second is to be devoted to my texts on feminism and cultural diversity, and will have Sutapa Biswas as the commentator.

### *notes to* duchamp in america

1  A fine scholarly source for the general history of the dandy is Ellen Moers, *The Dandy: Brummel to Beerbohm* (New York: Viking, 1960). Also see Mario Praz, *The Romantic Agony*, 2nd ed. (London: Oxford, 1951), especially chapter 4, "La Belle Dame Sans Merci," on the fatal woman theme. The late development of the camp version of dandy tastes is analyzed by Susan Sontag, "Notes on 'Camp,'" in her *Against Interpretation and Other Essays* (New York: Farrar, Strauss, Giroux, 1965), 275–92. One could argue that there is much of incipient camp in Duchamp's dandyism from the beginning and that it became almost a gross parody in some of his minor late works such as *Couple of Laundress' Aprons* of 1959 or the 1950s wedding present to the Julien Levys.

2  Norman Zierold, *Garbo* (New York: Stein and Day, 1969), 13.

3  Pierre Cabanne, *Dialogues with Marcel Duchamp*, trans. Ron Padgett (New York: Viking, 1971), 58–59.

4  Gabrielle Buffet-Picabia, "Some Memories of Pre-Dada: Picabia and Duchamp," in

Robert Motherwell, ed., *The Dada Painters and Poets: An Anthology* (New York: Wittenborn Schultz, 1951), 256–67.

5  Ibid., 260.

6  H. P. Roché, "Souvenirs of Marcel Duchamp," in Robert Lebel, *Marcel Duchamp*, 2nd ed., trans. George Heard Hamilton (New York: Grossman, 1967), 79–80.

7  Buffet-Picabia, "Some Memories," 260. She is quoting here from an interview of Duchamp by Sweeney.

8  "A Complete Reversal of Art Opinions by Marcel Duchamp, Iconoclast," *Arts and Decoration* 5 (September 1915): 427.

9  Georges Hugnet, "The Dada Spirit in Painting," trans. Ralph Manheim. In Motherwell, *Dada Painters and Poets*, 186.

10 James Johnson Sweeney, [Interview with Marcel Duchamp], *Museum of Modern Art Bulletin* 13, nos. 4–5, (1946): 20.

11 A highly interesting and informative biography of Duchamp, including speculations on the nature of Rrose Sélavy, is being currently written by Alice Marquis of the University of California, San Diego.

12 Duchamp played chess all his life, but began to do it with obsessive passion in Argentina in 1918.

13 William Seitz, "What Happened to Art?—An Interview with Marcel Duchamp on Present Consequences of New York's 1913 Armory Show," *Vogue*, February 15, 1963, 129.

14 Dore Ashton, "An interview with Marcel Duchamp," *Studio International* (June 1966), 217.

15 Probably Duchamp's first manuscript in English is "The" of 1915, where he takes a short text and replaces each article "the" with an asterisk.

16 From "A l'Infinitif," in Michel Sanouillet and Elmer Peterson. eds., *Salt Seller, The Writings of Marcel Duchamp* (New York: Oxford, 1973), 74.

17 The friendship between Walter Arensberg and Duchamp set the tone for the inbred, private, apolitical, and elegant nature of New York Dada: high spirits were present but so were good manners. Arensberg has been characterized by Milton Brown (*American Painting from the Armory Show to the Depression* [Princeton University Press, 1955], 98) as the most obsessively private of the earlier American collectors—a man dominated by his "fastidious taste, his intellectuality, and his love of the esoteric." It is a description that would fit Duchamp.

18 Quoted in Rudi Blesh, *Stuart Davis* (New York: Grove, 1960), 17.

19 The Vaché quotation is from "Two Letters by Jacques Vaché (to André Breton) 1917–1918," trans. Clara Cohen. In Motherwell, ed., *Dada Painters and Poets*, 70. Of Rigaud, Duchamp told Cabanne: "We had great sympathy for each other." (*Dialogues*, 62). Harriet and Sidney Janis wrote an article, "Marcel Duchamp: Anti-Artist," where they talk of his skepticism potentially leading to suicide, but concluded that Duchamp's irony tempered his despair and turned it into indifference (reprinted in Motherwell, ed., *Dada Painters and Poets*, 311–12). Hans Richter made a similar point in his *Dada Art and Anti-Art* (London: Thames and Hudson, 1965), 87.

20 Sanouillet and Peterson, *Salt Seller*, 56.

21 Most of Duchamp's impact on 1915–1923 New York was through his literal presence

on the scene, and through the legends and myths surrounding that presence. Little work of his could be seen publicly after the furor of the *Nude* in the 1913 Armory Show. Indeed, *The Large Glass* was never exhibited until 1926, and then only once. Though two readymades had been shown in the Bourgeois Gallery in 1916 (at the same time, the Montross Gallery showed *Pharmacy*) the only real recognition on a public level of the readymades was in 1917 through the rejection of the *Fountain* (ironically, its acceptance might well have caused less attention).

### *notes to* the aesthetic of indifference

I am deeply indebted to Joe and Wanda Corn, and to Nan Rosenthal for sustained intellectual friendship and for their close and highly constructive critical reading of this manuscript. The period I have written about is the period of my adult life: I came to the United States (from England) during the McCarthy period. I lived in Berkeley during the 1960s and wrote a dissertation there on Duchamp and America. I have had a long, intense and ambivalent history of attitudes toward Duchamp, Cage, Rauschenberg and Johns. Writing this essay has been a way of trying to write a partial intellectual autobiography, an accounting of my interest in these artists.

1   The whole issue of a positive cult of neutrality (and the often accompanying Dandyism and Camp) in the 1950s is complex. I have singled out Duchamp, Cage, Cunningham, Rauschenberg and Johns but they did not exist, obviously, in a vacuum either socially or intellectually. Contiguous, among others, was the poetic world of Frank O'Hara and John Ashbery and their friends. O'Hara and Ashbery had met in 1949 and were lifelong friends until O'Hara's death in 1966. Both were closely allied with artists and both espoused ideas and artistic stances that moved in parallel directions with those of the Aesthetic of Indifference. Indeed, in 1949 O'Hara had written a poem "Homage to Rrose Sélavy." Among O'Hara's many friends, who included Johns and Cunningham, was Larry Rivers, an enigmatic figure of this period whom one would certainly examine if one were to widen the study of neutrality experiments in the early 1950s. Rivers's *Washington Crossing the Delaware* (1953) was a curious ironic homage to the founder of the American republic done in the year in which McCarthy's attack on the democracy of the American republic was at its most virulent. Other figures appropriate to a broader study of the evolution of a "cool" aesthetic during the 1950s would be Ad Reinhardt, Barnett Newman and Robert Motherwell. I would like to thank David Antin here for a helpful discussion concerning the O'Hara/Ashbery circle affinities with the Aesthetic, and also for referring me to an excellent study: *Frank O'Hara: Poet Among Painters* by Marjorie Perloff (1977). Another study germane to these issues is Susan Sontag's essay "Notes on 'Camp'," in her *Against Interpretation and Other Essays* (New York: Farrar, Strauss, and Giroux, 1965), 275–92.

2   Motherwell and Reinhardt, eds., *Modern Artists in America* (New York: Wittenborn Schultz, 1951). Dondero's diatribes were ominously paralleled by ones from within the ranks of modern art. In a 1952 anthology, (*America in Crisis: Fourteen Crucial*

*Episodes in American History*, ed. Daniel Aaron [?: Shoe String Press, 1977 (1952)], now out of print), Meyer Schapiro, the art historian and critic, contributed a warning essay about these serious assaults on modernism, pointing out that not only bigots such as Dondero, but supposedly sophisticated leaders of the art establishment, as, for example, the director of the Metropolitan Museum of Art, Francis Henry Taylor, had condemned modern art as "meaningless" and "pornographic." A survey of the impact of these attacks is in "The Suppression of Art in the McCarthy Period," by William Hauptman, *Artforum* 12, no. 2 (October 1973): 48–52.

3  In 1952, Harold Rosenberg wrote his famous defense of abstract expressionism in the article "The American Action Painters," *Art News* 51, no. 8 (December 1952): 22–23, 48–50. This article was astutely characterized by Barbara Rose as "the first clear indication of a displacement of political ideas into the arena of aesthetics . . . writing about art, Rosenberg still resorts on occasion to the vocabulary and political tones that he used as a political writer in the thirties." ("Problems of Criticism IV: The Politics of Art, Part I," *Artforum* 6, no. 8 (February 1968): 31–32.

4  Pierre Cabanne, *Dialogues with Marcel Duchamp*, trans. Ron Padgett (New York: Viking, 1971), 103.

5  Richard Kostelanetz, "Conversation with John Cage," in Kostelanetz, ed. *John Cage*, (New York: Praeger, 1970), 8.

6  By 1950, the abstract expressionists were well established, both in terms of maturity of their work and public recognition of them as a group. For the early 1950s, they were certainly the most publicly visible and recognized of American avant-garde visual artists and were the stereotype of what a contemporary artist was like.

7  These quotations from George Segal come from an interview I did with him on February 26, 1973. Published for the first time in this book.

8  John Cage has discussed his impressions of Duchamp at length in Moira Roth and William Roth, "John Cage on Marcel Duchamp," reprinted in this book. Duchamp, when asked by an interviewer why his name was often associated with Cage, replied "We're great buddies. He comes and plays chess every week. . . . If people choose to associate us it's because we have a spiritual empathy, and a similar way of looking at things." ("Passport No. G255300," [an interview with Duchamp by Otto Hahn], *Art and Artists* 1, no. 4 (July 1996): 7–11.

9  Spearheading the revival of Dada in the McCarthy period was Robert Motherwell's anthology, *Dada Painters and Poets* (New York: Wittenborn Schultz, 1951), and the relevant Sidney Janis shows between 1950 and 1953: *Challenge and Defy*, 1950; *1913*, 1951; and *Dada 1916–1923*, 1953, the largest show of Dada in America since 1937. Also, the Rose Fried gallery put on two shows relating to Duchamp during this period.

10  A seminal article on the subject, and one that has greatly influenced me generally, is Max Kozloff's "American Painting During the Cold War," *Artforum* 11, no. 9 (May 1973): 43–54.

11  In 1953, at the height of the Cold War and McCarthyism, Clement Greenberg participated in a symposium on "Is the French Avant-Garde Over-Rated?" and answered with a decided yes in his "Contribution to a Symposium," *Arts Digest* 27, no. 20 (15 September 1953): 12–13, 27, and reprinted in his *Art and Culture* (Boston: Beacon Press, 1961), 124–26. Even more emphatic was the Stuart Davis article in the 1959

*Arts Yearbook* (n.p. , now out of print). The whole issue was devoted significantly to the comparison of New York and Paris contemporary art and in it Davis wrote triumphantly of the superiority of New York art.

12 Duchamp's *Etant Donnés* 1946–1966 was made in secrecy, and its creation only revealed in 1969 although there are veiled references to it in minor post-1946 works. What was publicly known of Duchamp's current production were such works as the small erotic sculpture pieces (*Female Fig Leaf*, 1950, *Objet-Dard*, 1951, and *Wedge of Chastity*, 1954) and other occasional pieces.

13 Reprinted in Kostelanetz, *John Cage*, 111, a statement originally distributed in 1953 by the Stable Gallery which had put on the first show of the Rauschenberg *White Paintings* that year.

14 This passage from one of Johns's notebooks was first published in 1965, and reprinted in Richard S. Field's catalogue of Jasper Johns prints (Philadelphia Museum of Art, 1970). Field analyzes this passage concerning a spy and a watchman, and reads it in terms of "rich allegories on the concept of the spectator (critic) and artist." True enough, it probably does refer to that, but I think what is also significant about the passage is that it shows Cold War imagery, unconsciously, still coloring the thinking of Johns in the 1960s. I would like to acknowledge here a marvelously fruitful discussion with Joe Corn concerning the Cold War implications of Johns's work. The recent study by Joan Carpenter ("The Infra-Iconography of Jasper Johns," *Art Journal* 36, no. 3 [spring 1977]: 221–27) suggests interesting possibilities in extending the "reading" of Johns through the use of infrared photographs.

### *notes to* identification

1 See Amelia Jones, *Postmodernism and the En-gendering of Marcel Duchamp* (New York: Cambridge University Press, 1994); Fred Orton, *Figuring Jasper Johns* (Cambridge, Mass.: Harvard University Press, 1994); Caroline A. Jones, "John Cage and the Abstract Expressionist Ego," *Critical Inquiry* 19, no. 4 (Summer 1993): 643–47; Ken Silver, "Modes of Disclosure: The Construction of Gay Identity and the Rise of Pop Art," in *Hand-Painted POP: American Art in Transition 1955–62*, ed. Russell Ferguson, exh. cat., The Museum of Contemporary Art, Los Angeles, 1993; Jill Johnston, *Jasper Johns: Privileged Information* (New York: Thames and Hudson, 1996); and my "The Art of Code," in *Significant Others*, ed. Whitney Chadwick and Isabelle de Courtivron (New York: Thames and Hudson, 1993).

2 Roth herself credits Max Kozloff's famous article "American Painting During the Cold War" in "The Aesthetic of Indifference." She writes, "A seminal article on the subject, and one that has greatly influenced me generally, is Max Kozloff's 'American Painting During the Cold War,' *Artforum* 11, no. 9 (May 1973): 43–54." Moira Roth, "The Aesthetic of Indifference," reprinted in this book; note 10, page 172. Hereafter, page numbers cited for this essay will be from this book.

3 "Opposition, Incorporated: The Homosexualization of American Art" (Northwestern University, 1995). I am currently revising this dissertation for publication as a book.

4 Roth, "The Aesthetic of Indifference,"41.

5 Ibid., 35.

6  Ibid., 35.

7  Ibid., 36.

8  See the beginning of her notes for "The Aesthetic of Indifference," page 171 of this book.

9  Roth, "The Aesthetic of Indifference," 43.

10 Ibid., 37.

11 Ibid. Although risking essentialism, Roth's construction of homosexuality as a factor worthy of art historical analysis—quite rare at the time—is even more unusual for its positioning of queerness in terms of specifically oppositional praxis.

12 John Cage, *Silence: Lectures and Writings* (Middletown, Conn.: Wesleyan University Press, 1973), 109.

13 Michael Crichton, *Jasper Johns* (New York: Abrams, 1977), 13.

14 Andy Warhol, *The Philosophy of Andy Warhol: From A to B and Back Again* (New York: Harcourt Brace, 1975), 7.

15 Frank O'Hara, "In Memory of My Feelings," in *The Selected Poems of Frank O'Hara* (New York: Vintage Books, 1974), 105–10. Despite his rejection of a singular selfhood, O'Hara wrote so often in the first person that the "Lunch Poems" published in *Standing Still and Walking in New York* were called his "I do this, I do that poems." That there is an "I" in O'Hara's works, observing, attentive and reportorial is everywhere in evidence, but that "I" does not reveal an "inner life" or operate out of an essentialized interiority. Indeed, he was vociferously opposed to any type of confessional poetry, as his satirical text "Personism" makes clear. Even O'Hara's most deeply personal poem, "Joe's Jacket," which describes his movements, thoughts and feelings during the long weekend when he fell in love with the last important man in his life, Vincent Warren, contains a long meditation on the limits of self-expression. The poem's refrain, "now I will say it, thank god, I knew you would" eloquently conveys this tone of a self produced only in and through social engagement, self-actualized only among company, for whom to be solitary is not to be.

16 Pierre Cabanne, *Dialogues with Marcel Duchamp*, trans. Ron Padgett (New York: Viking, 1971), 64–65.

17 Moira Roth, "Marcel Duchamp in America: A Self Ready-Made," reprinted in this book; this citation is from page 30. Hereafter, page numbers cited for this essay will be from this book.

18 Roth actually lists a number of Duchamp's other performative identities, including the hermetic scholar, the inventor, and the gambler.

19 This is not to suggest that Duchamp didn't have a pessimistic side. It is merely to question the automatic connection of that pessimism to his dandyism.

20 Roth, "Marcel Duchamp in America," 29.

21 Beau Brummell was in fact a working class man who never married and achieved his renown solely through the manipulation of aesthetic codes.

22 Oscar Wilde, "The Critic as Artist," in *The Portable Oscar Wilde*, ed. Richard Aldington and Stanley Weintraub (New York: Viking, 1981), 126.

23 Jonathan Dollimore, *Sexual Dissidence: Augustine to Wilde, Freud to Foucault* (Oxford: Clarendon Press, 1991), 63.

24 Examples of this are legion, but perhaps the most telling is *Etant Donnés,* in which even

the female body is redesigned so as to look unnatural.

25 There does not seem to be any evidence of Duchamp's queerness as expressed on an erotic plane, although Paul Franklin is completing a dissertation at Harvard that may bring new evidence to light. Nonetheless, the malleability of the metaphor of the closet to presumably straight men like Duchamp is very much my point.

26 Oscar Wilde, *The Picture of Dorian Gray*, in Aldington and Weintraub, eds, *Oscar Wilde*, 163.

27 And, concomitantly, this mystified demarcation of public from private spheres of identity regulates what gets seen on the stage of culture as culture (i.e. culturally produced) and thus worthy of discussion and debate—effectively consigning many dissident perspectives, such as that of queers, to the realm of the private and hence the unseen and unseeable.

28 Duchamp's immigrant identity may be worth considering in this light. Perhaps finding himself culturally distinct abetted this sense of disidentification.

29 See Michael Leja, *Reframing Abstract Expressionism* (New Haven: Yale University Press, 1993).

30 Frank O'Hara's "How to Proceed in the Arts" is a classic counter to this tendency. In his *Art Chronicles 1954–1966* (New York: Braziller, 1975), 92–98.

31 Robert Rauschenberg, in an unpublished 1961 transcript of the symposium on Assemblage, organized by William Seitz following the *The Art of Assemblage* exhibition at the Museum of Modern Art (MOMA); MOMA archives: 23.

32 Jasper Johns, "Sketchbook Notes," in *Jasper Johns: Writing, Sketchbook Notes, Interviews*, ed. Kirk Varnedoe (New York: Museum of Modern Art/Abrams, 1996), 50. It is interesting to note that at nearly the same time that Duchamp is problematizing the notion of an expressive authorial meaning, the poet T. S. Eliot is doing likewise. Eliot writes of " . . . the difficulty caused by the author's having left out something which the reader is used to finding; so that the reader, bewildered, gropes about for what is absent, and puzzles his head for a kind of 'meaning' which is not there, and is not meant to be there." T. S. Eliot, "The Use of Poetry and the Use of Criticism," quoted in *The Norton Anthology of Modern Poetry*, ed. Richard Ellman (New York: Norton, 1973), 458.

33 Ross Chambers. *Room for Maneuver: Reading Oppositional Narrative* (Chicago: University of Chicago Press, 1991), 251.

34 John D'Emilio, "The Homosexual Menace: The Politics of Sexuality in Cold War America," in *Passion, and Power: Sexuality in History*, ed. Kathy Peiss and Christina Simmons (Philadelphia: Temple University Press, 1989): 226–40.

35 See Caroline A. Jones, "John Cage and the Abstract Expressionist Ego."

36 Chambers, *Room for Maneuver*.

37 Fred Orton's article first suggested to me the applicability of these Derridian concepts to art history. I am heavily indebted to his pioneering work. See his "On Being Bent 'Blue' (Second State): An Introduction to Jacques Derrida/A Footnote on Jasper Johns," *Oxford Art Journal* 12, no. 1 (1989): 35–46.

38 Cage, "On Robert Rauschenberg, Artist, and His Work," *Metro*, May 1961. Reprinted in his *Silence*, 98.

39 Ibid.

40 A classic example of this possibility can be found in the history of the reception of Johns's *Flag* paintings. As I've written in another context, " … Alfred Barr, Jr. wanted to immediately purchase Johns's famed *Flag* of 1954 right out of its first showing at the Leo Castelli Gallery, but then lost his nerve out of fear of controversy (It was left to Philip Johnson to make the purchase; he only donated the work decades later in memory of Alfred Barr.) That's a strong argument for the transformative potential of what may seem like passivity, especially for those without the power to define official culture. Remember that Calas's almost subversive description of *Flag* as "a sign that has lost its significance" was penned at the height of Cold War jingoistic nationalism. Like so many gay men before them, instead of making statements, these queer artists marked out their resistance through nuanced allusion and the manipulation of things." See my "Passive Resistance: On the Success of Queer Artists in Cold War American Art," *Image* 3 (December 1996): 139.

41 Roth, "The Aesthetic of Indifference," 41.

42 Harold Rosenberg, *The Dedefinition of Art* (New York: Horizon Press, 1972), 91, quotes Newman's comments on the *White Paintings*.

43 Rauschenberg to Betty Parsons, 18 October, 1951, Archives of American Art, Betty Parsons Papers. Reprinted in Walter Hopps, *Rauschenberg: The Early Fifties*, exh. cat. (Houston: The Menil Collection, 1991), 230.

44 Michel Foucault, *The Order of Things: An Archeology of the Human Sciences* (London: Tavistock, 1970), 342–43.

## *notes to* john cage on marcel duchamp

1  *Dreams That Money Can Buy*, a film by Hans Richter, 1944–46. John Cage wrote the music for Duchamp's sequence in the film (*Music for Marcel Duchamp*, piano solo, 1947).

2  Mary Reynolds was a close friend of Marcel Duchamp for thirty years. She died in Paris in 1950.

3  John Cage, *A Year From Monday: New Lectures and Writings* (Middletown, Conn.: Wesleyan University Press, 1967).

4  Walter Hopps, Ulf Linde, and Arturo Schwarz, *Marcel Duchamp: Ready-Mades, etc. (1913–1964)* (Paris: Le Terrain Vague, 1964). The original edition was issued for a Duchamp exhibition, Galleria Schwarz, Milan, June–Sept., 1964.

5  *Musical Erratum*: ink on standard sheet music paper, approx. 12½ x 19½", 1913. The original was lost; the size never recorded. The work, a musical composition, was Duchamp's first implementation of chance, using Lewis Carroll's theory, with musical intervals taking the place of words. "First you write a sentence,/ And then you chop it small;/ Then mix the bits, and sort them out/ Just as they chance to fall:/ The order of the phrases makes/ No difference at all." (From Lewis Carroll, *The Complete Works* [New York: Random House, 1939], 790.) Duchamp jotted down the notes as he drew them out of a hat; he was supposed to sing the resulting score with his two sisters, Yvonne and Magdeleine.

6  *Etant Donnés: 1° la Chute d'Eau, 2° le Gaz d'Eclairage*, 1946–66 (Philadelphia Museum of Art).

7  Pierre Cabanne, *Entretiens avec Marcel Duchamp* (Paris: Belfond, 1967).

8  John Cage, *Silence: Lectures and Writings* (Middletown, Conn.: Wesleyan University Press, 1961).

9  Richard Kostelanetz, ed., *John Cage* (New York: Praeger, 1970).

10 *Reunion*, chess concert, Toronto, 1968. For a chess match arranged by John Cage with David Tudor, Gordon Mumma, and David Behrman, Lowell Cross constructed a chess board with circuits; moves on the board transmitted or cut off sound produced by the several musicians. Duchamp played with Cage and Mrs. Duchamp.

11 Pierre Cabanne, *Dialogues with Marcel Duchamp*, trans. Ron Padgett, (New York: Viking, 1971).

## notes to introduction to unpublished interviews with vito acconci and george segal about marcel duchamp

1  See list of artists and critics interviewed in my introduction, "Now and Then," note 25.

2  Moira Roth, "Ivan Karp on Marcel Duchamp," *Studio International,* February 1974, n. p.

## note to introduction to the voice of shigeko kubota

1  Shigeko Kubota, quoted in Moira Roth, "The Voice of Shigeko Kubota: 'A Fusion of Art and Life, Asia and America. . . , '" in *Shigeko Kubota: Video Sculpture*, ed. Mary Jane Jacob (New York: American Museum of the Moving Image, 1991), 77.

## notes to the voice of shigeko kubota

27 Kubota's work as a writer for a Japanese periodical, *Bijutsu Techo*, encouraged her to explore a wider circle of art in New York than that of Fluxus. She translated the diaries of Andy Warhol into Japanese; she also conducted interviews with him, Willoughby Sharpe, and Yvonne Rainer; she wrote a laudatory response to the Howard Wise 1969 exhibition *TV as a Creative Medium*. Most important, she wrote at length on Duchamp, especially on the *Etant Donnés*, which had been put on exhibition in Philadelphia shortly after his death.

28 See Moira Roth and William Roth, "John Cage on Marcel Duchamp," reprinted in this book.

29 Mary Jane Jacob, *Shigeko Kubota: Video Scupture* (New York: American Museum of the Moving Image, 1991), 16.

30 Ibid.

31 Jeanine Mellinger and D. L. Bean, "Shigeko Kubota." Interview in *Profile* 3, no. 6 (November 1983): 3.

32 Vito Acconci, in unpublished interview with author, January 31, 1973. Printed for the first time in this book; this citation is from page 91.

33 Jacob, *Shigeko Kubota*, 24.

34 Kubota consciously upturned the image of the original flat grave of Duchamp in preference of a vertical format. She stated "I made [a] tower of graves from floor to ceiling and the I put [a] mirror on the floor. ... You know, going to the universe you have to think of more space." (Mellinger and Bean, 4, note 15). There were two pieces in Kubota's first one-person video exhibition: *Marcel Duchamp's Grave* and the single-channel video entitled *Self-Portrait,* surely an interestingly revealing choice of Kubota's.

35 Chicago, Museum of Contemporary Art, *Shigeko Kubota, Option 9*, text by Cindy Neal (Chicago, 1981), n. p.

36 Jacob, *Shigeko Kubota*, 24.

37 Ibid, 73.

38 Jacob, *Shigeko Kubota*, 46.

39 Ibid.

40 Chicago (note 35), n. p.

41 Ibid.

42 Jacob, *Shigeko Kubota*, 28.

<p style="text-align:center">• • •</p>

62 Jacob, *Shigeko Kubota*, 68.

63 Ibid.

64 Ibid.

65 Yukio Mishima, *The Temple of the Golden Pavilion* (New York: Putnam, 1980), 256.

66 Ibid, 258.

67 Ibid, 261.

68 Ibid, 262.

69 Jacob, *Shigeko Kubota*, 68.

### *notes to* talking back

1  I am deeply grateful to Naomi Sawelson-Gorse for her initial invitation to participate in this symposium and for her insistence—when I voiced my original hesitations, telling her I was no longer that interested in Duchamp and had, indeed, stopped writing on him—that I should nevertheless do a presentation, and her encouragement to "do whatever I liked." I want to acknowledge, also, the most helpful suggestions and criticisms made by fax exchange and in phone conversations with Whitney Chadwick, Irit Rogoff, and Abigail Solomon-Godeau during the time I was composing this performance. Diane Tani, too, was most generous with her help in making the slides for the letter exchange between myself and Duchamp.

2  bell hooks, "Talking Back," in *Out There: Marginalization and Contemporary Cultures*, ed. Russell Ferguson, Martha Gever, Trinh T. Minh-ha and Cornel West (New York: The New Museum of Contemporary Art, and Cambridge, Mass.: MIT Press, 1990), 327–40.

3  Moira Roth, "Marcel Duchamp and America, 1913–1974," University of California,

Berkeley, 1974. In my dissertation acknowledgments, I write at the end that "Perhaps most of all I have a debt to Marcel Duchamp. In the last few years, sometimes I have admired him, sometimes I have had ambiguous and negative feelings about him, but in either case, his effect on me has been profound."

4   See my interview with Vito Acconci, January 31, 1973, published for the first time in this book.

5   Moira Roth, "Robert Smithson on Duchamp: An Interview," reprinted in this book. Hereafter, page numbers cited for this essay will be from this book.

6   Ibid., 87.

7   Ibid., 88–89.

8   See my "Marcel Duchamp in America: A Self Ready-Made," reprinted in this book.

9   In 1977 Sheldon Nodelman and I were both teaching at the University of California, San Diego. By this time, I had completed my dissertation on Duchamp (which I never published), and was deeply involved in performance art research—hence my interest in the performative aspects of Duchamp.

10  Sheldon Nodelman had given a lecture, entitled "Once More to this Star," earlier that day in the symposium.

11  See my "Marcel Duchamp in America."

12  "The Aesthetic of Indifference," reprinted in this book. In the postscript to this essay, I explain that "The period I have written about is the period of my adult life. I came to the United States (from England) during the McCarthy period. I lived in Berkeley during the 1960s and wrote a dissertation on Duchamp and America. I have had a long and ambivalent history of attitudes toward Duchamp, Cage, Rauschenberg, and Johns. Writing this essay has been a way of trying to write a partial intellectual autobiography, an accounting of my interests in these artists."

13  Amelia Jones, one of the participants in this October 1995 conference, had just made her presentation prior to mine with a lecture entitled, "Duchamp and the En-Gendering of the Artistic Subject," a subject that she had already explored at length in her book, *Postmodernism and the En-Gendering of Marcel Duchamp* (New York: Cambridge University Press, 1994).

14  Moira Roth and Diane Tani, "Interview with Lynn Hershman," in Lynn Hershman, *Lynn Hershman*, Chimaera Monographs 4 (Belfort, France: Centre International de Création Vidéo Montbéliard Belfort, 1992), 116.

15  Moira Roth, "The Voice of Shigeko Kubota: 'A Fusion of Art and Life, Asia and America . . . ,'" excerpts of which are in this book. Hereafter, page numbers cited for this essay will be from this book.

16  Shigeko Kubota, *Duchampiana: Marcel Duchamp's Grave* (1972–1975), a freestanding plywood construction that can contain up to twelve monitors.

17  See my "The Voice of Shigeko Kubota," 111.

18  Sharon Grace, "Television, Electronic Kids, and Duchamp, An Interview through the Wires with Shigeko Kubota," *Art Com* 4, no. 3 (Fall 1977): 21.

19  Guillermo Gomez-Peña, "Border Culture: The Multicultural Paradigm," in *The Decade Show: Frameworks of Identity in the 1980s*, (New York: The Museum of Contemporary Hispanic Art, The New Museum of Contemporary Art, and The Studio Museum in Harlem), 1990.

20 I have been profoundly influenced by Faith Ringgold's work and politics, and since the mid-1980s I have written a number of essays on her and edited her autobiography, *We Flew Over the Bridge: The Memoirs of Faith Ringgold* (Boston: Little, Brown, 1995).

21 The texts and reproductions of the twelve story quilts of The French Collection Series by Faith Ringgold can be found in the forthcoming *Dancing at the Louvre: Faith Ringgold's French Collection and Other Story Quilts* (New York: The New Museum of Contemporary Art, and Berkeley: University of California Press, 1998).

22 Ibid.

23 Ibid.

24 Ibid.

25 Moira Roth, "Dinner at Gertrude Stein's: A Conversation with Faith Ringgold," *Artweek,* February 13, 1992, 11.

26 Ringgold is now at work on The American Collection, and it appears as of this writing that there will be no references to Duchamp in it. See my essay, "Of Cotton and Sunflower Fields: The Making of the French and American Collections," in *Dancing at the Louvre.*

## notes *to* five stories

1 HPSCHD, at the Urbana campus, University of Illinois, May 16, 1969.

2 Moira Roth and William Roth, "John Cage on Marcel Duchamp, An Interview," reprinted in this book.

3 This Ponope gathering, "Word of Mouth," arranged by Crown Point Press, was held at the beginning of 1980.

4 John Cage died on August 12, 1992.

## notes *to* difference

1 I am happy to report that the Harvey Milk Institute, with over a thousand students and eighty classes in the spring 1997 semester, is now the largest queer studies organization in the world.

2 Martin Duberman, *Black Mountain: An Exploration in Community* (New York: Dutton, 1972), 229.

3 See my "John Cage's Queer Silence or How to Avoid Making Matters Worse," from the forthcoming *"Here Comes Everybody": John Cage,* edited by David Bernstein.

4 Moira Roth, "Talking Back," in the forthcoming *Women Artists and Modernism,* ed. Katy Deepwell (Manchester: University of Manchester Press, 1998), appearing simultaneously in this book.

5 Amelia Jones, *Postmodernism and the En-gendering of Marcel Duchamp* (New York: Cambridge University Press, 1994).

6 Tellingly, the only instance in which she offered a more traditionally scholarly engage-

ment with Duchamp took place in a discussion of the Japanese American artist, Shigeko Kubota, whom she analyzed as having successfully made Duchamp her own. I am not entirely convinced by Roth's determination to show how Kubota successfully distances herself from the gravitational pull of Duchamp.

# permissions